Scenic Photography | 101

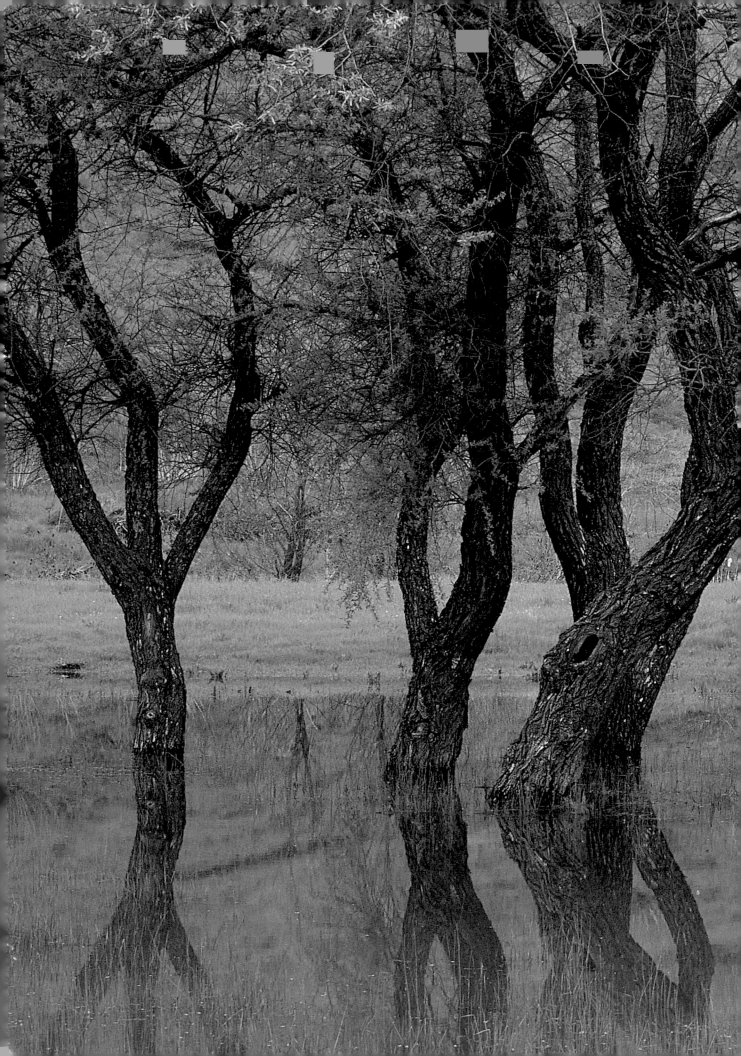

Scenic

Photography 101

A Crash Course in Shooting Better Pictures Outdoors

Kerry Drager

Amphoto Books

An imprint of Watson-Guptill Publications

New York

PAGE 1 *Golden Gate Bridge, San Francisco. 180mm lens,*
 Fuji Velvia
PAGES 2–3 *Tree reflections. 85mm lens, Fuji Velvia*
PAGE 5 *Leaves. 55mm lens, Kodachrome 25*
PAGES 6–7 *Mono Lake sunrise, near Yosemite National Park.*
 85mm lens, Fuji Velvia

[*Note: Unless otherwise specified, all lens and film information refers to 35mm camera format.*]

Editor: Alisa Palazzo
Designer: Derek Bacchus
Production Manager: Hector Campbell
Editorial Concept: Robin Simmen

Copyright © 1999 Kerry Drager

First published in 1999 in New York by Amphoto Books,
an imprint of Watson-Guptill Publications, a division of BPI
Communications, Inc., 1515 Broadway, New York, N.Y. 10036

Library of Congress Cataloging-in-Publication Data
Drager, Kerry.
 Scenic photography 101 : a crash course in shooting better
pictures outdoors / Kerry Drager.
 p. cm.
 Includes index.
 ISBN 0-8174-5819-0
 1. Landscape photography. 2. Outdoor photography.
 I. Title.
TR660.D73 1999
778.7'1—dc21 99-29592
 CIP

Printed in Hong Kong

1 2 3 4 5 6 / 04 03 02 01 00 99

ACKNOWLEDGMENTS

Many people contributed to the creation of this book.

I extend special thanks to my wife, Mary Summers,

my stepchildren, Dan and Kristin Summers, and

my mother, Helen Drager, for their love, support,

and enthusiasm; and to Jan Haag and Dick Schmidt

for their valuable advice, encouragement, and

friendship. Extra gratitude also goes to Amphoto's

staff, including Robin Simmen for her confidence

in this project and Alisa Palazzo for her editing

and guidance.

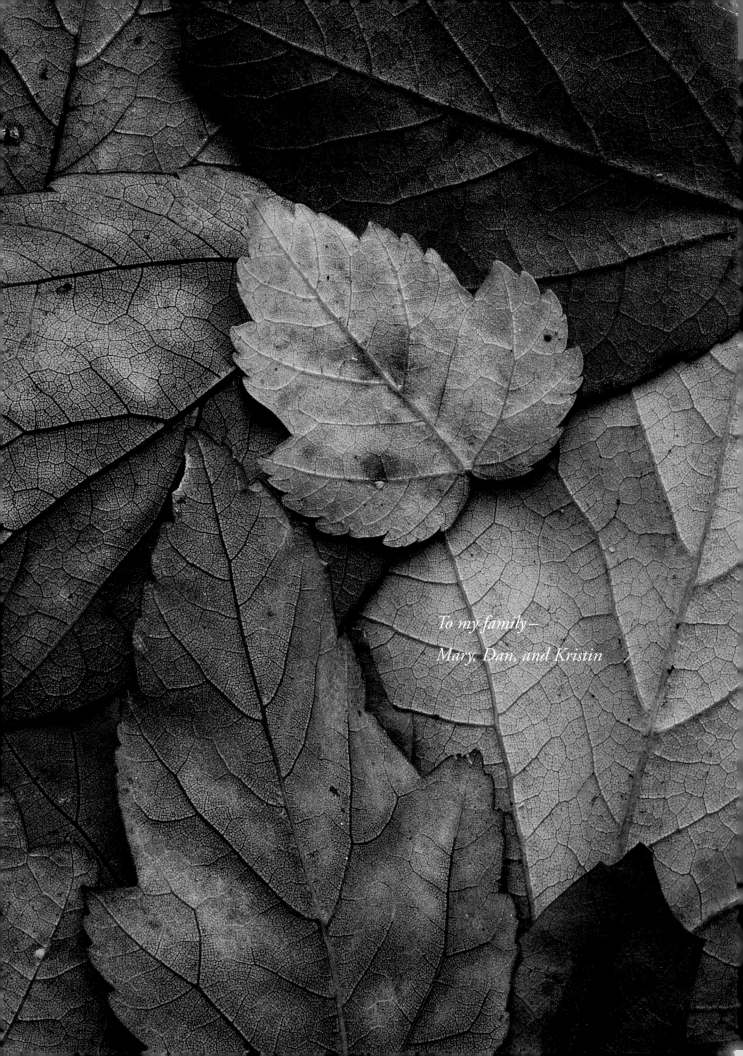

To my family—
Mary, Dan, and Kristin

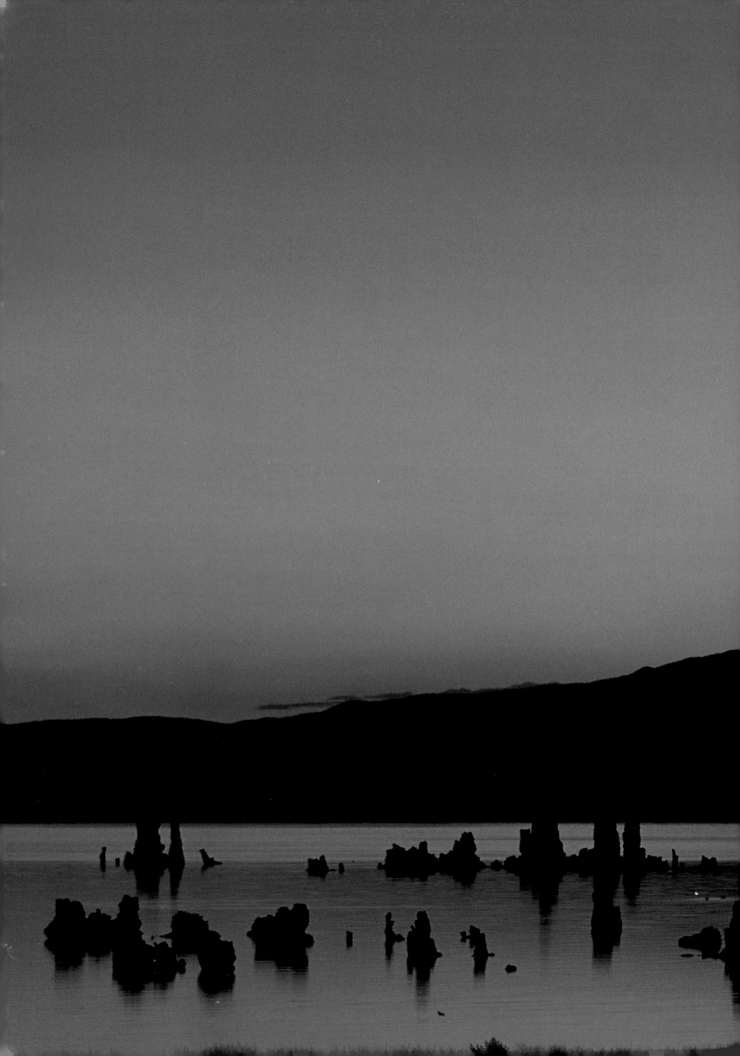

Contents

Introduction

My photography evolved out of a love of travel and the outdoors, as well as out of a desire to share my favorite escapes with family and friends. Perhaps that describes your motivations, too. But how often have you said, "Well, I guess you had to be there," after showing more disappointing photographs?

Certainly, there's nothing like experiencing a special scene firsthand, but there's also nothing like the satisfaction of successfully capturing those places on film. This book is about the quest to turn your travel and outdoor explorations into visual adventures. It's about working with color, composition, and content to help you create memorable photographs instead of forgettable snapshots.

Eye-catching photographs rarely just happen. Although today's cameras handle the nuts-and-bolts operations, advanced equipment alone is no guarantee that your scenic photographs will match your expectations. A big vision—not a big budget—results in pictures that count. And, regardless of your current level of ability, it's easier than you might think to improve your skills. The tricks, tips, and techniques outlined in these pages will get you started on your photographic journey.

Scenic Photography 101 is geared for beginners, serious amateurs, and aspiring professionals who wish to develop or fine-tune their shooting eye. The first chapter explores ways of breaking out of the snapshot rut, while subsequent chapters focus on exploiting natural light and designing compelling images. However, don't expect complicated formulas, esoteric theories, or arbitrary guidelines; instead, expect down-to-earth advice that shows how to look beyond what casual observers see and produce your own beautiful images in your own individual style. Along the way, we'll tackle some of the technical challenges that can impede your photography.

Since there's no foolproof recipe for getting things perfect every time, an underlying theme of this book is the importance of taking risks, of trying out new methods. Unquestionably, any of a number of time-tested procedures can spice up your photography, and we'll review them here; but on occasion (actually, on many occasions), breaking the "rules" means the difference between an average shot and a real showstopper. Coming up with fresh outlooks is what experimentation is all about.

Don't assume, though, that you must travel to exotic locales to make exciting photographs. Possibilities for dynamic scenics exist almost everywhere, including in and around your own home town. Photographing close-at-hand locations is an easy, enjoyable, and inexpensive way to tone up your techniques.

Most of the tips I offer can be performed with any camera, whether you own a basic 35mm point-and-shoot, a state-of-the-art single-lens-reflex (SLR), an Advanced Photo System (APS) model, a medium-format outfit, or a digital camera that doesn't even use conventional film. That the photos in this book were all made with standard 35mm cameras and lenses. In any case, regardless of the technology used for recording and reproducing images, photography at its essence remains an exercise in creative seeing.

In addition, because my personal and professional work is geared toward sharing my travels with others, I strive for a realistic blend of art and information. As a result, I never use strong filters, double exposures, or darkroom or computer manipulations to change a scene. Still, certain common filters (to bring out the natural colors or to tone down contrast, for example) and minor digital alterations (to eliminate scratches or fix other slight flaws) can help ensure the best possible reproduction and narrow the gap between what the eye sees and what the camera records.

There's another key aspect in the photographic process: the fun factor. The idea is to pick subjects that appeal to you so that the process of *looking* for a picture is just as fulfilling as that of *making* the picture. For example, rarely do I arrive on a scene and immediately start firing away. As I seek out subjects that interest me, I generally spend far more time searching than shooting. And there still are occasions when I don't even make a photograph—perhaps the light's not right or the scene poses design problems. Ultimately, even if a session falls short of my photographic hopes, I still find satisfaction in the twin acts of wandering and watching. The enjoyment of the great outdoors and the pursuit of great photographs . . . now, aren't those worthwhile goals?

While attending a county fair at twilight, I set up my tripod and took an exposure that lasted several seconds, knowing that the slow shutter speed would result in a whirl of colors. To make the most of my subject, I took several photographs of the scene, using different compositions, lenses, and formats.

[24mm lens, Fuji Velvia]

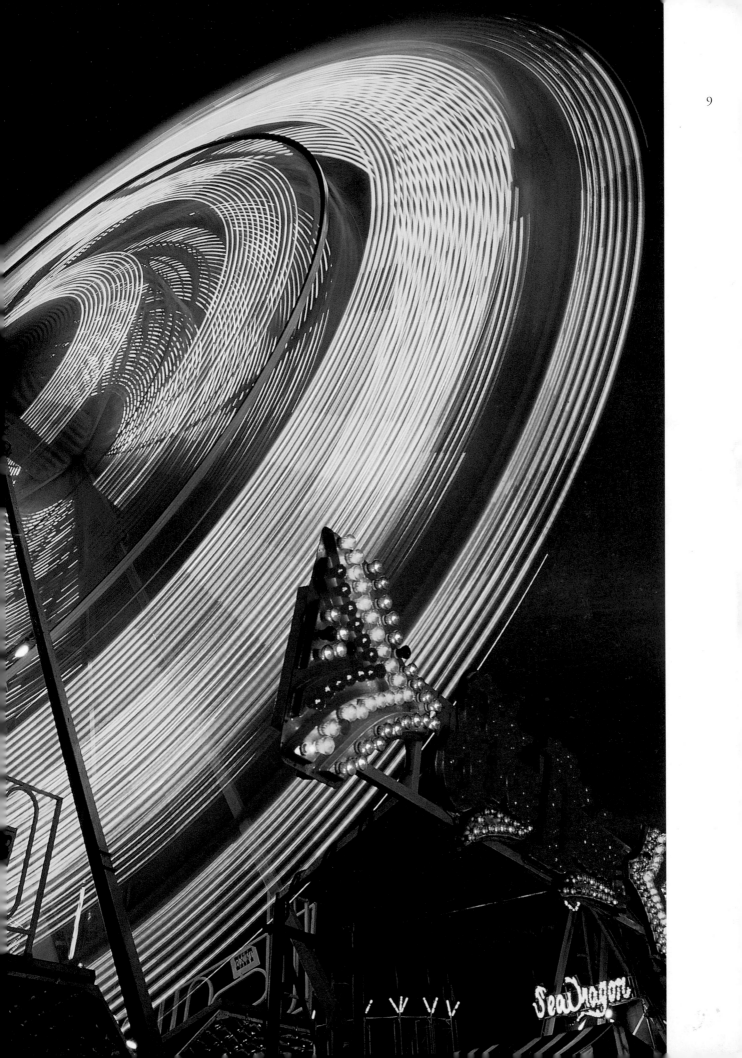

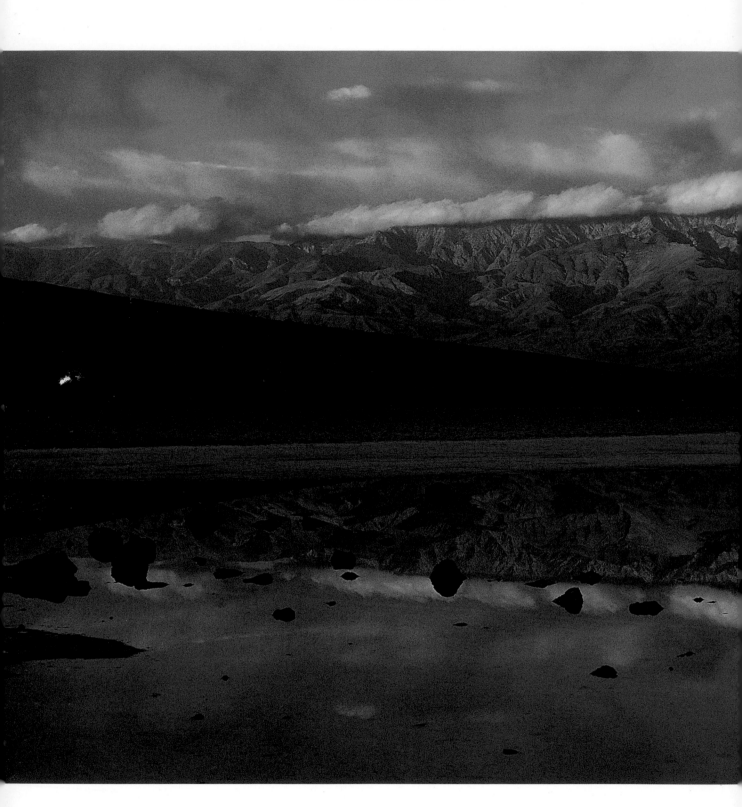

North America's lowest altitude—282 feet below sea level—lies on the salt flats just beyond this spot: Badwater, Death Valley National Park, Califor-nia. At midday, tourists generally dominate the scene. When I got there early one morning, however, clouds and drama made up the view. Almost any camera, whether simple or sophisticated, could have record-ed this scene.

[50mm lens, Kodachrome 25]

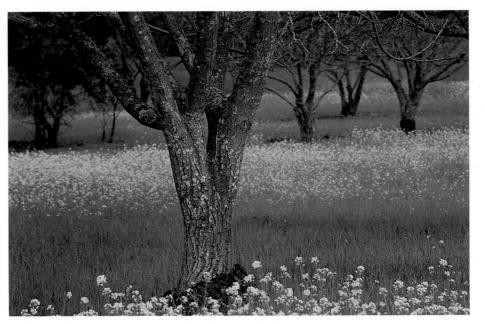

During a drive through the country, I decided to devote what little time I had for photography to capturing one single scene — this springtime orchard. The diffused overcast light helped pump up the greens and yellows, while my telephoto lens let me zero in on one tree, with the background transformed into soft shapes and colors. This image meant more to me than an entire batch of quick snapshots.

[180mm lens, Fuji Velvia]

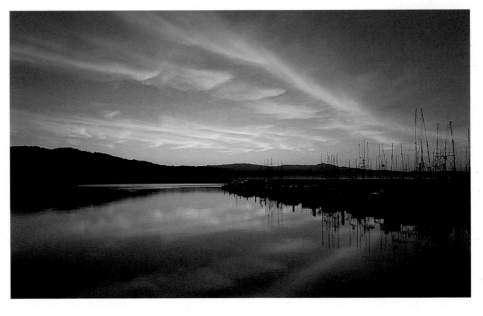

Obtaining dynamic scenics often involves planning, preparation, and in this case, an alarm clock. The strategy behind making this photograph began one afternoon at a marina in Half Moon Bay, California, when I imagined what the scene might look like at dawn. I set my alarm clock, and early the next morning, I was out photographing these wonderful colors.

[24mm lens, Fuji Velvia]

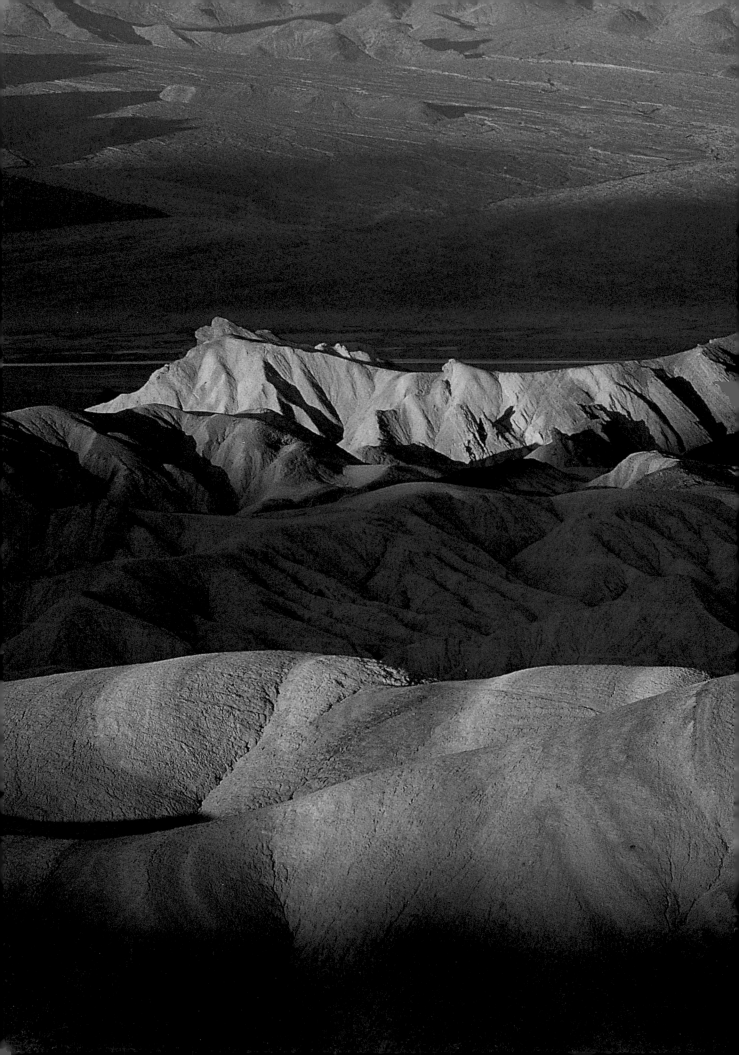

1 | **Developing Your Vision**

14

Beyond Snapshots

The best way to guarantee the production of too many run-of-the-mill snapshots and too few top-of-the-line photographs is to be in too much of a hurry. Does the following scenario sound familiar? You arrive at a designated location, pull out your camera, and fire off a quick shot from the first vantage point you see. Then, you're back to the car and off to the next subject.

Sure, these "been there / seen that" pictures may remind you of pleasant times from your weekend or vacation getaway, but they won't be inspirational for viewers who weren't with you. I took some of my favorite personal photographs on an exhilarating and exhausting hike to the top of Mount Shasta, northern California's 14,162-foot landmark. Viewing these pictures has special value for those of us who made the climb, but for others, the photos of distant hazy landscapes and weary climbers have little significance.

Making successful scenic photographs that appeal to all viewers generally requires a thoughtful, deliberate approach. However, there are many ways to record a subject; while attending numerous field workshops, both as a participant and an instructor, I've watched photographers shooting the same scene in the same light, yet each interpreting things in his or her own individual style. And that's the idea behind this chapter: to help you develop your own unique ways of seeing—and recording—the world around you.

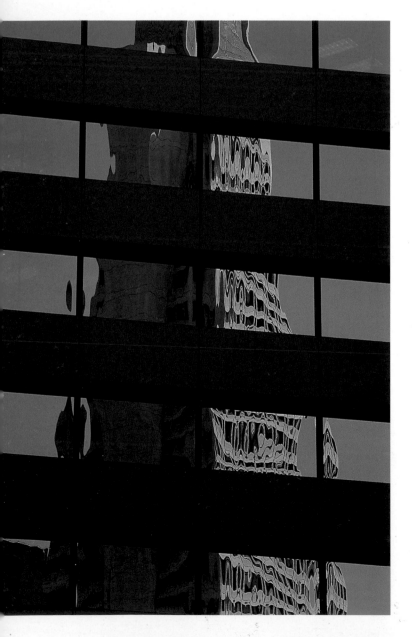

Developing your vision means dropping the "ready, aim, fire" attitude and, instead, slowing down and exploring a subject's picture potential. That's exactly what I did during a visit to San Francisco (left). After searching for straight-on ways to shoot the Transamerica pyramid, I found the best view of my subject behind me, mirrored in the windows of another office building.

[180mm lens, Fuji Velvia]

You don't have to travel far to develop your vision. Any subject, anywhere, works. One day, I looked for potential camera positions to capture this office building (opposite) in Sacramento, near my home, during the evening twilight. I checked at street level first but found this view from the top of a parking garage.

[75–150mm zoom lens, Kodachrome 25]

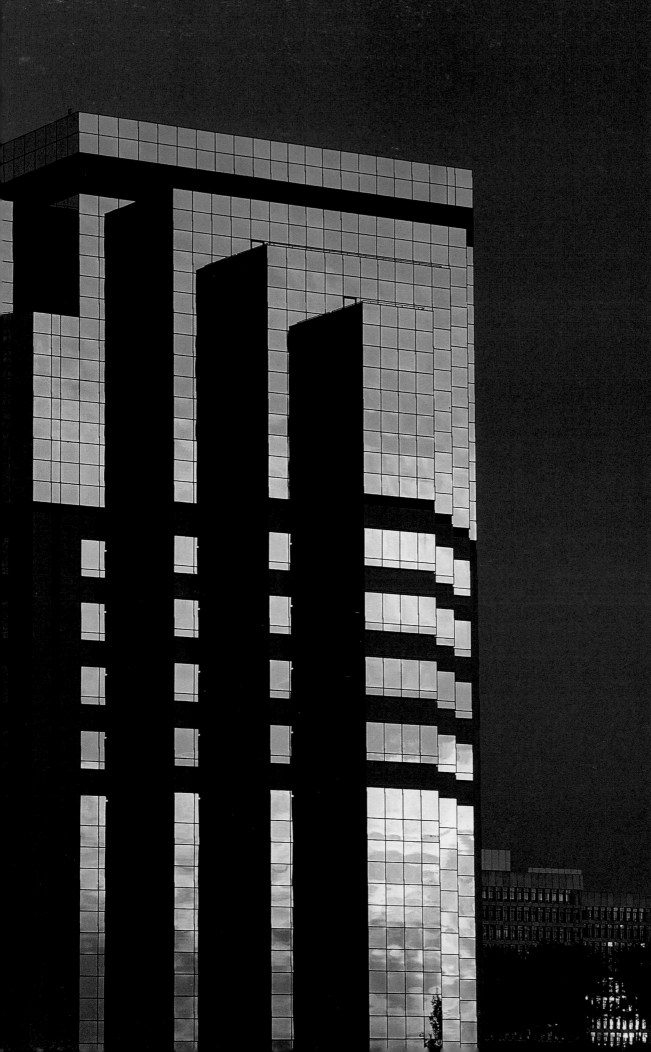

Getting Out

There can be many excuses for not putting your camera to use, but if amount of time is a problem, quality of time doesn't have to be. Start by photographing around your home, neighborhood, nearby city, or surrounding countryside. Regular outings in your area, even if only for a few hours, will help hone your skills. There's value in practicing camerawork close to home. A friend once told me that as he experimented with a new lens, he found that he took some of his best photos in his own back yard—literally. On other occasions, you can perform "dry-shooting" exercises, in which you look for interesting subjects and then picture potential images in your mind. You can dry-shoot at any time, with any subject, and without a camera.

On your next pressure-packed family or group trip, ask yourself the following: Do I really need to shoot a visual diary, recording every place I visit, every person I'm with? The idea is to think about your subject and explore your surroundings, instead of dashing from place to place, relying only on your first impressions. Do this by matching the time you have with a subject you can handle. If you only have a short period of time, choose a small scene. Emphasizing quality time—rather than quantity of pictures—may lead to fewer overall images, but more of them will be worthwhile and fewer will be uninspired.

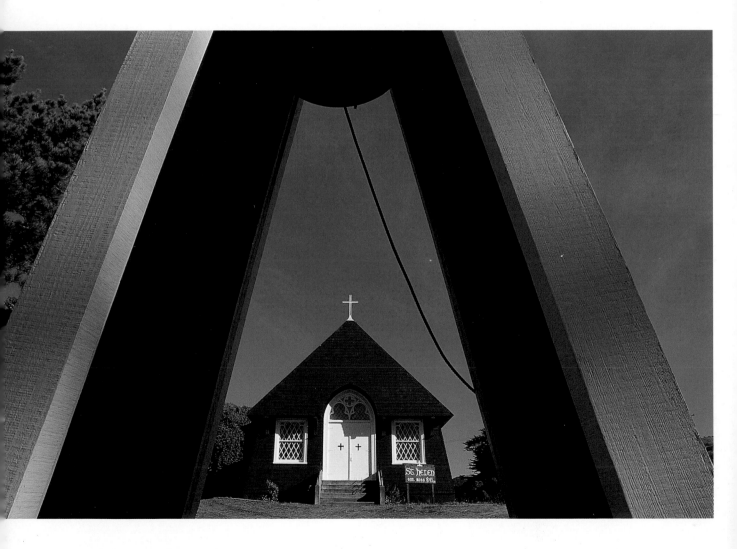

My wife and I ventured off the freeways one day in search of interesting shops, galleries, and photo stops. Since time was tight, I decided to attempt one well-thought-out picture. This church north of San Francisco came equipped with great color and character, and a bell tower that provided the perfect frame.

[24mm lens, Fuji Velvia]

Keep in mind, though, that one photograph records one particular moment in one particular way. Often, you can shoot the same outdoor subjects day in and day out, season in and season out and never capture the same image twice. When you find a scene that motivates you, you should work it every which way you can, within whatever time constraints you have, because the photographic possibilities are numerous. If you're inclined to leave a scene without exhausting all of its possibilities, consider that the photos might *not* be better down the street or over the next hill.

Following your instincts can help. Curiosity may inspire you to take a second look at a photogenic building or to investigate what a scene looks like when the sun hits it from another angle. Exploring your subject thoroughly also means trying new things (with lighting, composition, points of view) and realizing that not every shot you take can be a winner. When experimenting, you may not always know what you'll get if you snap the shutter, but what will you get if you *don't*?

For many close-to-home subjects, I go back for seconds, perhaps thirds. The act of shooting a subject, inspecting the results later, and then returning to the scene is one of the most valuable ways to sharpen your eye and your photographs—whether you're a beginner or an expert. You'll enjoy yourself, too, as you see all the intricate ways in which light can alter a subject and how a composition can be fine-tuned. Soon your efforts will consistently match your vision.

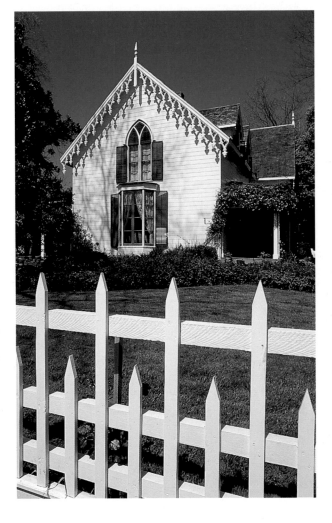 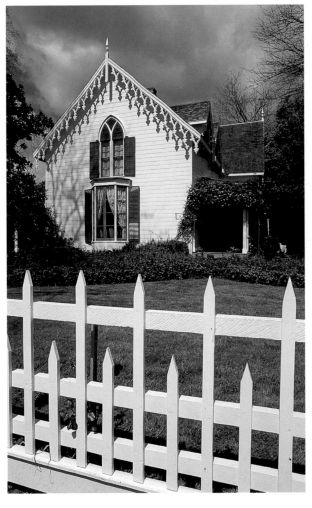

When I find a scene I like and I have the opportunity, I'm never satisfied with making just one photograph. A single shot records only what you see at a particular time, but what about other conditions? I liked this historic home with its white fence and blue sky. However, when clouds set in the next day, I set up again for a similar composition—but with a different mood.

[Both photos: 24mm lens, Fuji Velvia]

Planning and Preparation

A photographer I know tells the story of how "luck" worked for him on a trip to Alaska. With a telephoto lens, he framed a glacier towering over several hikers. The scene was a stunner, but it got even better when one couple held hands momentarily to steady each other. Their silhouettes connected, turning the scene into a magical moment in a magnificent landscape.

When it comes to photographing the great outdoors, luck has its place—a spectacular rainbow here, the sudden emergence of a wild animal there. However, in the long run it is careful planning that leads to superb scenics. As a photographer, you should explore the ways in which you can put yourself in the right place at the right time for the right photo. After all, for luck to happen, my friend in the above story had to be on the scene and with his camera. And that was no accident.

Before You Go Of course, it's not always enough to surround yourself with intriguing scenes. For the best odds of getting the best shots, preparation for outdoor and travel photography should begin before you set out. Nothing disappoints quite like being in a promising place at the wrong time, especially if you expected the flowers to be blooming or the autumn foliage to be turning colors. I dread the words, "You should have been here last month." And you should, too.

A serious amateur's photo trip should proceed almost like a professional's assignment. Even a quick shooting trip around town should involve a plan of action, although it may be scaled down. There are a few steps you can follow for arranging successful photo outings. The first concerns any friends or family members who may accompany you. Scheduling picture-taking sessions isn't much of a problem if everyone in your group is a photographer. Just be sure their photographic interests are at least partially similar to yours. However, drawing up an itinerary that involves non-photographers should ensure that no one's needs are compromised. Avoid conflicts by accepting some give-and-take—a photo session here in exchange for a shopping trip there, for example. If you're going with an organized tour, look for groups that allow some personal time and that proceed at a relaxed pace. Avoid the seven-countries-in-seven-days trip.

Fog is often a possibility along California's coast, so I always factor in flexibility. With the warm light of late afternoon hitting *the countryside, I found a nice wide turnout along Highway 1 and took a series of unplanned photographs with my* *tripod-mounted camera. A short time later, when I reached my sunset destination, fog had enveloped the coast, and I was glad I'd* *made this spur-of-the-moment schedule change.*

[75–150mm zoom lens, Kodachrome 25]

The next step is to learn all you can about your destination. Travel-related books, magazine and newspaper articles, computer research, auto clubs, travel agents, and tour companies can all improve your chances for having a rewarding photo venture. Most cities and countries have tourism boards that provide free materials, while state travel bureaus often publish colorful guides. During your research, look for unusual attractions, historic sites, natural areas, and unique parts of cities, and also check for weather patterns and seasonal features. If possible, ask photographers who've been to your chosen destination for ideas on where and when to shoot.

Lastly, draw up two lists. The first is a tentative shooting plan containing possible photography spots. For a multi-day trip, my list of potential scenes may run one typed page or more; for an afternoon outing near my home, perhaps a few handwritten lines. My rundown covers not only general locations that seem inviting, but also specific subjects.

The second list is a pre-trip checklist of camera gear and other necessities. It only took forgetting one piece of essential equipment—my tripod—to encourage me to devise a system that's more reliable than my memory. This checklist can be for a short morning or afternoon excursion, or for an extended trip. Each outing, though, has different requirements; I rarely pack a full complement of camera accessories on every outing. I consider the following: Will I need to drag along my big lens? If I leave my monster tripod at home, can I get by with a less-weighty model? My goal is to travel light, yet efficiently. (That's a *goal*; I'm not saying that I always travel light *and* efficiently at the same time.)

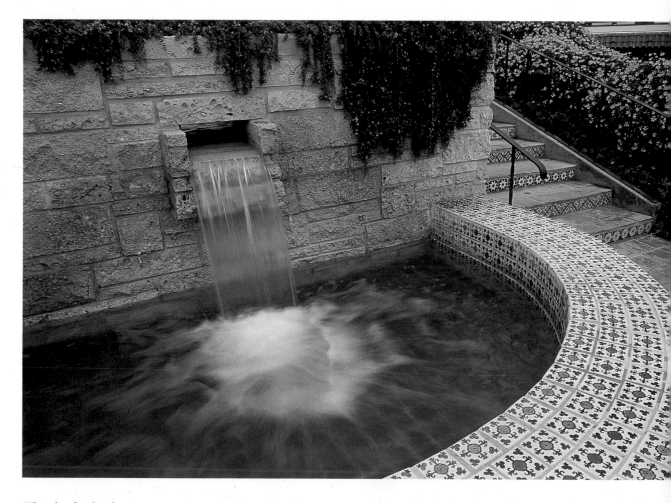

The idea for the above photograph kicked around in the back of my mind for a couple of weeks. When clouds filled the sky, I filled my frame with tile work and flowing water. A small lens opening (f/22) let me keep everything sharp but also allowed me to use a slow shutter speed (1/4 sec.) to capture a sense of motion in the water.

[24mm lens, Fuji Velvia]

Preparing for a balloon race (opposite) is pretty straightforward: Arrive early to get a feel for the event, and pre-visualize some of the photographs you might want to make. I stood near several particularly colorful balloons as the crews got things ready for takeoff. Not all the balloons left at the same time, so after one balloon faded into the distance, I ran to another.

[50mm lens, Kodachrome 64]

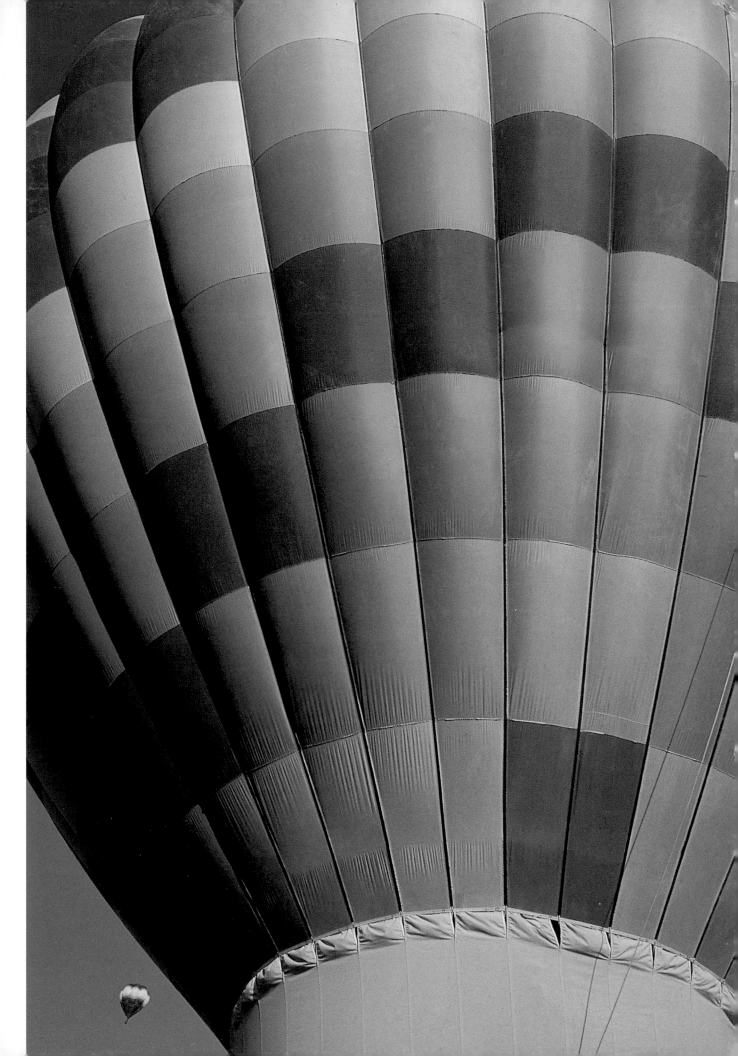

On Location

Preparation and planning also continue once you arrive on the scene. Unfortunately, few of us have time to scout things out thoroughly for a day or two before shooting; in most cases, you'll find that you must start photographing almost immediately, making it even more crucial to perform advance research and, once at your destination, get a quick feel for the locale.

Over the years, I've devised a flexible rundown of routines. The particulars depend on the location, length of stay, and whether I already know the area (in which case, I can skip the get-acquainted activities). In any case, a multi-day or multi-week tour is actually a series of half-day or full-day photo sessions in which I fine-tune my initial overall shooting list with day-by-day game plans. At a new location, there's always self-imposed pressure to start capturing the definitive images immediately. But it takes time to determine precisely where and when to photograph. To start, I force myself to settle down, familiarize myself with the area, and get a better sense of the photographic potential. If I can, I take an orientation tour of the town, museum, park, or other area attractions. Along the way, I try to get an idea of how the cityscape or landscape might appear at different times of the day.

Most tourist areas and national parks feature justifiably famous views that have been photographed by everyone from pros to camera-toting tourists. I attack these spots first just to get them out of my system, although I still strive to make unique renditions.

Then I turn my camera toward off-the-beaten-path locales. If I need suggestions, I stop at the visitor center or chamber of commerce office to check brochures, examine exhibits, and ask such questions as: What spots do you recommend for photography? Or, are there any interesting places that aren't well known? I also inquire about any special events or colorful goings-on. Other local sources of ideas for picturesque areas include bookstores, camera shops, and photography galleries. Along the way, I might ask park rangers or shop owners for their favorite getaways. During my investigations, I always carry a map and notebook to keep track of where, what, and when.

Next, I draw up a loose schedule for my upcoming photo outings. I adjust the itinerary to accommodate the latest weather forecast (overcast conditions may call for a subject switch) and sunrise and sunset times. I also compose an abbreviated checklist of equipment essentials for each day: photo outfit, snacks, jacket, and so on.

My day usually begins before sunrise. Besides allowing me to enjoy the fresh conditions and soothing light, rising in early morning also lets me squeeze in a photo shoot before my traveling companions get up and go. The length of these daybreak sessions varies; cloudy conditions, for example, might extend my time in the field since overcast light remains fairly constant and can produce vibrantly colored scenics, especially for smaller subjects. The rest of the day until late afternoon is devoted to touring, eating, and assorted group activities. Along the way, I keep my camera handy and look for potential photo-taking spots for later that day and the next morning.

During a coastal camping trip, I discovered this staircase going down to the beach (top), and I planned to silhouette it against the sunset sky. Heavy fog took care of that idea, but when I returned shortly after sunrise on the following day,

I found sunlit wood backed by lingering fog. I made a number of exposures of the scene, since each series of rolling waves varied from the next; this image is one of my favorites.

[24mm lens, Fuji Velvia]

While relaxing one rainy afternoon at a lodge in Wyoming's Grand Teton National Park, I was ready for photography just in case. When the rain stopped, I headed out to a pre-selected spot (bottom), set up my tripod, framed a composi-

tion, and determined that if the sun ever came out, I'd take an exposure reading off a neutral-gray cloud. The sun's emergence lasted just long enough to snap a few photos.

[85mm lens, Kodachrome 64]

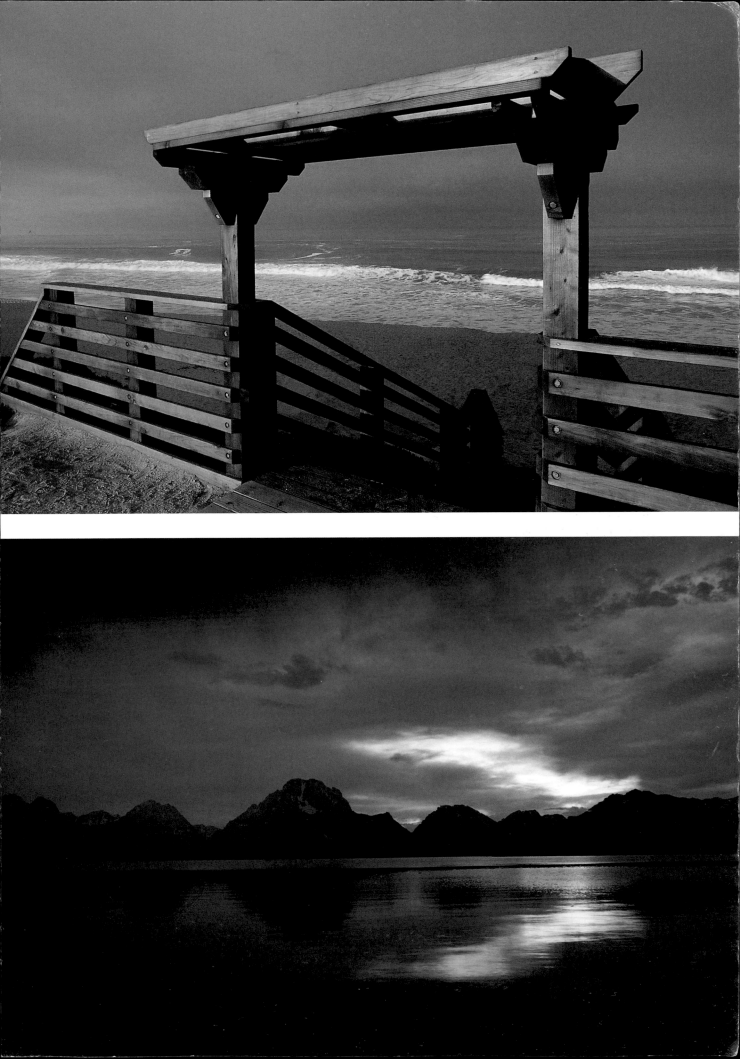

24

Expect the Unexpected

While preparation is important, don't get locked into an unyielding agenda. Plan for spontaneity, too, since photogenic treats can pop up suddenly. Whether at home or far afield, there are benefits to roaming around and looking for the unexpected without any fixed schedules or predetermined subjects to impair your creative eye. Find an uncharted (but safe) road, and see where it goes and what it passes. In the fall, skip the interstate and search for pumpkin patches and ragamuffin scarecrows. As you travel, get out of the car and walk around; often, you can find more — and better — photographic opportunities on a one-mile walk than on a hundred-mile drive.

Weather can play a role in planning, as well. I may head out expecting to capture big landscapes, but fog or overcast conditions could call for more modest sites. By not being locked into a particular subject, I'm ready to choose scenes that match the light, and the resulting photos will reflect that attention. However, flexibility works both ways — on occasion, giving up is the honorable thing to do. Sometimes an acceptable image fails to present itself, even after time well spent looking. Instead of slipping into guaranteed mediocrity ("Well, this shot is better than nothing"), I'll skip the unsatisfying picture altogether and try again somewhere else. As with the picture opposite, I've made a number of my best scenics during trips planned for other subjects.

When I made this image in California's Lassen Volcanic National Park, I was on a cross-country skiing mountain adventure on which I'd anticipated shooting some sweeping snowscapes. Unfortunately,

the sky turned overcast and the snowcapped peaks became lost in clouds. However, I had many other photographic subjects in mind that day and was in a spontaneous mode. So, I focused on smaller scenes

and, just as sunlight slipped through, found a glistening slope of swirling snow. This pleasant surprise proves the significance of luck in photography; but it also shows that the more you concentrate on your

art, prepare for your shooting trips, and expect the unexpected, the luckier you'll be.

[75–150mm zoom lens, Kodachrome 64]

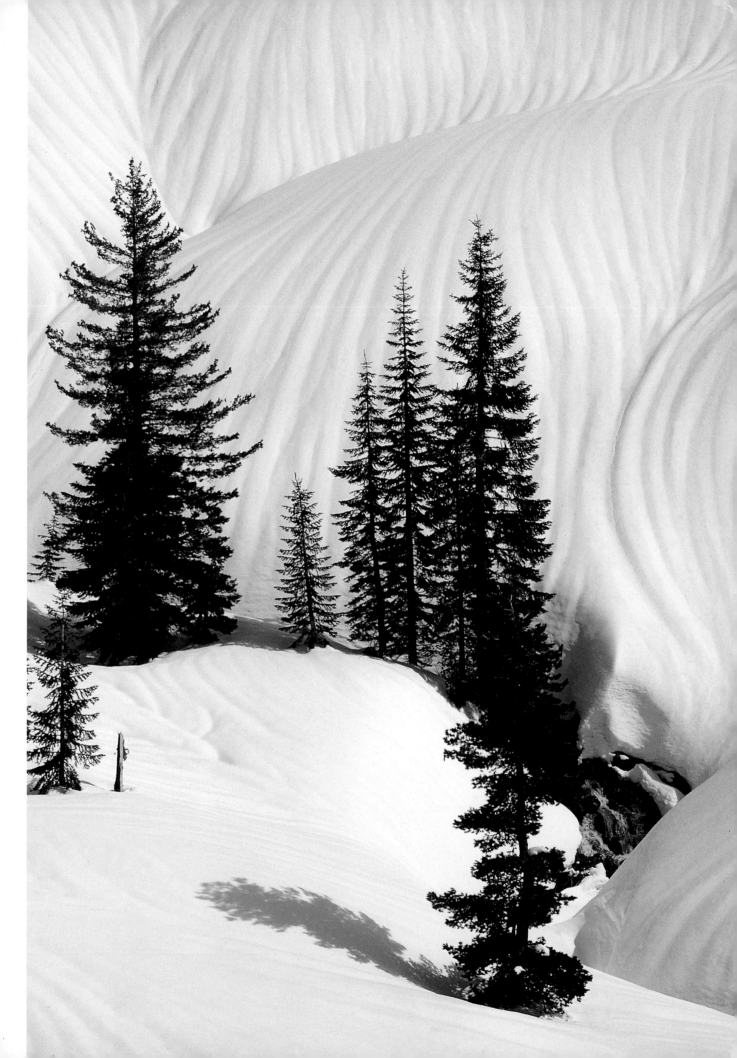

Editing Your Work

It has been said that the difference between beginners and experienced photographers is that novices show *all* their pictures while experts show *only* their best. Although it's not easy to assess your work, self-critiquing is a key step in a photographer's growth. The editing process involves more than just admiring your good pictures and tossing the rest; it involves trying to determine *why* certain photographs succeed and others don't.

Getting a handle on your own work begins with studying other people's pictures displayed in print and online, in gallery shows, and in professional programs (such as workshops and slide shows). When doing so, note how the photographer made use of light, zeroed in on the subject, and framed the scene. Ask yourself the following: What do I like and why? How could I do it differently? Then, compare published images with your own efforts.

Next, start learning to analyze your own work as dispassionately as possible, casting aside the emotions that can cloud objectivity. This isn't easy. You might find it worthwhile to obtain second opinions. Ask a college instructor, a local professional, or an advanced amateur whose work you admire to evaluate your images. Participating in group critique sessions (in classes, seminars, and camera-club meetings, for instance) can be enlightening as well.

As part of your editing process, you should also develop an organizing strategy. I use a four-file rating system: *personal, acceptable, outtake,* and *portfolio*. You can apply this approach to any filing system, whether you store your images in photo albums, slide cabinets, or digital files (okay, okay, and shoe boxes, too).

The *personal* file consists of all my family and vacation snapshots—the pictures that mean something only to me and my family or friends. The other three files pertain to my "serious photography." The *acceptable* (or *professional*) file consists of images I rate in quality from "good enough" to "very good." I categorize these photos according to geographic location or subject. The *outtake* file includes questionable images—ones I just don't know whether to save or toss. I periodically re-review these, and while almost all wind up in the wastebasket, I invariably find a few keepers that make me wonder what was I thinking when I set them aside. And finally, the *portfolio* file consists of what I consider my best work. I've presented this portfolio to prospective publishers, but its foremost function has been to serve as a photography quality goal. It usually totals around 100 images, but there's no hard-and-fast number. New pictures occasionally break in and older ones occasionally drop back to the *acceptable* file.

So how many "good photos" do I typically obtain from a given roll of film? It varies, depending on subject difficulty, exposure problems, and so on. However, usually at least a few per roll go into my acceptable-quality file. The bigger question is: How often do I get a portfolio-quality image? Rarely. But even if I don't always meet my highest expectations, I always find that my photo shoots complete another, equally exciting objective: getting out and exploring the visual possibilities and striving to further develop my vision.

For me, the differences between these two images go beyond merely vertical and horizontal formats. Turning the camera on its side (this page) simplified the composition and, to my eye, made it more striking. In my very subjective edit-ing system, I've rated the horizontal interpretation as an acceptable-quality keep-er and the vertical version as one of my top portfolio photographs.

[Both photos: 24mm lens, Fuji Velvia]

Cameras

Today's state-of-the-art, idiot-proof cameras are supposed to make photographing a snap. I've often heard people say, "I'll take better pictures once I get a better camera." Yet we all know people who have the latest high-tech, high-priced cameras and continue to take uninspired images. It's the eye behind the viewfinder that turns scenes with potential into pictures that matter. In fact, almost any camera, whether it's a bare-bones or full-features model, is capable of capturing dynamic images. Nevertheless, your choice of camera is important, and the choices are bewildering.

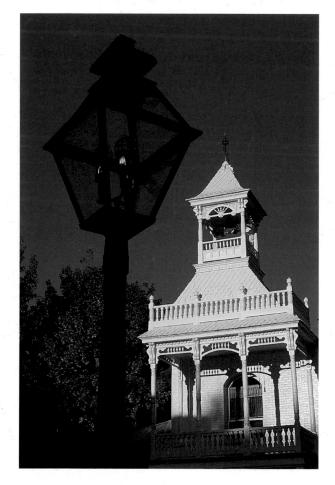

Most cameras fall into two categories: single-lens-reflex and rangefinder (or non-reflex). The single-lens-reflex (SLR) camera allows viewing directly through the picture-taking lens, letting you see exactly, or almost exactly, what you'll record in the photo. The rangefinder, or non-reflex, camera has a viewfinder that is separate from the picture-taking lens, so what you see can be different from what you get in the actual photo, especially when working close up. Rangefinders, however, are sleeker, quieter, and smoother (since they have no moving reflex mirror) than SLRs.

In addition to these categories, there are a number of camera systems. The 35mm system is preferred by many photo enthusiasts and professionals. The best and most versatile of these are the 35mm SLR cameras, which allow the use of numerous lenses and accessories, and have varied operating modes and advanced functions. Rangefinders come in three styles: full-size 35mm cameras with interchangeable lenses and exposure-override options; autofocus autoexposure compact cameras (many including zoom lenses and miscellaneous modes); and basic point-and-shoot

You can photograph very different subjects and achieve very different results using the same type of camera. For example, at first glance these two photographs appear to have little in common, but they were both made with the same camera body — a

Nikon FM2 35mm. Only the lenses were different: I shot the firehouse with a normal (50mm) lens and the alpine scene with a wide-angle (24mm) lens. But I could have used almost any camera to capture either of these scenes. To ensure good

results, I treated my 35mm camera just like a large-format rig — supporting it on a tripod to facilitate careful composition.

[50mm lens (opposite), 24mm lens (above), Fuji Velvia (both photos)]

cameras (however, the lack of focusing and exposure controls limits shooting options).

Advanced Photo System (APS) cameras offer three print formats on the same roll of film, along with convenience in film loading, storage, and reprinting. APS cameras range from simple point-and-shoot models to deluxe SLRs; the small APS film size (24mm) means that all APS cameras are generally more compact than their 35mm counterparts. Due to its slightly larger format, however, 35mm cameras have the edge over APS cameras in enlargement print quality.

Digital cameras record and store images for direct computer use. Pictures can then be viewed, edited, e-mailed, posted on web sites, or made into prints. As of this writing, digital image quality lags behind that of film, and compared to film-based systems, digital cameras offer fewer features for controlling the pre-recorded image. The technology, though, is ever-evolving. Incidentally, pictures from film cameras also can wind up as digital images, if they're scanned into a computer.

Medium-format camera systems come in both SLR and non-reflex (rangefinder) forms. They use film that permits negative/transparency sizes of 2 1/4 x 2 1/4 inch, 6 x 4.5 cm (or 645), 6 x 7 cm, 6 x 8 cm, and 6 x 9 cm. The negatives or transparencies (slides) enable both big and sharp prints and are favored by many commercial photographers.

View or large-format cameras are the traditional choice of landscape and fine-art photographers, with the 4 x 5-inch format (negatives or transparencies) being a common size. A view camera is even slower to operate than the slowest medium-formats, but it allows extensive control over perspective and focus.

So, which format is best? As a rule, as film format increases in size, final image quality also increases; but as camera size increases, versatility and ease-of-use decrease. If you shoot strictly landscapes and nothing else, perhaps a big rig might be a better choice. For me, a small-format 35mm SLR system provides the flexibility, spontaneity, and lens and accessory range I need; plus, the film size is more than adequate for most professional applications.

Buying a Camera If you already own a camera that has the features you want, feels comfortable, and works properly, stick with it. If you're in the market for a new camera, only you can decide which of the new models meets your needs and budget. It doesn't help to ask professionals or advanced amateurs what equipment they use, because you'll find little overlap in brands, let alone specific models. However, there are some general buying guidelines you can keep in mind.

Any proper purchasing venture begins with a check of buyer's guides and magazine or online product reviews. Then it's on to manufacturers' brochures, information sheets, or web sites for complete summaries of each camera's features. If you're serious about photography, you'll want a camera with at least a few creative controls and exposure-override options. This doesn't mean you must purchase a top-dollar "professional" model; the marketplace is filled with quality cameras that offer assorted features at assorted prices.

After this preliminary research you should be able to narrow down your choices to a few cameras. Then it's time to discuss your needs with a knowledgeable photo store sales clerk. Communicate your price range, the type of subjects you'll most often be photographing, and the features you can and can't live without. This will narrow your selection further, hopefully to no more than two or three models. Next, ask for a demonstration of your remaining contenders. Afterward, give each one an in-store trial yourself. Consider how each camera feels in your hands and up against your face.

If you aren't ready for all the extra features that a certain system offers, consider buying a basic outfit and adding to it as your interests and budget expand. It's better to build and evolve through two or three upgrades over a few years than to spend a lot of money up front for an expensive system that you find isn't right for you.

Finally, many experienced photographers own two cameras: a favored one that they use for most outings, and a not-quite-so-serious, take-anywhere compact model for casual trips. Still other photographers, myself included, have more than one SLR camera body; one acts as a backup should the other fail, and having two bodies also lets you keep different lenses on each one or load them with different film. If a lot of drama is about to happen in a brief span of time — at sunrise or sunset, for example — I load both bodies with the *same* film, preparing in advance for a time-saving switch when the light is changing quickly. The second body, incidentally, doesn't have to be comparable in quality and cost to the first; as long as it accepts the same lenses and accessories, it can be a stripped-down model.

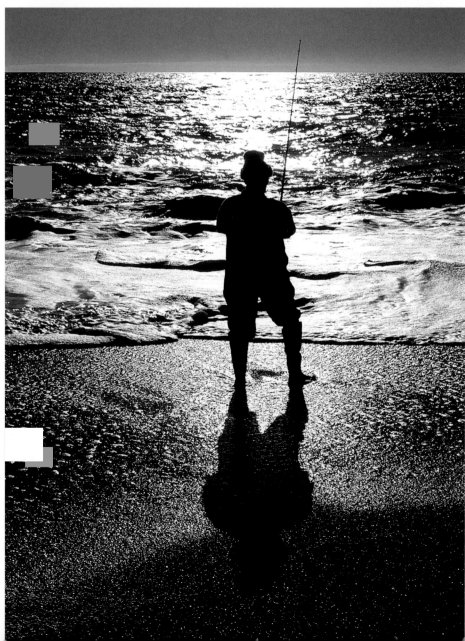

Using a smaller format
(35mm) camera made
photographing easier when
I shifted from grand land-
scapes to intimate scenics.
I was able to record medi-
um close-ups of desert wild-
flowers (dune primrose
and sand verbena here)
by mounting a specialized
macro lens on my 35mm
camera body.

[55mm macro lens,
Fuji Velvia]

Small-format (35mm)
cameras permit quick
subject switches from static
scenics to shots that include
people in the landscape.
On this day, I was ready to
capture a seascape with my
tripod-mounted camera
when I discovered this lone
fisherman—just the sub-
ject for a silhouette made
with a hand-held camera.

[50mm lens, Kodachrome 64]

Know Your Camera

I'm sure you've heard this advice: Don't buy a new camera the day before you leave on a big trip and expect your photography to proceed without problems. This applies not only to the shiny new camera removed fresh from its box, but also to the dusty old camera yanked from the back of a closet.

I learned this the hard way. After my backup camera body landed in the repair shop, I pulled an older camera out of storage to use as my interim back-up. It was the same brand as my primary camera but a different model. Sure, I hadn't used it in a while, but I felt I didn't need to waste time reacquainting myself with a backup camera I once knew intimately. I loaded both my primary and my interim backup camera with film in preparation for a beautiful sunset. The photos made with my main camera? Superb. The photos from my backup? Well, perhaps I should have spent time reviewing the camera manual to prevent mixing up all the functions and ending up with under-exposed sunsets.

Most aspiring photographers simply do not shoot enough to always know their cameras well. They only use their cameras on vacations, during occasional weekend trips, or at family gatherings. As a result, each time they pull out their gear, it's back to basics and questions such as: Is there film still in the camera? If so, what type of film is it? How do I put in new batteries? Does the camera even run on batteries? Can I switch lenses with this camera? And so on. Out in the field, these same photographers continue to function in the frustration stage, not quite reaching that satisfying point at which they're able to concentrate more on the making of the picture than on the workings of the camera.

To go about mastering your new—or old—camera, first dig out the instruction booklet and read it. Then plan some short practice sessions around your home, down the street, at a park, or in the surrounding countryside. For these initial drills, it doesn't matter if you have film in the camera; the idea is to become thoroughly familiar with the camera's feel and operation. Check the focusing system, and work all the controls. If you have different lenses, switch back and forth from one lens to another. If you have a zoom lens, zoom in and out. Try each exposure mode, both in sunlight and in shade. Learn the default settings and custom functions. Figure out everything your camera is capable of doing, even if you don't plan to use each and every feature.

Fine photography takes a good effort. Getting out and shooting whenever possible will keep your camera skills sharp. Familiarizing yourself with your equipment not only turns the decision-making process into an intuitive affair, but it alerts you to possible malfunctions—and it's better to know this *before* a major expedition. Camera comprehension is just one more step in proceeding beyond the snapshot stage; as the technical side of photography gradually becomes second nature to you, you'll find that your images gradually improve.

You can capture sunsets with any camera, although non-adjustable models may require faster-speed film to handle the lower light levels. Regardless of what camera you use, however, the factors critical to success are: being there ready to shoot and being familiar with your camera's operation.

[85mm lens, Fuji Velvia]

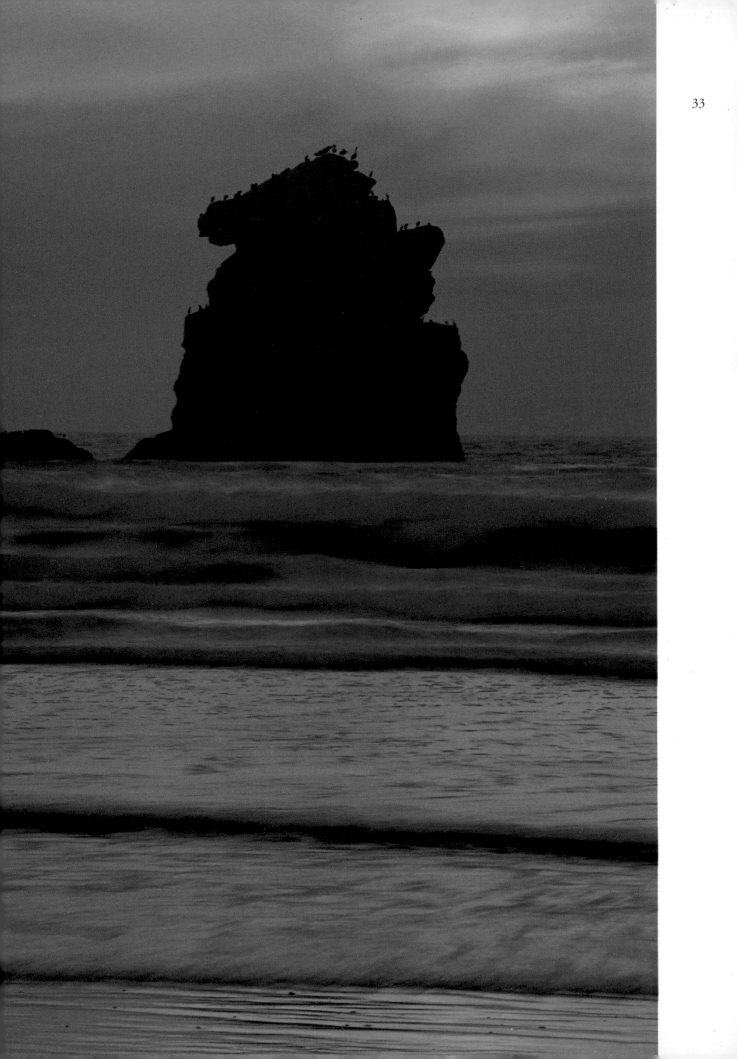

Tripods

34

I doubt anyone really enjoys lugging around a tripod, but there are several good arguments for using one. It increases image sharpness by eliminating the risk of camera movement. It opens up a whole non-flash world of available light, for example making it possible to photograph in the dramatic time at the end of the day, when the light is low and the resulting exposures are long. And it also permits various creative techniques, such as blurring a moving subject with a slow shutter speed.

In addition, one other reason is at least as important: A tripod stresses the fact that most compelling scenic images are made thoughtfully and deliberately. Tripods encourage photo-making discipline, since setting up and using a tripod slows down the picture-taking process. Besides holding your camera steady, the tripod also keeps it in any position you choose, so you can frame your picture with more precision. If you need to tweak your composition, it's easy to do when the viewfinder remains steady. If a cloud obscures the sun, you can wait for the light to improve while your carefully thought-out composition stays put.

Tips for Buying a Tripod I like to think of *tripod* as another word for *compromise*. Most cheaply made tripods are too short, too wobbly, won't stay put, and won't work on uneven turf. Yet try the other extreme—a sturdy, but bulky and hefty model—and you might not want to carry it. To strike a balance between these two options, look for a tripod that's substantial enough to perform, yet light enough to carry. Expect a trade-off, though, between weight and stability. Study product reviews, look at advertisements, read manufacturers' literature, and then shop around. Once you find a possibility, try it out in the store; see how easily it opens and how high and low it goes.

For the best shopping test, attach your camera and biggest lens to the tripod, and operate the tripod's key component—the head. It should be easy to adjust and should hold your camera securely for vertical, horizontal, and intermediate positions. A traditional tripod head is the two-handled tilt/pan type. For ease and speed, my choice is the ball-and-socket head, but it must be fairly large and well made, with a precise and firm locking action. Most of the better tripods are available "legs only," allowing for the use of interchangeable heads. After testing the tripod, imagine using it and hauling it around on outings. If it doesn't feel just right, or isn't quite what you're looking for, keep shopping.

If you use a tripod a lot, screwing your camera on and off of it becomes tedious. A quick-release mechanism—a plate that attaches to the camera's tripod socket and a platform that fits on the tripod head—permits swift camera mounting and removal. Just be sure it won't loosen or release by accident.

A sunlit scene like this one, (left) in California's Death Valley, may not require additional support to steady the camera, but a tripod serves another significant purpose: It forces the photographer to slow down, and carefully compose the picture.

[85mm lens, Fuji Velvia]

Photographing this old courthouse at day's first light (top opposite) required a camera support. The exposure lasted for several seconds due to the low light levels, so I needed the tripod to keep the camera steady throughout the exposure. These bold tones at dawn twilight didn't last that much longer than the exposure—only a few minutes.

[180mm lens, Fuji Velvia]

Carnival rides (bottom opposite) are made for fun and photography—especially in the evening. Due to low light and slow-speed film, I had to use an exposure of several seconds, but that's just what I wanted in order to record this colorful study of blurred motion. A tripod was essential to keep my camera rock steady during the long exposure.

[24mm lens, Fuji Velvia]

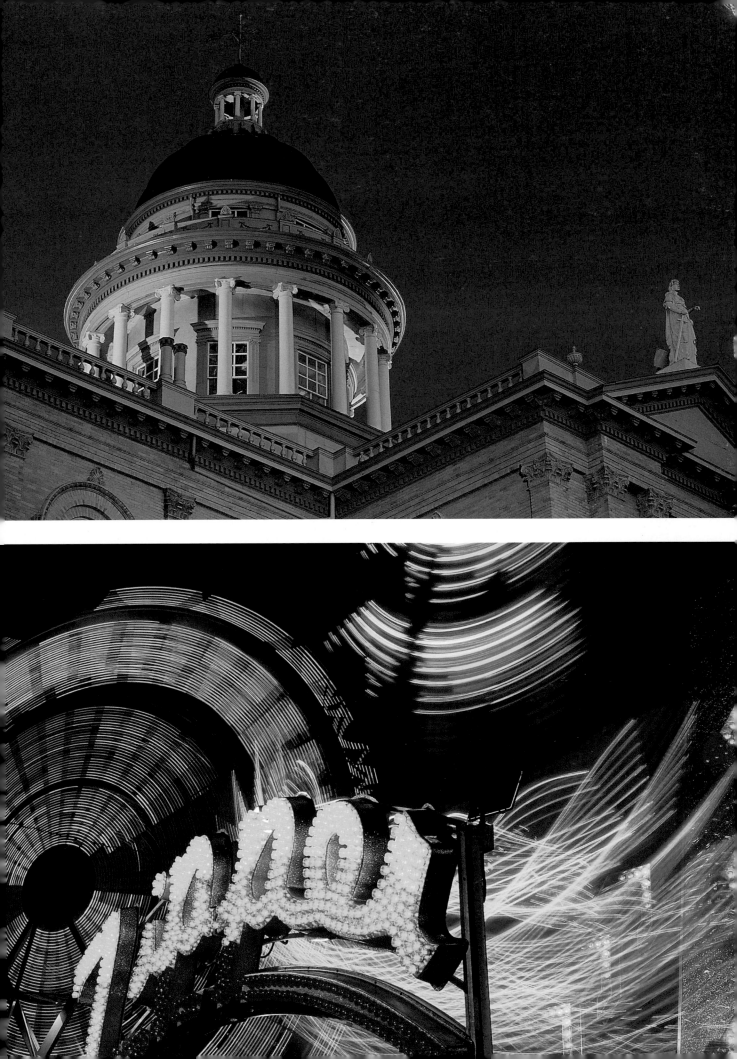

36

Keep in mind that not every spot on which you plant your tripod will be perfectly level, so consider buying a tripod that has independently adjustable and spreadable legs. Frequently, I've needed to position a leg or two at different heights, or other times, in a horizontal position—for example, while setting up on rocky terrain or on a staircase. In addition, a tripod that is capable of collapsing to near-ground level lets you shoot subjects that require low-level positioning.

For making candid and action shots, a regulation-size tripod may hinder, if not prevent, taking a photograph. In other circumstances, a tripod may simply be impractical. Alternative camera supports include a *monopod,* which is essentially a tripod with only one leg, and a *table-top tripod* or *minipod,* which has three legs, folds up small, weighs a pound or less, and can handle almost any camera (except a super-beefy model or one with a long lens). You can set up the miniature tripod on a bench, log, chair, table, boulder, or even the ground.

Tips for Using Your Tripod My own photography improved immediately once I began using a full-sized tripod to photograph stationary scenics, such as wilderness landscapes, urban scenes, or country vistas. Although you can accomplish most of the techniques in this book without a tripod or other camera support, sooner or later most serious scenic shooters start packing what has been called "the accessory photographers love to hate."

Out in the field, after making the effort to extend the tripod legs and lock your camera in place, it's tempting to just stay put, even if you don't know whether there's a potentially better vantage point somewhere else. Instead of doing this, wander around and scan your surroundings with just your camera *before* you set up your tripod. Only when you've lined up your shot should you break out the tripod and arrange your composition.

For times when you'd like to be in the photo, using a camera's self-timer (combined with a tripod) lets you step into your picture. Most self-timers allow about 10 seconds for you to get into the picture, although some cameras offer variable time delays. Photographers without tripods can improvise by setting their cameras firmly on top of a rock, railing, or other object. Photographer Dick Schmidt sometimes hangs his camera by its strap from a tree branch of the perfect height. At other times, he even balances his camera atop a tree limb. Regardless of the variation of his "treepod," as he calls it, he always makes sure the camera strap securely holds things in place.

Rather than avoid tripods, another possibility is to do what I do: have two tripods—a lightweight travel model and a rock-solid heavy model. This gives me the versatility to handle almost any situation. For those few cases when every ounce counts, I pack the lightweight tripod, which can go just about anywhere I can. For all my other work, I use the sturdy, carry-in-my-car tripod, which can manage long lenses, windy conditions, and rocky earth. On extended auto trips, I take both.

No matter what type of tripod (or other support) you use, never leave your camera unattended, especially when it's windy out. I've seen gusts of wind topple other photographers' tripods, with cameras attached. In high-wind conditions, look for a sheltered spot; otherwise, shoot from as low a position as possible.

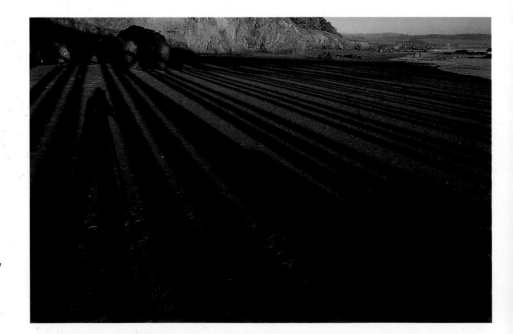

I use a tripod for almost every scene I shoot—just as my shadow here shows. For this late-afternoon view beneath a pier, my tripod also let me keep my composition in place as I waited periodically for beachgoers to walk through my picture's frame.

[24mm lens, Fuji Velvia]

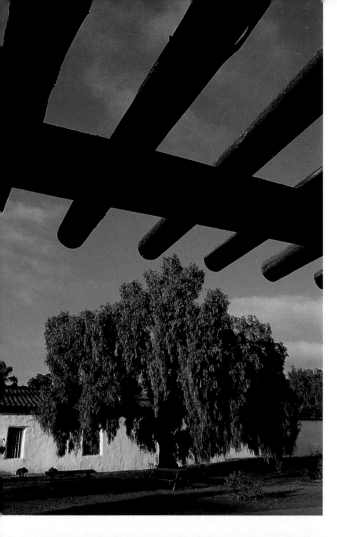

The making of this photograph spanned two days. I was looking for a fresh way to photograph this historic building in San Diego. On an overcast day, I imagined the scene framed by the overhang against a blue sky. I returned the next sunny day, and pointed my tripod-mounted camera upward. I remained there for a few hours with the camera on the tripod. Occasionally, as I waited for the light to improve, curious tourists stopped to ask what I was doing. Since the camera was secure on the tripod, I motioned for them to look through the viewfinder. One by one, each smiled with surprise. Being able to share what you see with others is an added bonus to using a tripod.

[24mm lens, Fuji Velvia]

At a classic car show one day, I found this brilliant red car. I set my camera on a tripod and used a wide-angle lens. The tripod kept my composition ready as I waited for the right pair of showgoers to stop and stare. The couple never knew they were the stars of my headlamp-reflection scene.

[24mm lens, Fuji Velvia]

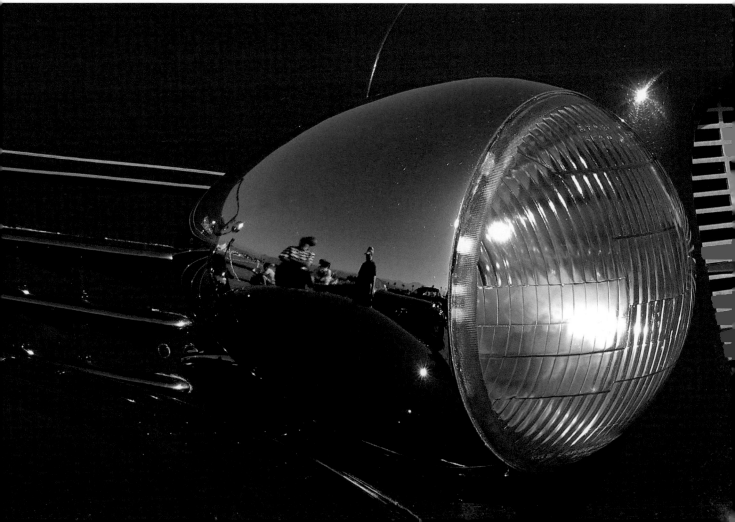

2 | **Light and Color**

Film

Digital imaging hasn't replaced film yet. In fact, the marketplace boasts more quality films than ever, including over 100 35mm films from which to select. Add APS and larger format film options to the mix, and you'll begin to grasp how complicated the film selection process can be.

Having so many options leads to quite a few questions: Is print film as good as slide film? What does "film speed" mean? What's the difference between "professional" and "amateur" films? Which film captures a scene's colors in the most realistic way? And, the bottom-line question: Which film should I use? Since different films interpret light and color in different ways, your film choice is an important one, and you should give it some thought.

The Basics

Each type of film has its own characteristics, most of which are described using common film terms. To begin, all films are rated as to their sensitivity to light. This is the *film speed,* also called its ISO (International Standards Organization) rating. Fast films (those with higher ISO numbers) react more quickly to light and allow the use of faster shutter speeds; slow films (those with lower ISO numbers) respond more slowly to light, requiring the use of slower shutter speeds. Film speeds include ISO 25 to ISO 100 (slow), ISO 200 (medium), ISO 400 (fast) and ISO 800-plus (ultra-fast).

With ISO numbers, the math makes sense. For example, ISO 100 film needs twice as much light as ISO 200 film, while ISO 400 film is 3 stops faster than ISO 50 film. There's also a direct link between the film speed, the exposure setting, and the resulting image. In general, image quality improves as the film speed decreases. So, although slower films (ISO 100 for color negative or print film, and less than ISO 100 for slide or transparency film) demand slower shutter speeds, they usually provide the best image quality—with sharper details and richer colors—and are preferred for static scenes. Fast films (ISO 200 and higher), on the other hand, are more suitable for candid, action, and other hand-held-camera photography.

In addition to speed, there are other film characteristics to consider. *Contrast* relates to the film's ability to record light and dark extremes; high-contrast films increase tonal differences, while low-contrast films capture a wider tonal range. *Resolution* refers to how well a film reproduces fine details. *Color saturation* relates to color intensity; saturated films often produce more dramatic tones. *Color balance,* as concerns outdoor photography, refers to whether the film has a neutral color cast (ideal for capturing skin tones) or a warmer one (good for scenics). *Latitude* involves the film's response to overexposure and underexposure; color slide or transparency films have little latitude, while print, or negative, films can produce usable photos over a broader range of exposures.

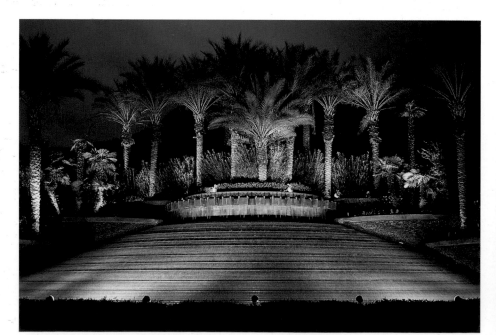

This fountain looks pretty good at any time of day, but I wanted to photograph it in evening twilight. A long exposure of several seconds, a normal lens, and Fuji Velvia—a low-speed slide film known for its vivid colors—helped me record this desert resort scene near Palm Springs, California.

[50mm lens, Fuji Velvia]

Many old-time lighthouses, such as this one in San Diego, are kept shipshape as historic attractions. One morning, I noticed storm clouds starting to gather and, anticipating the contrast of a white lighthouse against a deep gray sky, got ready to shoot. The sunlight shining on the structure lasted for less than a minute. In this photo, I like the neutral color balance — white whites, gray grays, and no warm cast — of Kodachrome.

[85mm lens, Kodachrome 25]

Which Film Is Best for You? There is no single best film for scenic photography. Your best bet is to limit the selection, based on your personal preferences and specific uses. Plan to compromise somewhat between speed, image characteristics, color balance, and sharpness. Also keep in mind that a film's properties may matter more in theory than in practice. While graininess, for instance, may be discernible in huge prints, it's far less conspicuous in standard-size pictures.

The first decision to consider is whether you should use slide or print film. Nearly all casual photographers use print, or negative, film but many experienced shooters choose slide, or transparency, film. In any case, the two types of films have their share of pros and cons.

Most book, magazine, and calendar editors want images in slide form. And, there's nothing as beautiful as color slides projected on a giant screen for slide shows. Since slides are camera originals, they're not susceptible to printing variables (of course, you can make prints from selected slide images). With slide film, exposure and color reproduction more closely represent the photographer's intentions, rather than the lab's. When printing or scanning, you can refer to the slide itself for comparison (it's more difficult to analyze a color negative). In addition, the effect of a filter on slide film is often more apparent in the final photo, because with negative film, automatic printing machines may "correct" the effects of a mild filter.

Prints from color print (negative) film, on the other hand, are convenient to show and give to others. And while the what-you-see-is-what-you-get character of slide film may be what you want at times, good print photofinishing can often turn poorly exposed negatives into nice prints. Print film's broad exposure latitude can produce good results with any camera—even the most basic point-and-shoot models—while finicky slide film necessitates the use of cameras that offer at least a few exposure-control options. Although prints made from negatives usually offer better quality at lower prices than prints made from slides, print quality can vary widely between photo labs.

Once you've decided between slide and print film, it's easy to further narrow your film choices. For example, a number of slide films are billed for outdoor use; these fall primarily within the slow-speed range, and offer saturated colors and a warm color balance, the traits many scenic photographers prefer. Other slow- to medium-speed films are not as vibrant, because they're designed to provide neutral hues and natural skin tones. To get a handle on all the films on the market, check camera magazines, photography-related web sites, and manufacturers' data sheets, which list a particular film's characteristics and intended uses.

Comparison Tests To really understand the specific films you're considering, you should run your own tests. Buy a roll of each type of film that interests you. The film can be any ISO rating or brand, but don't mix film types—compare print film to print film and slide film to slide film. Choose several scenes that vary in colors and contrast. Photograph them however you wish, just keep notes on what you're doing. After using one film, change to the next and reshoot the same scenes with the identical light, lenses, and exposures. For best results, use a tripod, and take the rolls to your regular photo lab. When your images come back, compare everything—color balance, color saturation, image sharpness—and see which you prefer.

Professional vs. Amateur Films Film ages. Professional films are designed to hit their peak color balance shortly after the time of sale, since professionals and other serious photographers generally use their film right away. That's why manufacturers advise refrigerating this film as much as possible (before and after exposure, prior to developing) to slow down its color-shift process. Amateur, or consumer, films—which can yield excellent results, too—are designed to accommodate an extended period of storage, since most casual photographers tend to leave film in their cameras for longer periods of time. After considering your photo needs and habits, you can decide which type of film to use.

For this film-test subject I chose the gnarled wood of the ancient bristlecone pines in California's White Mountains. These trees (the world's oldest at up to 4,000 years old) have been aptly described as standing driftwood. I used Fuji Velvia and Kodachrome 25, both of which are low-speed films noted for their sharpness. Following the films' stated color characteristics, the Velvia (top) rendered bolder colors, while the Kodachrome (bottom) produced a more neutral color balance.

[Both photos: 24mm lens]

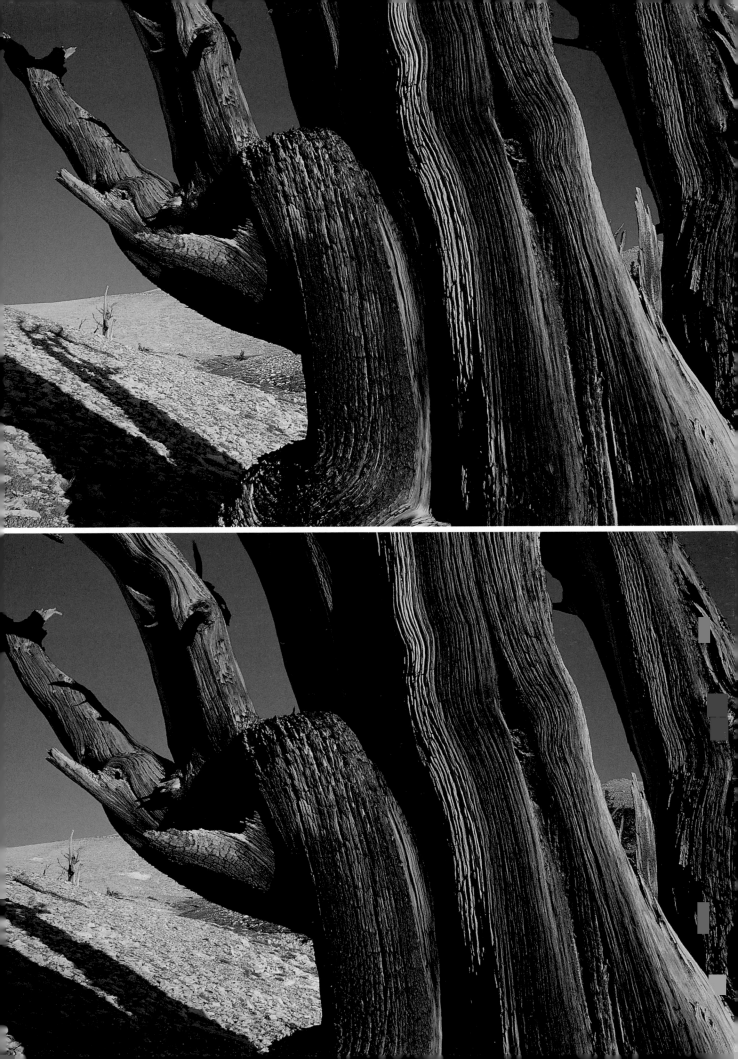

44

Why Choose Just One? Based on your preferences in a specific situation, your best film may vary. Recent technology has expanded the options. Some cameras make it easy to switch film in mid-roll, enabling you to change from slow to fast film and back again without missing a shot, while multi-speed films let you choose the ISO rating at the time you load the camera.

In any case, my present standard film is Fuji Velvia (ISO 50), a warm and saturated professional slide film that has been a longtime favorite of scenic photographers. When I need a bit more speed, I usually use a professional ISO 100 slide film. For the few occasions when I need faster speeds, I push either the ISO 100 film or the Velvia (see box). If I'm shooting portraits, I'll pick a slide film with a fairly neutral color balance. For family shots, I go with color negative (print) film. Pushing circumstances to the limits, I even employed a one-time-use camera for family snapshots during a trip to Disneyland. I framed vertical and horizontal shots, and tried low and side angles. The small camera's snapshot-size prints turned out just fine.

More important than a specific film selection is learning how the film you choose will perform in the various scenic arenas in which you'll be working. After all, films (or digital applications, for that matter) are just another variable in the recording of light and color.

Pushing Film

Seasoned photographers, especially those using slide film, may choose to push their film. *Pushing* is intentionally underexposing your film (by setting it at a higher ISO speed) to enable the use of faster shutter speeds; the photo lab must then extend the processing time to compensate for the underexposure.

Why might you want to push your film? Say you're using slow film when clouds roll in, an animal appears, or dusk approaches, and you can't switch to the faster film needed in these conditions. You can compensate for the faster film and shutter-speed requirements by increasing the ISO rating of your slower film, or setting the exposure-compensation dial to "underexpose."

If you use this technique, be sure to use the altered ISO consistently throughout the entire roll, otherwise there'll be a problem when the lab adjusts the developing time. Many films can be pushed at least 1 stop; check the manufacturer's recommendations or your photo lab's suggestions. Expect some contrast and color shifts in pushed photos, especially when going beyond a 1-stop boost. Also, plan to pay an extra fee to the lab.

While wandering around a college campus this classic Ford caught my eye. Tight framing left the parking lot out of the picture. A side- *by-side comparison between this shot, recorded on Koda-chrome, and one recorded on a more saturated film, such as Fuji Velvia, would* *probably show the latter to be richer in color. But I didn't have Velvia with me at the time, and I did have Kodachrome—and* *the colors still look pretty good, don't they?*

[75–150mm zoom lens, Kodachrome 25]

Exposure

46

People often believe their camera is all-knowing. But if that were true, photographs would never turn out too light (overexposed) or too dark (underexposed), and they would always capture the photographer's artistic intentions. Understanding exposure, and understanding how your camera operates, will help you manage color and light and will enable you to record scenes the way you want them recorded.

The Basics A camera's built-in meter measures the light in a scene or on a subject and then selects the two exposure settings—shutter speed and lens aperture—that work together to admit the "correct" amount of light into the camera to properly expose the picture.

Shutter speed controls the length of time the lens aperture stays open during exposure. Traditional speeds include 1 second, 1/2 sec., 1/4 sec., 1/8 sec., 1/15 sec., 1/30 sec., 1/60 sec., 1/125 sec., 1/250 sec., 1/500 sec., and 1/1000 sec., with some cameras offering slower and faster settings (and others offering fewer options). Each speed is half as fast as the next setting and twice as fast as the previous one. Some cameras, however, are capable of electronically setting speeds in between the standard ones noted above.

Lens aperture determines how much light enters the camera. Known as *f*-stops, the usual aperture settings include *f*/2, *f*/2.8, *f*/4, *f*/5.6, *f*/8, *f*/11, *f*/16, and *f*/22. Smaller numbers represent larger aperture openings, which let in more light through the lens; larger numbers represent smaller openings, which let in less light. Each *f*-stop opening lets in twice as much light as the next smaller one (the next larger number) and half as much as the previous larger one (the previous smaller number). Many lenses permit settings in between these standard 1-stop increments. Going from a larger to a smaller lens opening (say, *f*/8 to *f*/11) is called *stopping down*. The reverse, going from a smaller to a larger aperture (say, *f*/8 to *f*/5.6) is called *opening up*.

Aperture and shutter speed operate as a reciprocal team. Since a shift in one demands an equal shift in the other, numerous combinations exist in any lighting situation. For instance, 1/60 sec. at *f*/8 admits the same amount of light as 1/125 sec. at *f*/5.6 or 1/30 sec. at *f*/11. (The most basic point-and-shoot cameras, by the way, are pre-set for average sunlit scenes.) Each exposure setting also influences picture design; for example, shutter speeds affect motion, either blurring or freezing the action (see page 124), while apertures affect depth of field, providing either a wide or a narrow range of sharpness (see page 100). In the autoexposure mode, the camera adjusts automatically if you change either the shutter speed or the *f*-stop, so there's no impact on the final exposure.

The Problems No matter how sophisticated your camera, you still must review its exposure decisions. You should evaluate a scene from the camera's perspective, since your eyes can easily see details in extreme lighting conditions; this means that, in some situations, the proper exposure settings may be different from those dictated by the camera. Camera meters are geared toward metering frontlit scenes that are dominated by medium tones. In a scene with an even distribution of light and dark areas, an overall exposure reading often works fine, since the lights and darks generally cancel each other out.

However, lighting situations that involve greater contrasts in tones can throw off the camera's metering system and cause exposure difficulties. Problem conditions include areas of extreme lighting, of both *sunlight and shadow*—such as bursts of sunlight in deep forest, a silhouetted form outlined against a bright backdrop, harsh glare off a lake surface, a city scene marked by big areas of brights and darks, and spotlit or backlit landscapes. Other problems include color-contrast scenes with *pale tones and dark tones*—such as deep-toned buildings against pale backgrounds, light-colored or white buildings in dark-hued surroundings, or brilliant snowscapes or sandscapes against rich blue skies.

Any scene with strong light-and-shadow contrasts can be tricky to expose properly. An overall reading might work, with the light and dark tones perhaps canceling each other out, although I'd bracket my exposures if using slide film. I played it safe here, however, and spot-metered: I took a meter reading off a middle-toned patch of sunlit ground and used that exposure.

[24mm lens, Fuji Velvia]

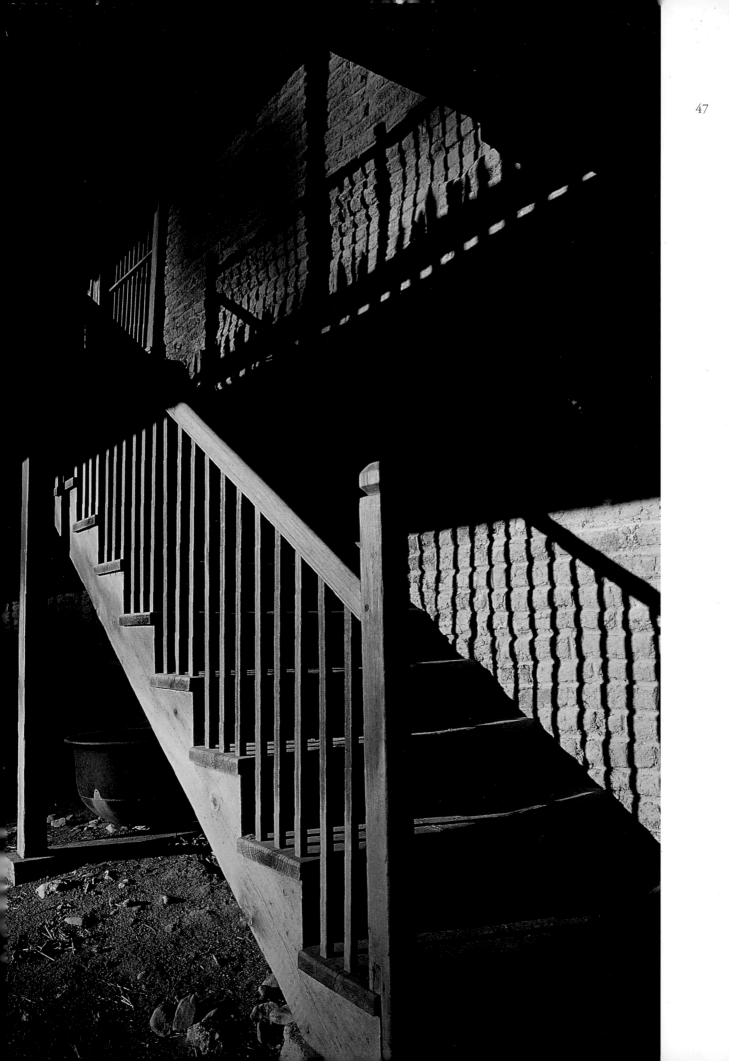

48

If a scene's main tone is either excessively dark or excessively light, things are also ripe for exposure errors, with the results being either the lightening up of the dark area (a washed-out silhouette, for example) or the darkening up of the light area (a dingy-gray snow field, perhaps). In addition, film can't handle both extremes of light or tonal scale at the same time; if a scene features a big, brilliant sky and a large, shadowed foreground, it's possible that nothing in the scene will be acceptably exposed, even if you try all of your camera's exposure-compensation modes.

In terms of exposure, color negative film is the most forgiving, since it tolerates fairly wide variations—meaning you can overexpose or underexpose to a certain degree and still come up with an acceptable photo. Fussy slide film has a margin of error of less than 1 stop over and under the ideal exposure. Digital cameras, too, require careful attention to exposure. In any case, whether you're shooting prints, slides or digital images, the greater the contrast in a scene, the more difficult it is to expose the whole scene in an acceptable way.

The Solutions When faced with hard-to-expose scenics, ask yourself the following: Must I shoot this subject in exactly this fashion? Or, will another, easier-to-expose composition or similar subject nearby do just as well? In some cases, you may be able to make high-contrast scenes work in your favor—for instance, when photographing a silhouette or a sidelit subject.

Changing your composition is the low-tech approach to solving an exposure dilemma. Sometimes a simple framing adjustment eliminates a distracting shadowy area or a glaring spot. On overcast days, pointing the camera down slightly can crop out a brilliant-white sky that may conflict with an otherwise low-contrast landscape. At sunrise or sunset, aiming the camera up may maximize a colorful sky and minimize a dark foreground. Or, turning your back to a low-in-the-sky sun, you'll find that the land or sea takes on beautiful, easy-to-expose tones.

If altering your composition still leaves you with a problem, however, consider using exposure override. For cleaner white snow, brighter sand, or darker nighttime, for example, check your camera's instruction booklet; some camera models offer a range of exposure modes, from full-frame-averaging to center-weighted to spot-metering. And many of the more sophisticated film-based and digital cameras have features that allow you to override the robot-like metering systems, making a photo darker or lighter than would have happened automatically. Among these possible features are: autoexposure lock buttons, EV (exposure value) or exposure-compensation dials, backlight compensation modes, and metered manual modes.

Most of these methods should work fine with print film or digital applications, but with finicky slide film, you should experiment to see which feature operates best in which lighting condition. In any case, always check that any exposure-compensation mode you use reverts back to zero or normal once you're through with it. Otherwise, you'll improperly expose any subsequent images.

My first choice for handling tricky lighting is to take a close-up or spot-metered reading off a middle-tone subject—such as green grass, gray rocks, an average-blue jacket, or a medium-brown wall—that is illuminated in the same light as the rest of the scene. A mid-blue sky or mid-gray storm clouds also work. I then lock in that exposure, swing back to aim at my original composition, and shoot using these substitute settings. The result is that average tones will be rendered average, darks will be dark, and lights will be light.

Another possibility is to use a gray card. Sold in camera stores, it is used to get that alternate reading. Simply hold it in front of your camera, make sure the light hitting the card is the same as that falling on your subject, take a meter reading off the card, and photograph your subject with that reading. Early in my career, I kept a gray card in my camera bag, but after leaving it home or losing it in the field too many times, I started regularly using on-site exposure references.

Searching for a fresh view of frequently photographed Scotty's Castle in Death Valley (top), I noticed a shadow cast from a nearby window. I took an alternate exposure reading off the blue sky. With those settings, I knew the outdoor scene would be properly exposed, while the shadowed doorway would make a striking black frame.

[55mm lens, Fuji Velvia]

This rock wall near my home (bottom) intrigued me for a number of months, but I never bothered to take the time for a photograph. Then one rainy weekend, I finally gave it a try. The soft light created a simple, low-contrast autoexposure metering situation.

[50mm lens, Fuji Velvia]

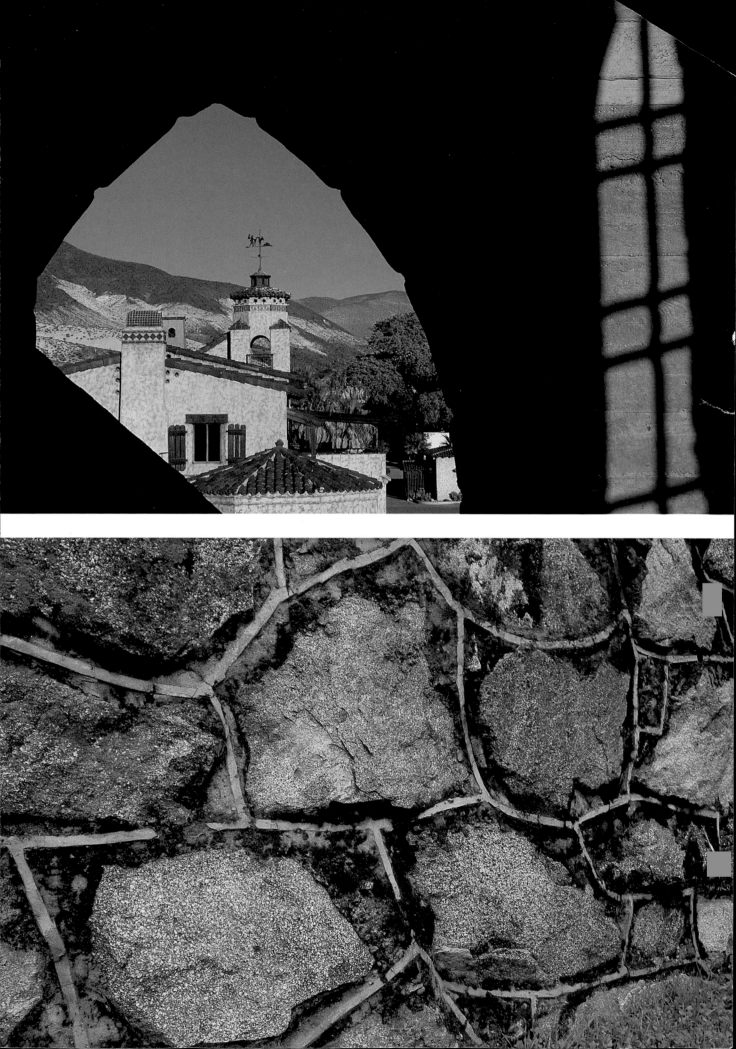

Bracketing

For scenics that seem tough to expose, professionals and serious amateurs use bracketing to prevent losing the shot altogether. Bracketing involves photographing around your indicated exposure—in other words, shooting additional frames with both more and less exposure. Some cameras offer a bracketing feature that automatically shifts the exposure value up and down.

To bracket, shoot one exposure at the suggested setting (or at an adjusted exposure you think is correct), then make some insurance shots both over and under that exposure reading. Generally, 1 stop each way should suffice: either in 2 half-stop increments in each direction with slide film (for a total of four extra exposures), or in 1 full-stop interval in each direction with print film (two additional shots). Occasionally, I'll bracket in one direction if the metering problem points primarily toward either underexposure or overexposure; for instance, in bright snow or fog, I'll shoot at the indicated setting, then take an extra frame or two with added light.

When you get your bracketed series of pictures developed, you may find that you like more than one rendition of the scene. Bracketing, however, is no substitute for striving to obtain precise exposures whenever possible. Habitual bracketing can be a money-consuming and time-consuming crutch. Of course, it also can mean the difference between a throwaway image and a portfolio keeper.

In this scene, the tonal difference between the sea and sky wasn't super extreme, and the auto-exposure metering systems in most cameras would probably work just fine for exposing color negative film. However, since I was using slide film, I took an alternate reading off a neutral-tone patch of sky that was out of the frame (top opposite). I then took one insurance shot over that reading (below) and one under it (bottom opposite). Setting things manually, I varied each exposure by 1/2 to 2/3 stop.

[All photos: 85mm lens, Ektachrome E100SW]

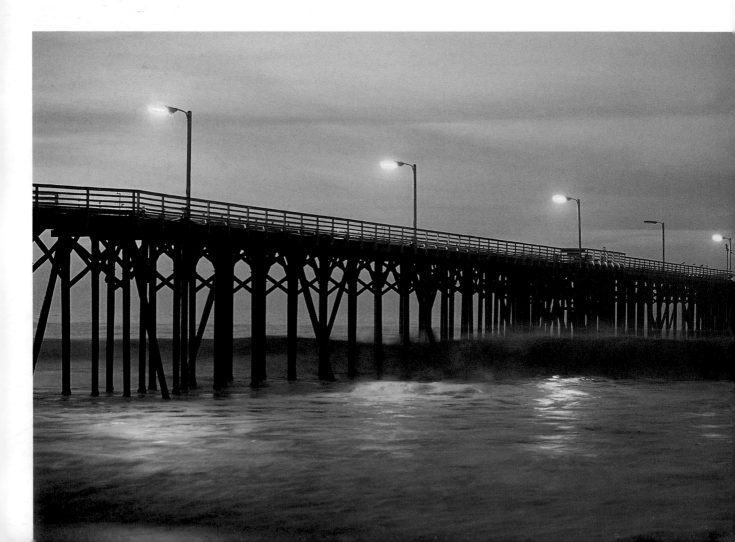

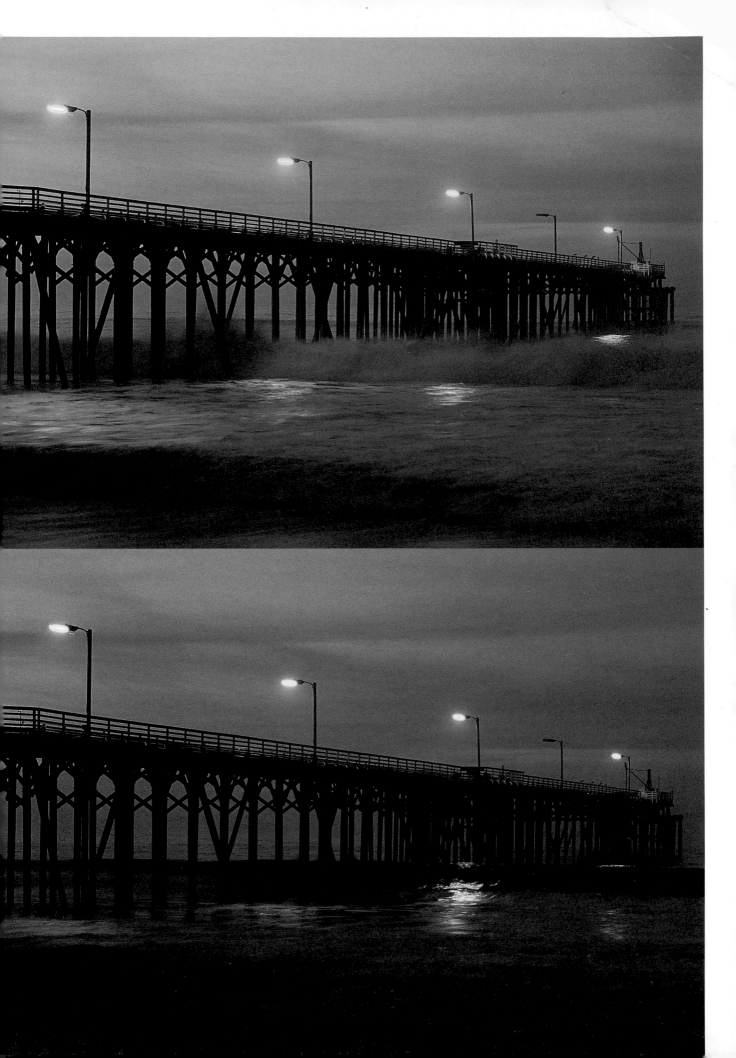

Exposure Accessories

52

There are a few camera accessories that can help you make better exposures. The *graduated filter* helps balance a scene's overall contrast. It comes in different strengths and is used most often for big landscapes in which the sky is far brighter than the ground. The bottom half of the filter is clear, and the top half is tinted. You align the tinted half with the brightest elements of the scene, and it dims them to match the more subdued tonal levels of the other areas. This diminishes contrast and allows you to record detail in all parts of the photograph. Assuming the graduated filter is gray (known as *neutral density*), it will retain a scene's natural colors in the final photo. (See page 68 for more on filters.)

Flash is another accessory that can help in certain exposure situations. A blast of controlled *fill flash* can brighten a nearby, shadowed object that's positioned against a sunlit background. For the most natural effect, the flash exposure should be at less than full power. Many cameras offer fill-flash capabilities, with some even featuring automatic flash bracketing.

A third option, a *portable reflector,* can bounce sunlight into nearby shadowed areas. You can use a commercially made collapsible model or a makeshift version constructed from anything with a reflective fin-ish. Unlike with flash, you can immediately see the effect of the reflector in your viewfinder. At times, a reflector works perfectly. However, it can be cumbersome at best; at worst, it can flap in the wind unless you talk someone into holding it for you.

When in doubt, shoot your scene both with *and* without the graduated filter, fill flash, or reflector, and compare the results. I find that, rather than struggle with additional equipment, I usually seek out an alternate subject or composition that's low in contrast, low in hassle, and doesn't need fixing with an accessory.

Changing Film Speed Sometimes it's not enough to know your camera's operating system; you must also know your camera's quirks. If your photos are consistently overexposed or underexposed, and you've already ruled out your lab or yourself as the likely culprit, then your camera may need to be repaired. Otherwise, plan to compensate for your camera's meter failings by always "underexposing" or "overexposing" accordingly. Some photographers calibrate their cameras by adjusting the ISO film speed to a setting based on their own preference, not on the manufacturer's specifications.

Before making such an ISO switch, you should do the following. Using the same low-contrast scene and composition, shoot a series of exposures at different film speeds on both sides of the official ISO.

Exercise

EXPOSURE THOUGHT AND PRACTICE

Winning the exposure battle takes technical know-how, evaluation skills, and just plain experience. First, learn in advance what all your camera buttons and features do so that you don't waste time in the field trying to figure things out. Next, start understanding how your camera sees so that you can begin to make your own exposure choices. During photo shoots, take notes on how you arrived at particular exposures, especially for difficult scenes.

Then, try the following dry-shooting exposure-evaluation drill: Point your camera at what you think is a middle-tone spot and take a manual reading. Then repeat the process, looking for other similarly toned objects in the same light. The idea is to get the same—or nearly the same—reading scene after scene. (Remember: This is a dry-shooting procedure; film isn't necessary.) After several sessions, you should become adept at quickly finding middle-tone subjects. And as time goes on, you'll start recognizing tones that are both lighter and darker than middle tones. These are crucial skills during tricky times and changing light, when you need to base your exposure on an alternate reading.

Of course, an auto-exposure camera without override features (or a basic model with pre-set settings) may force you to avoid extreme lighting conditions. But there are also times when no matter how sophisticated your camera, no matter what film you're using, no matter how many filters you own, it's just not possible to reproduce a high-contrast scene in a satisfactory way. You may have to wait for the light to improve or move on to another subject.

There are other times when the light is interesting, but things are happening fast; don't miss the moment because you were messing with metering modes. Shoot it the best and quickest way you can. Afterward, if the subject and light still look good, you can slow down and properly analyze things.

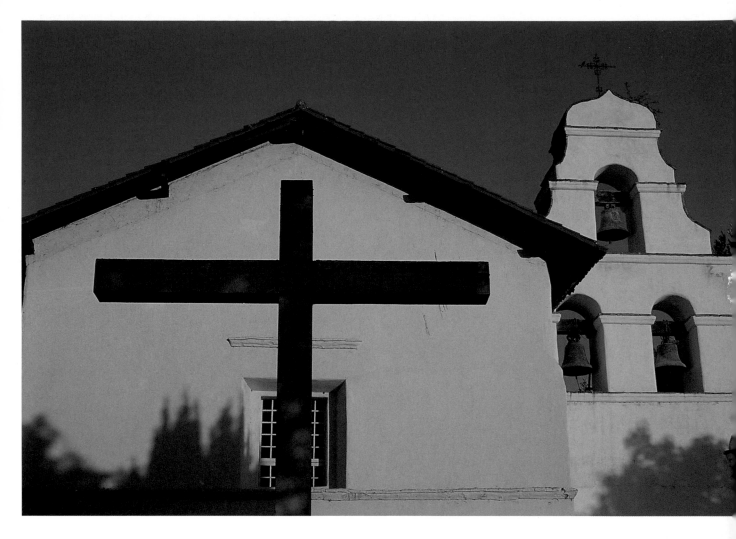

Jot down the ISO sequence for each series. For example, with ISO 100 slide film, shoot first at 100, then at 125 and 160 in one direction, and at 80 and 64 in the other. (With print film, use fewer and wider variations: With ISO 100 film, shoot first at 100, then at 50 and 200.) Repeat the process with other easy-to-expose scenes. Review your results and you'll likely find that the same ISO-rated image stands out in each series; then, always use the adjusted ISO number with that particular film and camera. If no ISO rating stands out, do this test over again with different scenes.

Working with Labs If a print comes back too dark or too light, or the colors are off, take it back to your photo lab and ask for a reprint; the negative may be fine, but the printing may have been botched. If you did bungle the exposure, try to figure out your mistake.

If you're dissatisfied with your lab, ask friends or professionals where they have their film developed. For personal attention, consider a custom lab, or at least a mini-lab or other facility that does its work on-site, so that you are able to talk directly with the technicians who handle the film and prints.

In anticipation of the sun rising behind me, I was ready for a vertical rendition of the triple-bell tower of Mission San Juan Bautista in California. While waiting, I discovered a cross nearby and thought it would make a nice silhouette when the sun rose. I changed to a horizontal composition just as the sun lit things up. In a situation like this, the wall's brightness can fool a camera meter into underexposure; so, either add a stop or so of light, or base your exposure off a middle-tone blue part of the sky.

[55mm lens, Fuji Velvia]

Mastering Light

54

For many beginner photographers, the urge to shoot usually strikes only when there's a lot of light—at high noon under a brilliant blue sky. At midday, though, the overhead light washes out subtle colors and makes distant views appear hazy and slightly blue. This may explain why the colors in your pictures sometimes don't look as vibrant as you remember them.

Light in scenic photography is really about its quality—its color, direction, and intensity, all of which change continuously as the sun's position shifts and as the weather changes. Expert photographers use natural light to inject drama, enhance tones, and create mood in their scenics. And perhaps the best thing about light is that you can take successful shots in wonderful light, even if your camera isn't so wonderful. While a simple point-and-shoot model has its shortcomings, it will capture better pictures when the light is better. Sure, the image quality may not match that of a top-of-the-line model, but working with light always pays off.

Managing at Midday Most dedicated scenic photographers shoot in early morning and late afternoon, when the color of the light is warmer and the differ-

ence between bright and shadowed areas is less extreme. In these conditions, film more easily captures the surrounding colors. However, you shouldn't use the benefits of photographing in these early and late prime times as an excuse to set photography aside during other times. Photographers often must use the entire day—either shoot it now or miss it altogether.

Although photographing in midday light requires care and creativity, opportunities can be found. For example, one of my off-and-on midday activities has involved capturing humorous roadside signs. For these types of subjects, the quality of light rarely matters.

Also, making photographs that include people in the scenery requires that you be out there when people are out there; and with special events, that's frequently in the middle of the day. While shooting the living-history program at a reconstructed 19th-century fort, I sought to capture a variety of storytelling pictures. The image below, for instance, showed only people dressed in period garb to fulfill the demands of a history-book project. In this case, the fort environment (the primary theme of the photo) dominated the frame in the bright sunlight. I managed the midday light by creating a composition that kept both foreground and background in the same light, and by avoiding large areas of shadow.

The uninteresting midday light during a historical reenactment at Sutter's Fort in Sacramento sent me in search of more interesting compositions. Here, I used a wide-angle lens and a small aperture (f/16) to get great depth of field. Using a tripod enabled me to keep my composition in place as I waited for other fort visitors to move out of the scene, and this let the fort subjects stand out in the background.

[24mm lens, Fuji Velvia]

Light and composition helped me record this adobe structure in two very different ways. After shooting a vertical view filled with foreground vegetation, I decided this horizontal building also deserved a horizontal portrayal. I had the opportunity to return the next morning, and I'm glad I did; I was able to photograph it in the vibrant daybreak light with a sociable seagull providing an additional touch.

[24mm lens (top), 85mm lens (bottom), Fuji Velvia (both photos)]

56

Some scenics, incidentally, demand that the sun shine down directly from above: for example, deep canyons, downtown cityscapes, or valleys surrounded by particularly steep mountains. Be ready, too, for puffy clouds in motion and shifting spots of light that can add depth to big views. A mix of cloudiness and sunshine is also a light combination that you can beef up with the use of a polarizing filter (see page 70). And in fall and winter, when the noon sun is lower in the sky, you'll find that the midday light is a little less intense than at other times of the year.

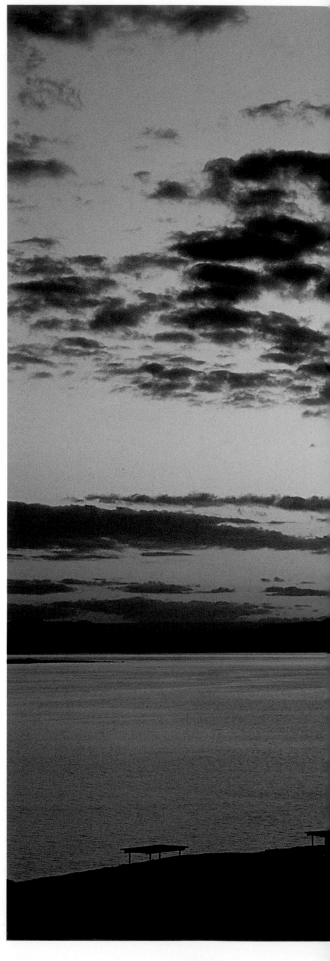

Some settings call for severe lighting. Sunset may have provided the right light for an overall look at California's Salton Sea (right), but midday light seemed ideal for capturing another mood and subject at the site: a lonely outhouse in a stark desert setting (above). I spent several days photographing the Salton Sea at both sunrise and sunset,

but my favorite image from this trip is the wooden out-house. I made the photo on a noontime break at a shoreline picnic area; the light was bright and harsh, just the thing for a subject standing all by itself in a desolate desert environment.

[50mm lens (above), 85mm lens (right), Fuji Velvia (both photos)]

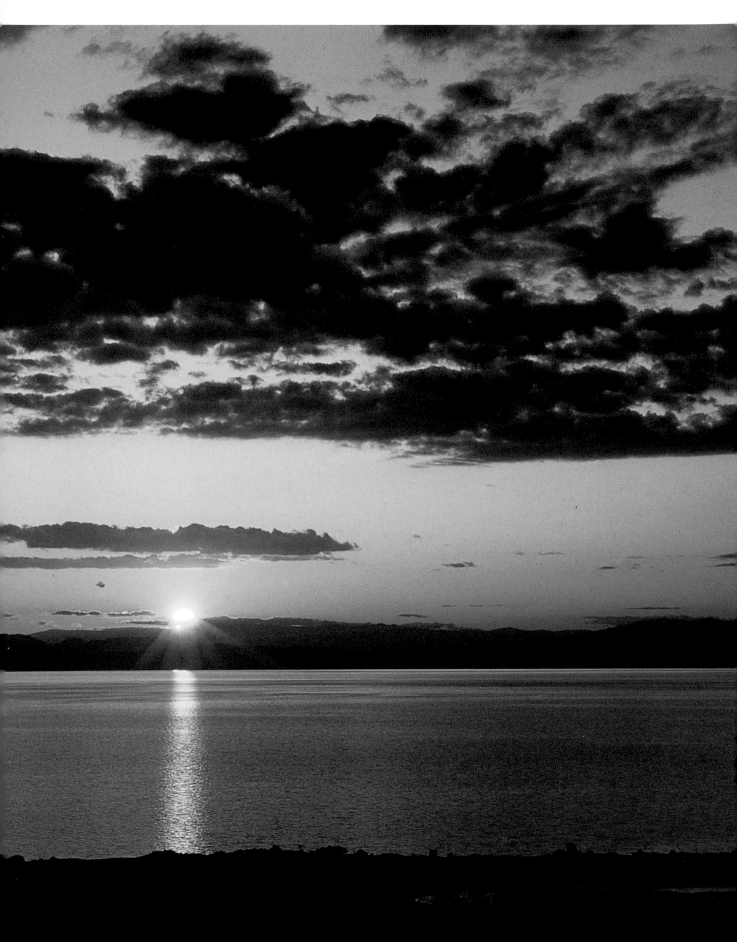

Learning about Light It's rare that a subject looks the same way twice. Light changes by the hour, day, and season; and when the clouds are moving and the sunlight is shifting, light becomes a moment-by-moment experience. In minutes, or seconds, light can turn dramatic and then become routine again. Although well-known places have been shot many times by many photographers, the fleeting nature of natural light lets you capture original photos of celebrated spots. No two days produce exactly the same conditions.

As a result, it's not always easy to understand light's intricacies. You probably already know the potential of light to create an exciting range of color—just recall the last sunset you saw. Many times, though, photographers are in such a rush that they don't stop and see the various ways in which light shapes scenes. It is important to study the complexities and the subtleties of nature's light show. Really understanding natural light means not only determining what your subject will look like in your photograph at that moment, but also imagining what it might look like at another time.

To increase your awareness of how natural light accents different parts of a scene over the course of a day, shoot the same subject throughout the day as the light changes (you can spread the photography out over several days). Any scene will do, but one that's close at hand may be easiest: your backyard, a nearby park, a distinctive bridge, a city building.

Begin early in the morning, and continue on through the day; be prepared for whatever conditions

58

Not far from my home is an 1850s brick building with rusted iron doors. On an overcast day (right), I stopped to make a shot in the diffused light, which revealed the scene's subtle tones. Just before the sun went down on another day, I photographed the building again (opposite). This is an example of how light can shape things in dramatically different ways.

[Both photos: 55mm lens, Fuji Velvia]

occur: crisp and clear or foggy and overcast. And be ready for when those conditions change. Photograph your scene several times during the day as the sun sweeps across the sky. At midday, look for some shaded areas where the light is even and soft (similar to light produced by heavy overcast conditions). In late afternoon, when shadows start to stretch, bring out your camera again, and don't pack up until after sundown's last colors. For the closest comparisons, use the same ideas, the same lenses, and the same film for each photography session.

On any shooting expedition, if the light's not quite right, I'll come back later when the light is better suited to the scene. If I can't return, I'll stick around and embark on a reconnaissance mission, searching out subjects that best suit the current lighting conditions. For the mid-afternoon scene on page 123, I liked what I saw at the time (a reflection of palm trees, an egret resting at the water's edge) and made the shot—even though I felt the scene might look more beautiful a few hours later in warm, early-evening light. I did return in "better" light, but the low-angled sun placed the shadows in all the wrong places, and the egret had long since fled.

Paying attention to light may be the most important thing you can do to produce meaningful images of new places and to capture fresh versions of familiar locales. Go out and stay a while. You, and the viewers of your photographs, will appreciate the time you take to explore the world of light and color.

Angles of Light

The angle of the light striking your subject is determined by the position of the sun in the sky. I first learned how to exploit the angle of light and position of the sun during a trip along the coast. My subject was a long, wooden pier. The late-afternoon light was nice, but hardly spectacular. As I was running out of compositional options, I walked a hundred yards to the other side of the wharf for a last look at my subject. There, I discovered backlight intrigue: rows of pillars dramatically silhouetted against a bright backdrop. Over the next few minutes, I made several shots. But, the images captured didn't excite me nearly as much as the insight gained. From that day on, working with angles of light became an invaluable tool.

Any time the sun is low in the sky, you can choose the direction in which you want the sun's rays to strike your subject by changing your position in relation to both the light and your subject. As a result, you can take advantage of the sharp contrast between brights and darks to produce high visual impact, or you can use the warm illumination at the ends of the day to capture vibrant colors. Too many photographers, however, fail to pay attention to the sun's position and the direction or angle of the light; they shoot almost exclusively in *toplight*—an often uninteresting kind of directional light in which the sun is immediately overhead. (The terms *toplight, frontlight, sidelight,* and *backlight* describe the direction of the light in relation to the subject, not the photographer.)

Although changing your position in relation to the sun is a surprisingly simple way to achieve visual variety in your photographs, it is also an unnervingly easy way to create special problems, especially with sidelighting and backlighting, as we'll see on the next few pages. Success hangs on an understanding of what light does and how it impacts your scene.

I love fishing piers, and this one provided all sorts of possibilities. On one side, I got a frontlit shot (right). In a backlit shot on the other side (top opposite), I was able to capture the pier and shorebirds in silhouette. And, in a late-day view (bottom opposite), I positioned myself so that just a piece of the sun peeked out from between two of the wooden supports. A small lens opening created the sunstar effect.

[55mm lens, Fuji Velvia (right); 85mm lens, Ektachrome 100SW (top opposite); 24mm lens, Fuji Velvia (bottom opposite)]

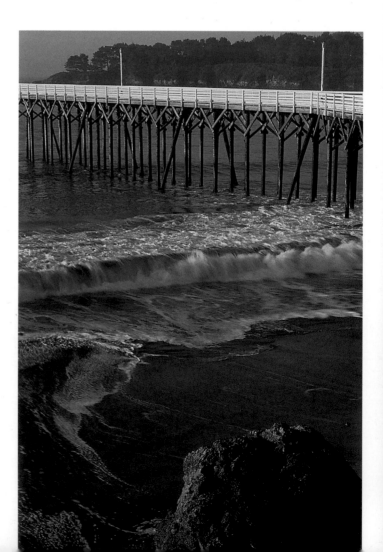

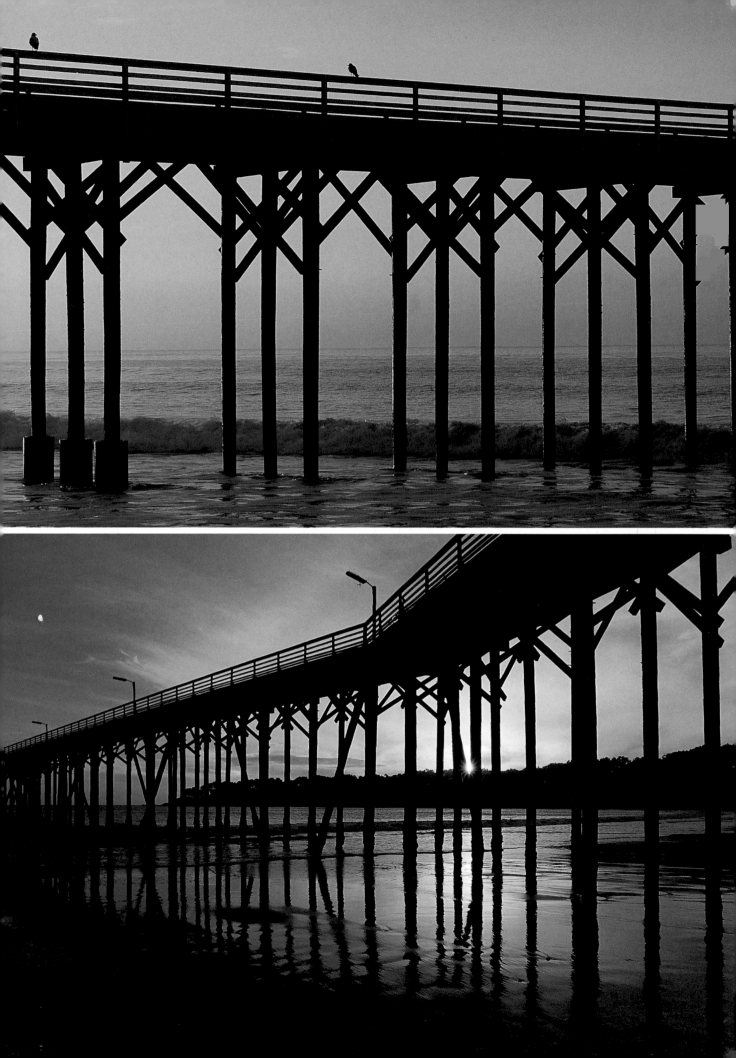

Frontlighting Frontlighting, which comes from behind you and hits the subject head-on, has long been either embraced or bashed. The old school of photo advice stated: For the best pictures, always shoot in frontlighting. More recently, the rule often is: For the best pictures, never shoot in frontlighting. My advice, however, is this: Sometimes frontlighting is good, other times it's not.

Frontlight has been called flat lighting, due to its even illumination of a scene. Since shadows fall to the rear of subjects and out of the camera's sight, objects lose their form, texture, and perspective. Also, with the sun fairly high above the horizon, the light can be harsh, wiping out subtleties of tones.

While frontlighting may lack sidelighting's dimension and backlighting's drama (which we'll get to), it has its virtues, too—namely in regard to exposure and color. First, it's convenient and easy to work with, since all sections of the scene fall within the same brightness range. This lack of contrast extremes generally translates into simple exposure circumstances—just set your camera on autopilot and fire away. Second, direct illumination is just the thing for capturing rich colors, eye-catching patterns, diversity in hues, and the vibrant tones of early and late day. It's always tempting to face the rising or setting sun (and photograph only it), but force yourself to try this: With your

back to the sunrise or sunset, watch the vivid colors that sweep across your surroundings; in this frontlight, any subject can work—from wilderness landscapes to city skylines, which are especially brilliant when tall buildings reflect low-angled light.

Photographing with the sun at your back also comes with a warning, however: Early in the morning or late in the day, the broad coverage of a wide-angle lens could allow your shadow to intrude into the scene. This may be your intention, as it was mine on page 36; otherwise, remedy the situation by altering your composition: Point your camera upward or to the side, to avoid the shadow, or switch to a lens with a longer focal length.

Other conditions can produce good frontlighting results, as well. Nice light, when the sun hovers fairly low on the horizon, can extend for a few hours after sunrise and can also begin a couple of hours before sunset. Or, frontlit scenes set against a background of passing storm clouds can be downright dramatic. For example, when photographing an interesting old adobe building, I found that my best effort was a frontlit, early-morning view (page 55, bottom). Initially, the conditions hadn't appeared promising; however, the sun came out and lit up the structure with a warm radiance, while a backdrop of storm clouds heightened the drama.

Wonderfully contorted Joshua trees aren't really trees at all; they're yuccas, some of which reach 35 to 40 feet in height. I shot this frontlit image early one *morning during a trip to the Mojave Desert. (Compare with the backlit, sunrise version on page 64.)*

[24mm lens, Fuji Velvia]

Sidelighting Sidelighting, which shines on a scene from the left or right, brings out shadows and highlights. It turns a flat-surfaced shot into a three-dimensional image. When you point your camera at an angle to the low-lying sun, a small scene takes on depth and dimension while big landscapes spread out in grand relief, with the low angle of light accentuating textures and contours.

The resulting elongated shadows that occur early or late in the day add tonal variety, provide direction, and help break up empty spaces in your picture. These shadows require careful framing; in fact, a really distinctive one might even serve as the star of your scenic composition. Strong early- or late-day sidelighting also accentuates texture by skimming across uneven surfaces. It can reveal the peeling paint of old wood, the roughness of a rock, and the sand of a beach. It can even enhance the sparkling coarseness of snowscapes. In scenes like this, each grain of sand and each granule of snow casts its own minute shadow due to the sidelight.

True sidelight comes in at a right angle to where you are pointing your camera — halfway between backlight and frontlight. But sometimes, an intermediate angle better emphasizes depth or better solves a design dilemma, such as creating a more pleasing arrangement of shadows and other elements in your scene. These intermediate sidelight angles come in midway between sidelight and frontlight, or between sidelight and backlight; in your viewfinder, the light comes from an upper or lower corner. Be aware, though, that some of these intermediate angles may cause lens flare (see page 66).

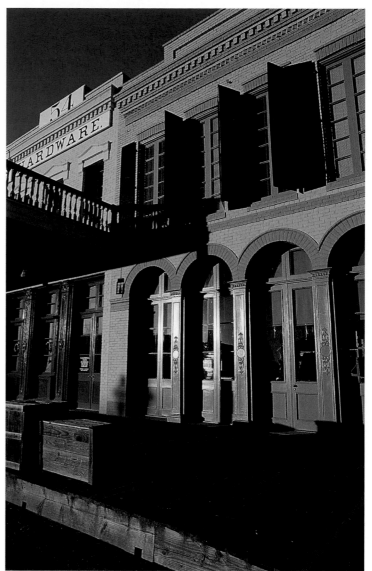

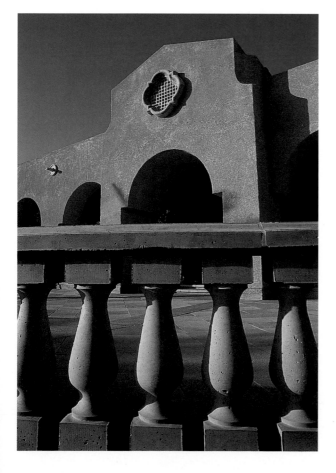

The distinctive architecture attracted me to this desert resort hotel (left) and prompted me to play with various angles of light. During the late afternoon, clear-sky weather conditions and strong sidelight created a sharply defined effect.

[24mm lens, Fuji Velvia]

Another example of sidelighting (above), this photo highlights how sidelight emphasizes depth. Also note the long shadows cast by the wooden boxes in the foreground; late afternoon light creates longer, more pronounced shadows.

[24mm lens, Fuji Velvia]

Backlighting and Silhouettes Shooting a back-lit scene is as challenging as it is rewarding. This is because backlighting—when the sun is behind the subject—is the trickiest light with which to work, since the best exposure can be tough to figure out. On the other hand, backlight can make translucent objects, such as autumn leaves or ships' sails, gleam magically; and other subjects take on a halo from rim lighting (when the outline of a subject catches rays of sunlight). Backlight also can create extended shadows stretching toward the camera.

Using backlighting, you can produce beautiful silhouette images—scenics reduced to light backgrounds and pure black shapes. For most of us, the first silhouettes we ever captured on film were strictly unintentional—family portraits in front of a window ("I thought the flash always went off indoors") and friends standing outside in deep shade with a bright sky behind ("I didn't know I needed flash outdoors").

An *intentional* silhouette in a photograph shows off your subject's contours, while leaving the rest of the subject to the imagination. To make one of these showstoppers, look for a shaded subject against a bright backdrop. Often (though not always) they're readily identifiable: for example, a bridge, person, tree, lighthouse, statue, tower, or jagged peak.

As for composition, keep things simple. Begin with an uncluttered background, usually the sky at sunrise or sunset. Then pick a strong shape that's sharply outlined. Note that any backlit object in your viewfinder will turn out black in the final picture. With that in mind, try to visualize how the *outline* of your silhouetted subject will look, since everything else about it will come out dark. When framing your scene, try to avoid the unsightly merging of two or more dark forms. Even if they're just barely touching, it may be too much; a step to the side should fix it. Also make sure your silhouetted subject doesn't blend in with the darkened horizon; if it does, choose a lower camera angle.

Silhouettes photographed against the sky aren't your only options. For example, I've focused on beachscapes from high atop sand dunes, while silhouetting beachgoers and shore birds against a glaring sea.

After capturing a frontlit view of a Joshua tree (page 62), I decided to make a silhouetted version (right). The sunrise backdrop added to the drama of the image.

[24mm lens, Kodachrome 25]

This desert cactus scene (top opposite) provides a good example of backlighting with a rim light effect.

[85mm lens, Fuji Velvia]

Backlighting silhouetted the trunk of this oak tree (bottom opposite) in Yosemite National Park, and created a translucent effect with its leaves. Early-morning mist contributed to the scene's mood.

[50mm lens, Kodachrome 64]

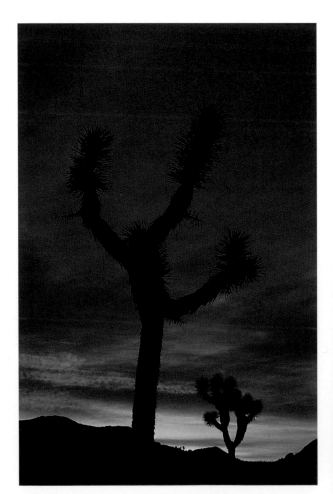

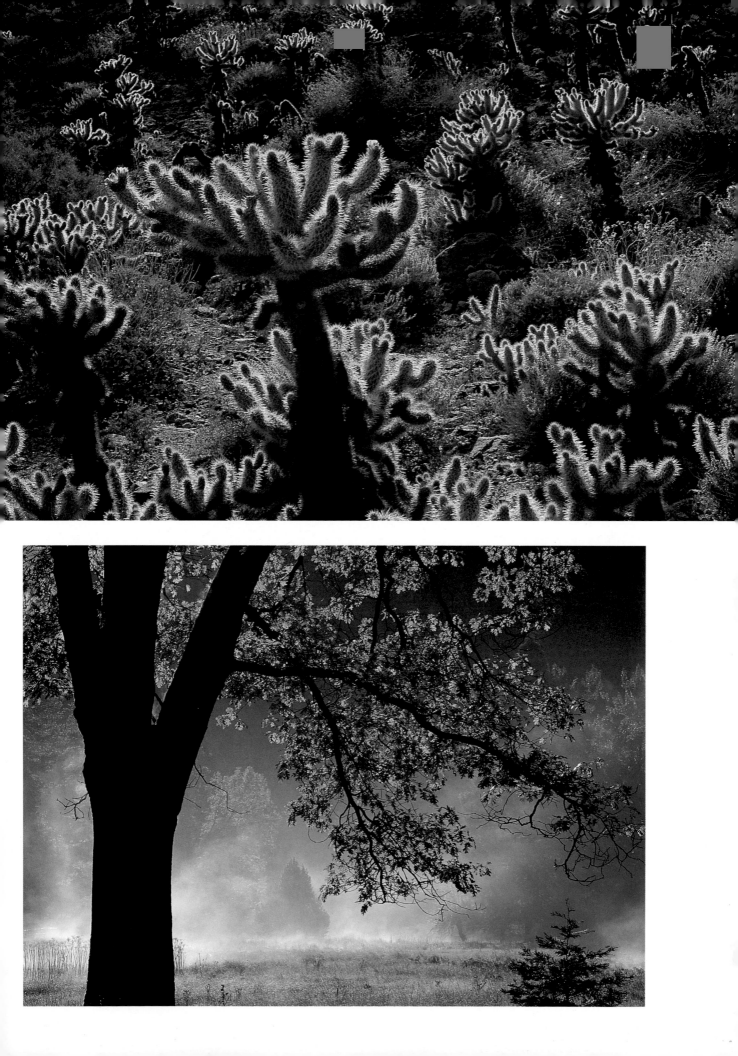

Sunbursts

You can combine sunbursts with silhouettes to heighten the drama in your scenics, and you can accomplish this effect without a filter at almost any time of the day. Begin by hiding the sun behind a silhouetted subject in your scene. Next, position your camera so that just a slice of light peeks around the object, and set your lens at the smallest possible aperture, say $f/16$ or $f/22$. The result will be a sunstar. This technique, by the way, is easiest to execute with a wide-angle lens. Small f-stops also can turn other strong light sources, such as street lamps, into sunstars.

The depth-of-field preview feature (see page 100), found on some cameras, is most frequently used to see what will be in sharp focus in the final image. However, because the viewfinder darkens as the lens closes down to a small aperture (make sure your lens is indeed set or programmed for a small opening), depth-of-field preview also gives you a rough idea of how a silhouette or sunburst will appear, and it also lets you see how sidelit shadow shots will look.

Lens Flare

When aiming your camera toward the sun, watch out for lens flare—unsightly splotches of light or a general fogginess over the frame. This occurs when direct sunlight, or powerful artificial light, hits the front of the lens and causes internal reflections. You can usually see these aberrations in your viewfinder. Avoid lens flare by positioning the camera so that the sun is blocked by one of the elements in your scene, or by something outside of the picture area.

Be careful when the sun is just out of your camera's field of vision. If you're not paying close attention, a slight camera or sun movement can cause the light to strike the lens. For example, it's possible to tip or move a hand-held camera slightly right before depressing the shutter and not even know about the resulting spots until reviewing the photo later. Use of a tripod requires caution, too; just when you've carefully framed your picture, the sun's angle can change a bit, causing an errant sunbeam to hit the front of your lens.

A good way to shield your glass from stray light beams is to use a lens hood, or sunshade, but be sure it's the proper one for your particular lens. Although I use a lens hood at all times (it also protects the lens glass from stray branches, fingers, dirt, and sea spray), I play it even safer in critical lighting, shading the front glass with my hand or hat. No matter what you use to shield your lens from stray light, take care that it doesn't block the lens' view.

Flare can affect sunburst images, although the use of a small f-stop helps reduce these irregularities (wide-open apertures can intensify the effects). Zoom lenses, which are more complex than fixed lenses, are especially prone to flare. Add still more optics— namely, a filter—and the flare problem is further compounded. As a result, I always remove any filter before shooting toward the sun, and whenever possible, I use single-length lenses in these situations. Although you may be able to minimize flare, sometimes it's impossible to remove every bit of it. Other times, the sun's angle on a subject is so visually promising that any flare is hardly noticeable.

Exposing for Side and Backlight

Sidelight and backlight pose special exposure pitfalls all their own. When metering a scene, you should usually give priority to the illuminated areas of a scene, with the shadows turning dark and losing detail. With backlighting, contrast is desirable, since the extremes between light and shadow are what make a silhouette.

For close-up objects, fill flash or a portable reflector can lighten shadowed parts of a scene. To capture a big, backlit landscape with a beautifully bright sky, you can use a graduated filter to even up the contrasting tones (unless you want to record the land as a silhouette). Another option, if your camera has it, is to set the backlight compensation feature; keep in mind, though, that this feature adds exposure to the entire scene, not just the shadowed foreground, and could wash out an already-bright background. Of course, when shooting silhouettes, make sure that you turn off any exposure-compensation modes.

At times, a promisingly dramatic scene contains strong sunlight, dark tonal areas, and absolutely no middle tones from which to take an alternate reading. In this situation, fiddle with your camera's exposure-compensation modes. Another option is to take a guess at the right settings for the scene's highlights. Assuming it's mid-morning to mid-afternoon in sunny conditions, go with 1/125 sec. at $f/11$ for ISO 50 color slide film and some ISO 100 color negative films; or, 1/125 sec. at $f/16$ for ISO 100 color slide film and certain ISO 100 color negative films. Earlier in the morning or late in the afternoon, you'll have to add 1 or 2 stops of exposure, even more in really dim light. With slide film, I'd use the manufacturer's suggested settings as a starting point for bracketing.

At sunset or sunrise, a wide-angle lens' broad view leaves certain parts of an image darker than the others. Unless you place your silhouetted subject within the brightest area of the frame, it may blend into the surrounding darkness. The proper exposure in scenes with this type of contrast is always a compromise. An autoexposure camera's average metering program could average out the lights and darks. Otherwise, meter a middle-tone area away from the scene's brightest and darkest sections, lock in that exposure, and recompose your shot.

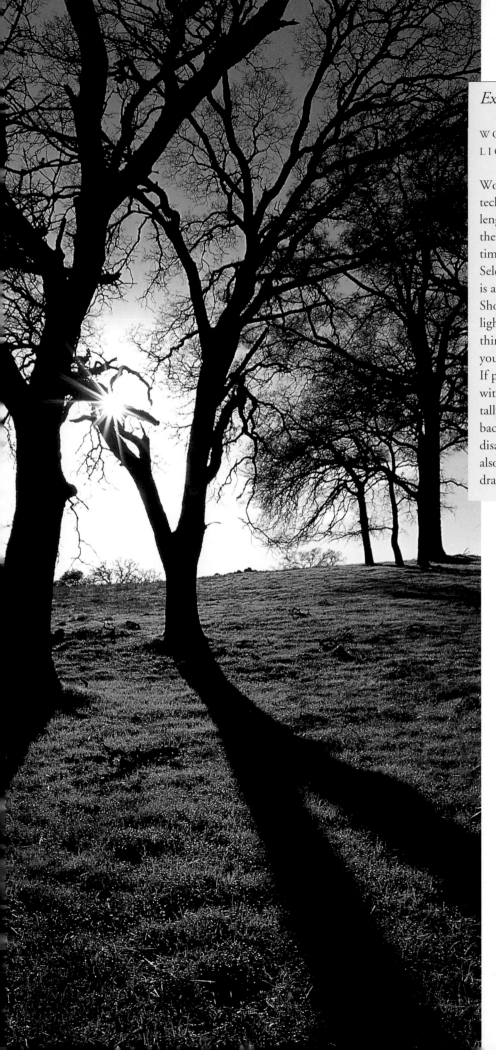

WORKING WITH LIGHT

Working with light can be a technical and creative challenge. It takes practice. Try the following exercise the next time you have a few minutes. Select a subject when the sun is at a low position in the sky. Shoot it first in direct frontlight, then in sidelight. Wrap things up by moving behind your subject for a backlit shot. If possible, repeat this exercise with other subjects. Incidentally, as you work with tricky backlight, expect some very disappointing pictures. But also be prepared for some very dramatic surprises.

Out in the countryside one day, I searched for a scene just like this: a composition of trees, shadows, and a sunburst. I determined my exposure by spot-metering a piece of medium-blue sky while keeping the sun out of the frame. Using a small f-stop (f/22) to create the sunstar effect, I then framed my image.

[24mm lens, Fuji Velvia]

Filters

One year, while doing some work for a local company, I became acquainted with one of the firm's security guards. In his spare time, he was an avid photographer who enjoyed experimenting with star effects, multiple exposures, wild colors, and misty images. Every month or so, he bought another special-effects filter, tried it out, and shared his results with me. I always looked forward to seeing his pictures, but I especially admired his enthusiasm and willingness to try new things.

When it comes to filters, I've noticed that photographers generally fall into one of four camps: the photo hobbyists who own dozens of filters because they want to experiment with the different ways in which to change reality; the purists who refuse to use any filter anytime, anywhere because they don't want reality changed in any way; the photographers who mount a protective filter on each lens, then forget they're there, never remove them, and never consider any other filters

because they just want to shoot a scene and be done with it; and the shooters, like myself, who use filters sparingly and then only to compensate for the camera's inability to record exactly what the eye sees.

With a little imagination and skill, the use of filters can be a low-effort method for controlling light and color. These optical accessories can make your photos look better than you hoped, or worse than you imagined. Filters come in the round, screw-in type and the rectangular style that attaches to the lens by means of a filter holder. Of course, not every filter is equal in quality. A mounted filter is part of your lens; therefore, if you put a poor-quality filter over a good-quality lens, you may end up with a so-so optical system. The top camera makers produce top filters, but several other companies also sell top-quality filters. Which filter you use depends on your photographic goal.

The popular and versatile *polarizer* (see page 70) cuts the reflections and glare that can interfere with the way your camera records colors. The *graduated*

At Alcatraz in San Francisco, I found the soft overcast light ideal for this flower scene. I tipped my wide-angle lens down *to keep the white sky out of the picture, but left enough of the background visible for reference. Sometimes I'll use a warming filter to* *warm up an overcast scene, but I wasn't sure if I needed one in this case, so I shot it both ways. I used a Tiffen 812 filter for the* *right image and no filter on the left image.*

[Both photos: 24mm lens, Fuji Velvia]

filter (see page 52) balances the lighting in high-contrast landscapes. *Warming filters* subdue the excessive bluish cast found in the shade on sunny days; these tones, reflected from a blue sky, are often less noticeable in person than in photos, since our eyes tend to "color-correct" scenes. Warming filters are generally designated within the 81 series, from weak to strong — 81A, 81B, and 81C. I sometimes use the 81A to add a touch of warmth in normal daylight. The filter's effect is more noticeable on slides than on prints.

To protect lenses against scratches, fingerprints, dings, and weather conditions, many photographers leave a pale-pink *skylight filter* or clear *UV filter* on their lenses full time. It's always cheaper to replace a filter than the primary lens. (Some photographers prefer the slightly stronger warming filter, for both its lens-protecting and warmth-providing abilities.)

Skylight and UV filters also offer other benefits, although the effects can be subtle with slides and nearly unnoticeable in color prints. Both absorb some of the hazy bluishness (caused by ultraviolet light) in distant landscapes at high altitudes. In addition, the skylight filter adds a bit of warmth to pictures made in open shade on blue-sky days. As for my own filter use, I apply a skylight only when there's a specific protective reason for doing so — in mist, snow, blowing sand, dust, or ocean spray. Otherwise, I usually rely on careful handling and on hard (not rubber) lens hoods for impact protection.

To alter a subject, there are many "creative" filters that produce special or surreal effects; dozens of options are available. To boost colors, *color enhancing* or *intensifying* filters help accentuate warm colors, such as the reds and oranges of autumn. Some enhancement filters increase the saturation over a wide color spectrum without influencing neutral tones. To correct colors, *color-compensating* (CC) filters are designed to fix the color balance in certain situations, such as very long exposures when a color shift is possible and when accurate color rendition is critical.

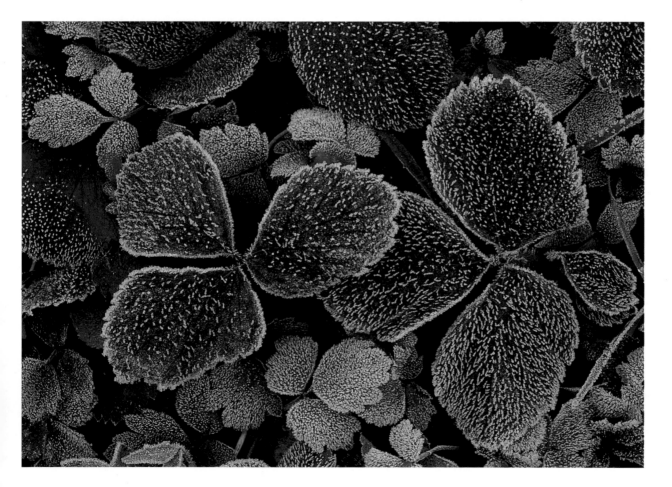

A clear sky reflects into shaded scenes like this, creating a bluish light that's more noticeable on film than in person.

Sometimes, however, a scene's color cast evokes a mood. And since the mood I wanted to evoke here was coolness (as in

an early-morning chill), I decided against using a warming filter.

[55mm lens, Kodachrome 64]

Using a Polarizer This most versatile of filters is effective with all film types and performs many acts of magic. The polarizer adds snap to the normally unappealing light of midday, deepening the blue of the sky and highlighting white clouds, snow-capped peaks, or stark white buildings against it. This rotating filter also reduces glare and distracting reflections that wash out colors. And, it can beef up the natural colors of most non-metal surfaces, from water to vegetation to glass to rainbows, without altering the picture's overall color balance.

As if that weren't enough, the polarizer also can minimize atmospheric haze (thus increasing the clarity in distant views) and can pump up the satura-tion of delicate colors (capturing the tones that look so wondrous to the eye but are so elusive in a photograph).

A polarizer is easy to use, but unlike with other filters, the camera's position is important. A polarizer hits its peak effectiveness when you're point-ing the camera at a right angle to the sun. With an SLR camera, you can preview the polarizer's effect in the viewfinder as you turn the filter. Or, you can preview the filter's effect before placing it on your camera by holding it in front of your eye and rotating it. I fre-quently do this, and if I can't detect any change in the scene, I don't use the filter. Sometimes I find that maxi-mum polarization isn't necessary every time, that the right effect lies at an intermediate grade.

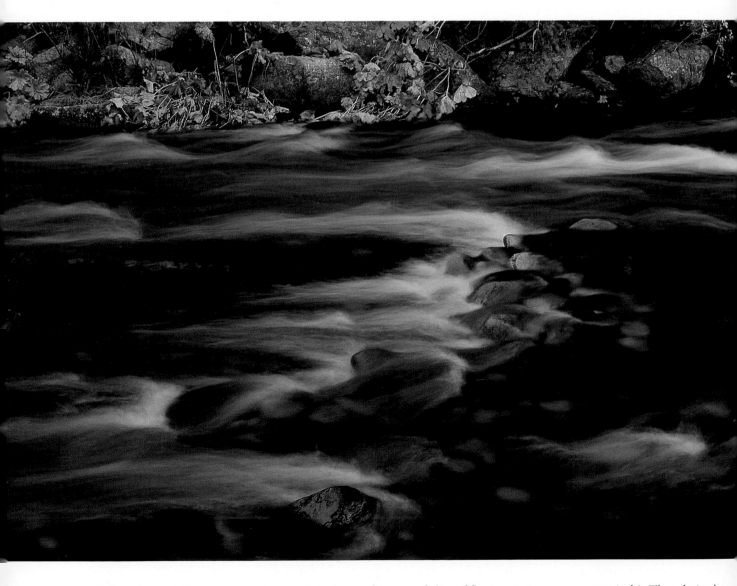

When photographing mountain creeks, I fre-quently use a polarizing filter for two reasons: it reduces the glare on the water's surface, and it cuts the amount of light entering the lens — with the necessary slow shutter speed helping to create a feeling of flowing motion. Here, you can compare the unpolarized and the polarized versions (top opposite and above, respectively). The polarized exposure was around 1 to 4 seconds at f/16.

[85mm lens, Fuji Velvia]

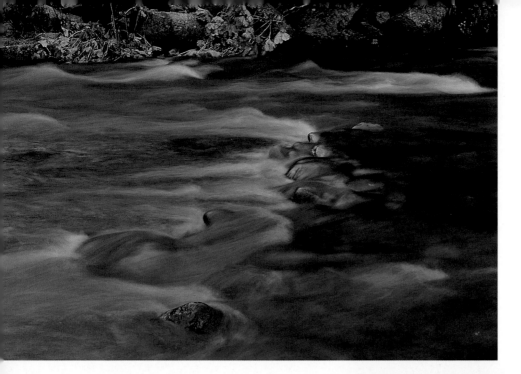

Most polarizing filters are of the neutral-density (gray) variety, although there are some specialized versions, too, such as a warm-tone polarizer, which offers a modest warming benefit with all the polarizer's attributes, and an enhancing polarizer, which increases colors while cutting glare.

Polarizer Considerations Using a polarizer isn't just a matter of slapping it on and forgetting about it. There are some considerations to keep in mind. Beware of an over-polarized look. After seeing too many garish scenes resulting from poor polarizer skills, some photographers have forever sworn them off. Today's super-saturated films often bring out the blues on sunny days without assistance from a filter; in fact, polarizing an already dynamic blue sky could turn it nearly black.

Also, don't get so carried away with the polarizer's ability to tone down annoying reflections that you use it mindlessly on scenes that rely on attention-grabbing brilliance. It is possible to kill the life and sparkle from some scenes. For instance, the highlights of refreshingly wet leaves or a pond's rippling surface could be wiped out by maximum polarization. And, forget trying to punch up a gray, overcast sky with a polarizer. It won't work on white. However, I often use it on other subjects in overcast conditions; if in doubt, take a look through the polarizer first and see.

For this image of a balancing desert rock, I used a polarizing filter to deepen the blue sky and spotlight the clouds, in order to dramatize the scene.

[24mm lens, Kodachrome 25]

These two shots, both made with a polarizer, show the filter's effect at different camera positions.

[Both photos: 24mm lens, Kodachrome 64]

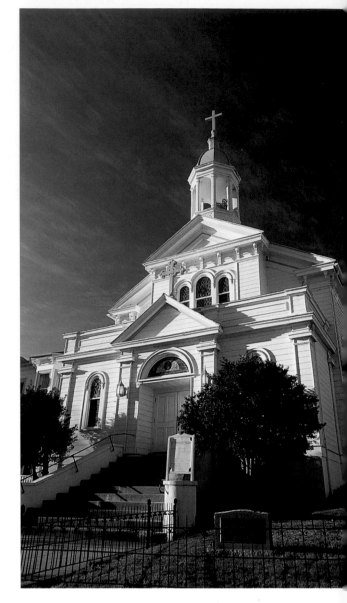

Watch out when composing grand scenics with a wide-angle lens. The wide view may encompass both unpolarized and polarized areas, often resulting in a graduated sky tone that runs from a deep blue on one side to a lighter tone on the other. To reduce the polarization shift and obtain a more uniform sky, narrow the field of view; either switch to a longer focal length or frame a vertical composition.

A polarizer is thicker than other filters, so adding one to a wide-angle or zoom lens could cause vignetting, when the corners of the scene get cut off in the photo. To check for possible vignetting, point your camera toward the sky, stop down the lens, and use the depth-of-field preview feature to see if your image appears full-frame. Otherwise, reduce the vignetting danger by using filters designed for your lenses, and consider removing the lens hood when using a polarizer. Many of the newer-style circular polarizers, incidentally, are slimmer than the older linear versions, and some manufacturers further minimize the vignetting risk by making the polarizer wider in diameter than the lens front.

Strong, or deeply tinted, filters — including polarizers — also reduce light by up to 2 stops. An SLR's through-the-lens metering system automatically compensates for this; otherwise, you must make a manual adjustment. When you're already working in heavy overcast conditions with a small aperture to increase the depth of field and a slow film for bold colors, this may mean shooting at a speed of a full second or longer. A tripod is the answer for camera stability — but not for subject movement. To combat subject motion and attain a sharp picture, either wait for a lull in any wind, remove your light-reducing polarizer, frame another composition that puts less emphasis on wind-susceptible subjects, or look for another subject altogether.

Sometimes, of course, having less light pass through the lens is desirable, for example when longer exposure times or wider lens apertures are needed. In fact, there's a filter made specifically for this purpose: the all-gray neutral-density (ND) filter.

Unless you have a really good reason for using it, remove your polarizer or other filter in sidelit or backlit situations. A filter heightens the possibility of sunlight hitting your lens and creating lens flare. Also, some photographers routinely stack filters (using two or more at once to combine effects). Beware, though: Stacking filters can cause potential problems with sharpness, flare, and vignetting, and can result in an overall reduction in optical quality. Keep in mind that if you aren't sure whether a filter will help or hurt your picture, you can shoot the scene both with and without the filter. This is a surefire, can't-miss technique, and there aren't too many of those in photography.

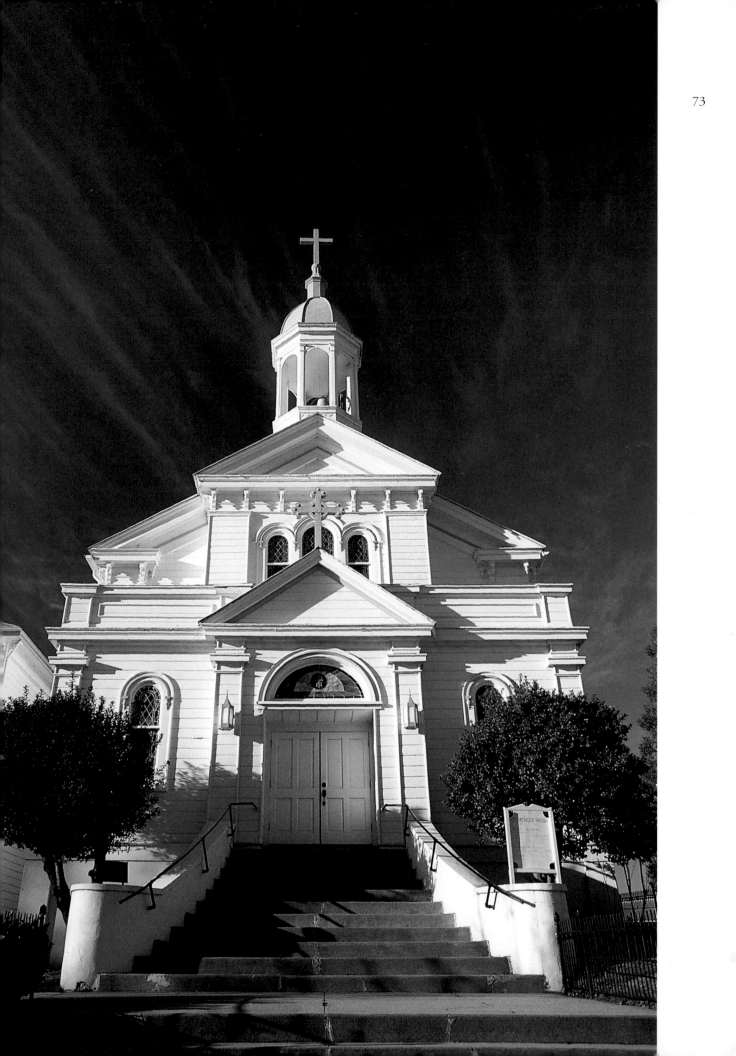

Sunup and Sundown

Like many photographers, I hate to rise early; I also like to eat dinner at a decent hour. But sometimes, photography, like every other art form, demands sacrifice. This mostly applies to photographing at sunup and sundown, times of the day when many casual photographers are either still in bed or having dinner. However, for those willing to adjust their eating and sleeping habits, dawn and dusk can be the most consistently satisfying times for outdoor photography.

First, or last, light paints the sky with reds, oranges, and pinks while softly illuminating the land. The light becomes really intriguing when a scattering of clouds hangs above the horizon, bounces light onto the landscape, and picks up a splash of colors. And wonderful light doesn't only occur once the sun rises or as it sets. Beautiful light also occurs at twilight — the otherworldly intervals between daylight and darkness. (See page 78.)

Shooting after hours is easier than you might realize. No exotic equipment or special film is necessary, and you can create artful images by experimenting with surprisingly simple strategies. Since eye-catching light is fleeting, however, capturing it with your camera does require planning. During midday, you can scout for potential shooting locales to return to late that day or early next morning.

Find out what time the sun rises or sets, and check the weather forecast. Think about the types of photos and subjects you want to capture. You'll probably want reasonably open territory, with no buildings or mountains blocking your view — unless you plan to use those as silhouettes. Look for strong shapes for potential silhouettes against a colorful sky, or for buildings that may light up dramatically at night. Try to imagine what the scene might look like at sunrise or sunset, in completely different light. Then check for other scenes that might glow nicely in the frontlit light of a low-in-the-sky sun. I keep a compass in my bag for times when I need to figure out where the sun will be.

It's easier to prepare for a sunset than a sunrise, because you can set up in daylight and then track the sun's progress. In the morning, the darkness gradually turns into a soft early light, but as the sun clears the horizon, things happen fast, and successful sunrise photographers must operate quickly. This means arriving on the scene early enough to check your surroundings, pick the best spot, and set up your gear. The planning begins the night before, when you gather everything together for the morning shoot. When you set your alarm, factor in how much time you need to get out of bed, get ready to leave, and reach your destination.

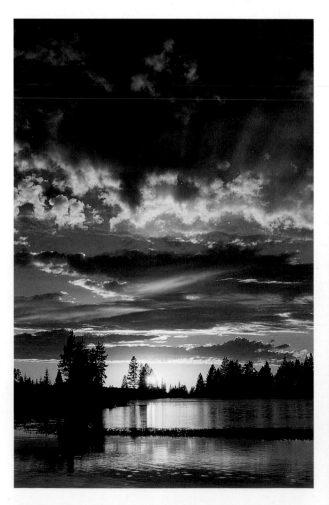

It would be hard to miss with a scene like this — unless you were one of the photographers near me who left after the sun set and the light was starting to fade (right). Minutes later, however, the colors just wouldn't quit, with the clouds and water reflecting intense pinks and reds

(opposite). For both views, I chose a vertical format to play up the vibrant sky over the water's reflection at Manzanita Lake in California's Lassen Volcanic National Park.

[Both photos: 85mm lens, Kodachrome 25]

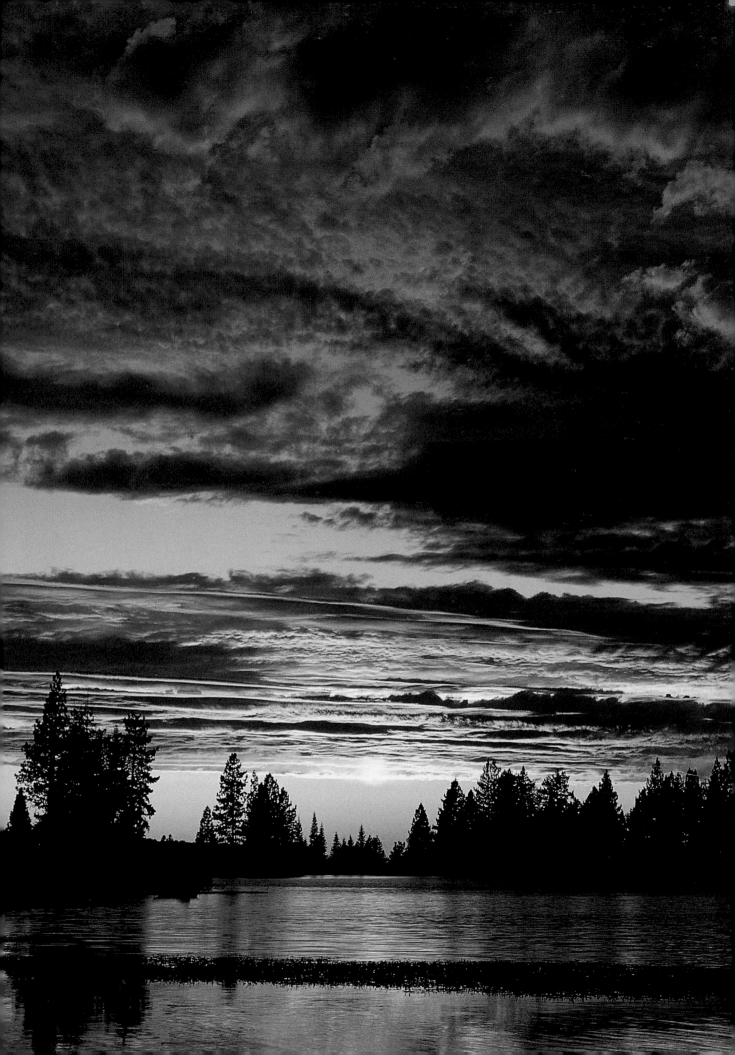

Once you arrive at your pre-dawn shooting site, plan to stumble around in dim light (don't forget a flashlight), expect things to be chilly (take your jacket), and if you haven't eaten already, anticipate getting hungry (pack a snack). If you're photographing the landscaped grounds of a resort area expect to hear the frightening (at least for photographers who have their gear spread out around them) spattering and sputtering of the automatic sprinkler system cranking up. The payoff for all this madness is an early-morning freshness and beautiful light that can lead to captivating photographs.

Sunset vs. Sunrise A sunset can be more vibrant than a sunrise, since daytime activities stir up particles and pollutants that add to the colors. With sunsets, the peak action usually occurs when the sun is right above the horizon or when it's about to vanish in a bank of low-lying clouds or fog. However, don't leave too soon after the sun dips below the horizon and the colors start to fade. Too many times to count, I've remained on the scene and captured a sudden burst of last-minute brilliance. This post-sunset glow is not predictable, however — a thick canopy of clouds out of your view could block the sunset's reflected colors. More times than I wish to recall, I've been disappointed as a darkening drabness enveloped a scene.

At the start of the day, the atmosphere can be crisp, clear, and calm, the latter offering possibilities for mirror-smooth lake or pool reflections. At daybreak, you'll find fewer tourists walking into your scene and less competition from other photographers vying for the best vantage points. (If safety is a concern in isolated spots, it's never a bad idea to check out things ahead of time and to travel with others.)

Don't get locked into always photographing just the sunset or sunrise itself, because exciting picture possibilities strike from every angle. With the sun at your back, you can focus on the long shadows and golden tones hitting your subject. No matter which way I'm facing, however, I always make it a point to look behind me from time to time. Sometimes things are going on in the opposite direction that are so special it makes me switch gears and scenes.

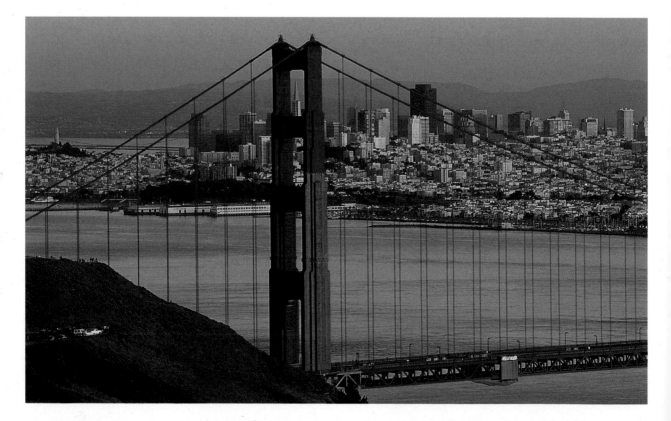

I've often driven the narrow and winding road through the Marin Headlands. There are many safe turnouts for parking and photography.

On weekends you won't be alone, but as with many popular areas, things start to thin out, peoplewise, just as the light starts to get beautiful. By employing different compositions and various lighting conditions, you'll find that the photographic interpretations are almost endless; here are three possibilities.

[180mm lens (above), 24mm lens (opposite, both photos), Fuji Velvia (all photos)]

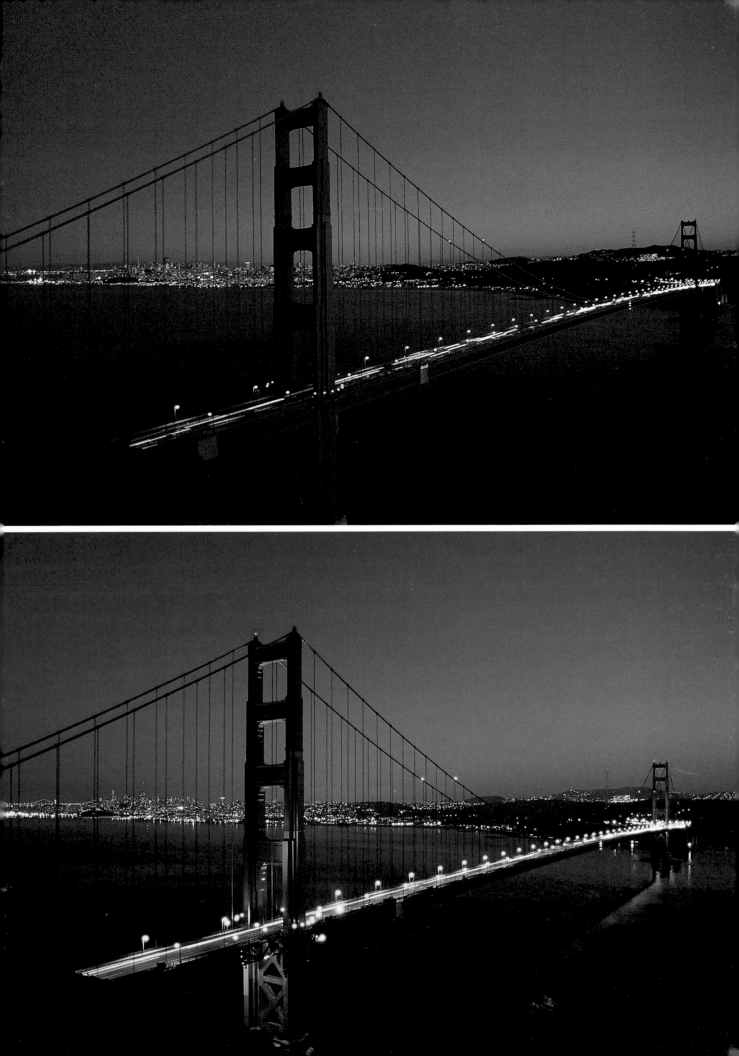

Twilight Sometimes called "the magic hour," twilight usually refers to the half hour or so before sunrise and the half hour after sunset. Twilight photography involves landscapes of soft light and pastel colors, and cityscapes of dramatic tones and multiple colors, with the sky a deep blue or purple. Even an overcast sky might take on a subtle, yet surreal, cast during twilight.

The possible subjects are endless. I've used twilight's bluish tint to create ethereal seascapes, and I've photographed a carnival ride with a long exposure and a mixture of natural and artificial light. On city streets, I've found that things often look better in the evening than in the daytime, because the dark areas obscure parked cars, unsightly trash containers, and blank pavement. I enjoy photographing moving traffic, which shows up as streaks because of the slow exposures involved in twilight photography. I've also put twilight's attributes to work photographing the Golden Gate bridge and San Francisco (see page 77). From high in the nearby hills of Marin County, the scene is spectacular at any time of day, but it's downright dazzling at dusk, when it's just dark enough for the city lights to shine brightly but before the sky turns black.

Neon and incandescent lights may show up nicely on everyday film, but fluorescent and mercury vapor lights, often found in street lamps and office buildings, can turn into a sickly green. If the greenish cast occupies just a small part of the picture frame, it probably won't detract from the more vibrant parts of your scene. Otherwise, to correct the colors you can use a *fluorescent filter*. This conversion filter will also alter other colors in the scene, which may or may not matter to you. Another option, with color prints, is to check with your photofinisher about correcting the color during the printing process.

Preparatory work diminishes the need for luck, though sometimes all your planning and preparations during a midday scouting trip can fail to prepare you for twilight photography conditions. As at many other times in photography, it pays to be flexible, just in case. For example, your camera may be mounted on a tripod, your scene framed, the light almost ready, but just as conditions rapidly edge toward perfection, a hot flash of light shines from the wrong building in the wrong place—right in the middle of your composition. Or you may have pre-selected an eye-catching monument that everyone says glows brightly in the evening, but you're there and—no lights. With the changing light and sky colors, this is no time to scurry about, hunting for a new scene. It's best to have a pre-selected, secondary composition in mind, just a few steps away and ready in a pinch.

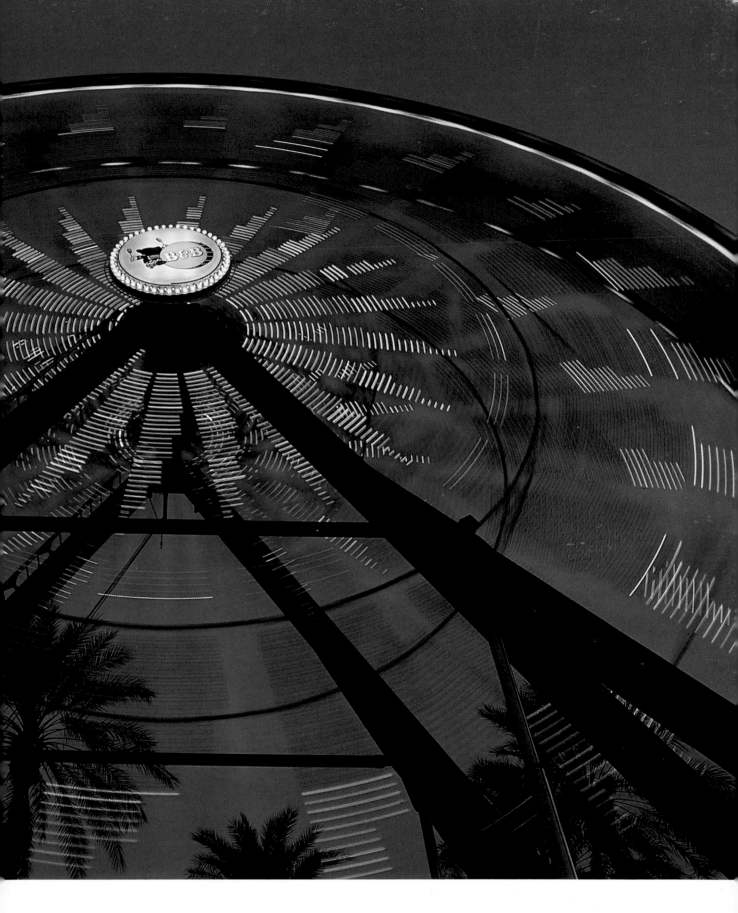

To create the kaleidoscopic effect of whirling red, orange, and green carnival-ride *lights set against a rich blue twilight sky, I used a tripod and a long exposure.* [24mm lens, Fuji Velvia]

80

Photographing this state capitol in the natural colors of dusk was my goal one evening. But the structure also has artificial lighting, which caused the greenish cast at the bottom of the building. I decided not to use a filter to correct the color, since it would also have affected the other colors in the scene. Another option for avoiding the green lights would have been to alter the composition: either tipping the camera up to crop out the green lights and include more of the dynamic sky, or zeroing in tight on the capitol's upper levels with a longer-length lens.

[180mm lens, Fuji Velvia]

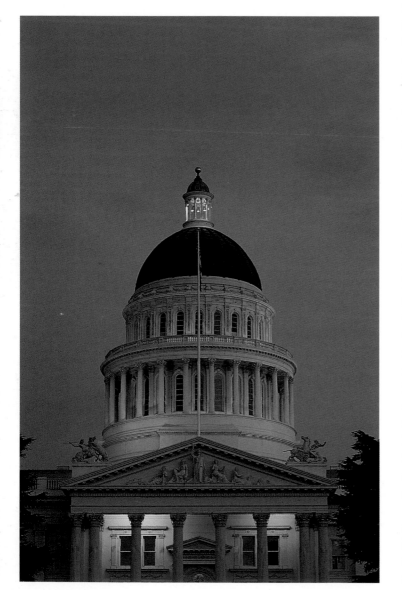

Low-Light Considerations

Frontlit sunup or sundown scenes don't have much contrast and are usually easy to expose. It's tricky backlighting that poses potential problems. One way to tackle it is to meter only the sky's middle tones, staying away from the scene's brightest and darkest areas. The result will be a vivid sky and silhouetted foreground, unless you use a graduated filter or fill flash to lighten things up front.

Not every backlit situation demands making a silhouetted image or using a filter or flash. You can brighten up twilight scenes with colorful reflections in water. Reflections help decrease the exposure extremes, perhaps enough to let you catch details in both the foreground and background. Be careful, however, since reflections are always a little darker than the background. An average (compromise) exposure, between the two areas, could work.

Many autoexposure cameras allow shutter speeds lasting many seconds, easily handling the longer exposures required for most twilight available-light applications. Otherwise, the "B" (Bulb) manual setting on your camera permits extra-long exposures. Exposures of a second or longer not only let you capture dark scenes but also let you blur moving lights to create effects such as the streaking of lights in traffic or on carnival rides.

Long exposures can cause underexposure and shifts in colors, what's known as *reciprocity failure.* Different films react differently, but they may require additional light to offset the reciprocity effect. According to manufacturer recommendations, most slide and print films can tolerate exposures down to 1 second, many to 10 seconds, without exposure adjustment or color-compensating filters. Reciprocity failure, however, applies more to slide film than to negative (print) film, because colors can be adjusted during the printing process. Since extended exposures could require extra light (1/3 to 1 stop, or more, depending on the film and length of exposure), I bracket on the side of overexposure. In twilight shooting, I never use a compensating filter; if the colors are slightly off, who's to know? And assuming you like the results, who cares?

Print film and digital applications are more forgiving of twilight-exposure errors than slide film. With slide film in particular, it's a good idea to take a few insurance shots; however, twilight boasts a fairly wide latitude, with several exposures yielding acceptable variations of a scene.

Low light might seem to call for super-fast film. But if you're using a tripod or camera support, go ahead and use your favorite slow-speed film so that you can take advantage of the film's superior color and image quality. Use a cable release to further ensure the sharpest pictures; and, if you have an SLR camera, consider using the mirror-lockup feature or the self-timer for added camera stability (see page 102).

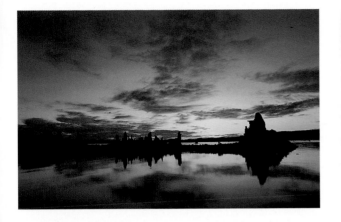
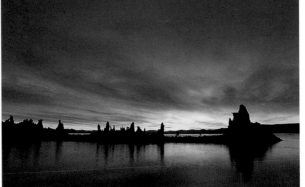

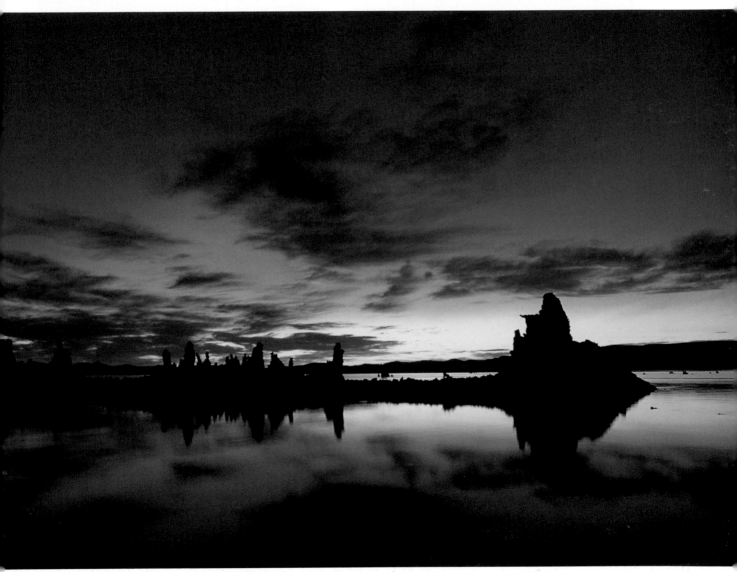

During several visits to Mono Lake in eastern California, I set up right along the shore of the lake. Although I knew how I would approach the scene,

I never could predict what I would get. But that's the nature of light.

[All photos: 24mm lens, Fuji Velvia]

Weather Considerations

Many photographers believe that good light requires good weather. As a result, they avoid photographing on overcast or stormy days, figuring they can't make decent images on days like these. However, you can get good pictures in less-than-ideal weather conditions.

If you're weatherwise, you can find picturesque prospects when cloud cover or a fog bank hangs like a giant white canopy over countrysides, seashores, or cityscapes. In fact, some subjects look their best in soft light. However, being weatherwise also means being ready for when the weather is wild. This doesn't obligate you to head out in a downpour or blizzard, but it does demand that you dash out right after the sunbeams burst through the clouds.

Weather in its different forms can evoke mood and introduce character into photography. It does, however, take getting used to the idea that weather that's a turn-off for tourists can be a turn-on for photographers. After viewing some of my "poor weather" photos, made in overcast conditions, many non-believers have proclaimed their conversion to off-season/off-weather photography. By focusing on the right subject and employing a few camera skills, the wrong weather can produce the right results.

Overcast Skies

I often rise in pre-dawn darkness, travel to a previously selected spot, and set up my gear, ready for spectacular colors to appear. Occasionally, I'm greeted with colorless dullness and clouds. But instead of complaining about getting up early for no reason, I simply switch gears and seek out those scenes that shine in the soft light of an overcast morning.

While midday's scorching sunlight can wipe out delicate shades and tone down vibrant colors, a white sky makes the entire color spectrum come alive — bold colors turn bolder and subtle hues become less subtle. The diffused light is just right for capturing intimate scenics and small details. Forest and city scenes, which can be splotched with dark and bright spots in sunlight, are particularly inviting when the sky turns white. In addition, cloudy conditions practically guarantee correct exposures, due to the even illumination they provide; there are no inky shadows or glaring highlights to fool a camera's metering system (assuming it's not registering the bright white sky).

The Weather's Edge

There's nothing like the photographic drama of the weather's edge — that period between "good" and "bad" weather. In these cases, the dark and imposing sky is often one to embrace, since scenes take on new dimensions with storm clouds. I once set out to photograph a white lighthouse in the early-morning light, but bright white overcast conditions prevailed. A white-against-white composition didn't excite me, but I noticed the clouds were starting to thicken, so I waited for the approaching storm to turn the sky a deep gray. When it did, sunlight slipped through, lighting up the lighthouse against a dramatically dark background (see page 41).

Working the weather's edge, you may wish to switch off autoexposure to achieve the exposure effects you want. You might want to capture a low-key scene that depicts things at the lower end of the neutral-tone scale — for example to record a gathering storm as ominous and imposing. In this case, the exposure you want is probably not the one the camera will choose. This is when a working knowledge of your camera is essential, since underexposing may force you to manipulate the compensation controls. In addition, be aware that cloudy conditions reduce the light in a scene. At midday, for example, the exposure difference between bright sunlight and heavy overcast situations can run 3 stops, perhaps requiring the use of a tripod or other camera support.

Dealing with a Blank Sky

The pure white sky trips up many cloudy-day photographers, since the viewer's eye is always attracted first to the brightest part of a picture. A blank sky will register as a stark white or a light gray, so if that highlighted area is very large, it will overwhelm everything else in your photograph.

There are, however, a few techniques you can try for dealing with an empty white sky. You can leave the sky out of the frame altogether by looking for compositions that don't include the horizon, or by switching to a longer lens or changing your shooting angle. Or, if you wish to include the sky, either disguise it behind trees or buildings, or crop things as closely as possible, leaving just a sliver of whiteness in the photo. In addition, a graduated neutral-density filter can lessen a scene's tonal range. However, if the sky is truly featureless, you'll still wind up with a blank sky, and you may need to go back to one of the other options.

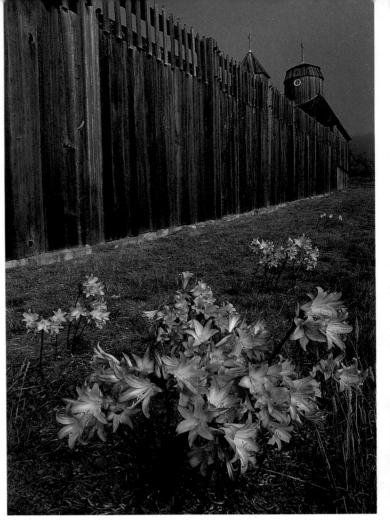

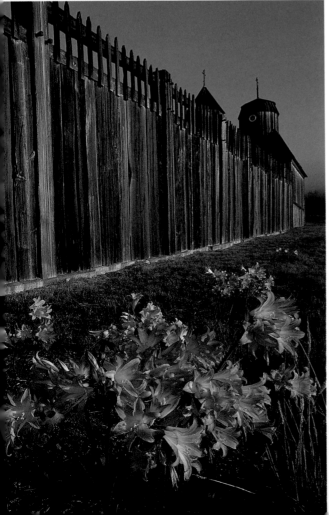

Being weatherwise means remaining flexible. I drove two hours in the early-morning darkness to this coastal historic park, planning to photograph the wooden walls of its old fort in the glowing light of sunrise. But when I arrived, fog shrouded the coast. I immediately pursued another type of scene: a grouping of brightly colored flowers as the foreground's main subject, with the fort serving merely as a backdrop. Using a wide-angle lens and taking advantage of the windless conditions, I framed a composition that combined both the foreground and background elements. Sure, the fort didn't bask in the early-morning warmth as I'd envisioned, but with the flower-filled foreground, it didn't have to. When the sun came out, I kept right on shooting and ended up with a nice choice of images.

[All photos: 24mm lens, Fuji Velvia]

Fog Fog occurs most often in the early morning and in the evening. In general, I prefer a uniform, but thin, fog, rather than the super-dense, pea-soup kind that can blot out everything that's not close at hand. When photographing trees, for instance, I'll focus on a clear and distinct tree, letting others fade mysteriously into the distance. Patchy fog can be interesting as well, since it often allows spots of blue sky and sunlight to break through.

Once you locate a foggy scene, you must work fast before the conditions you see disappear; fog's direction and density can change quickly. As in other overcast conditions, colors can pop out in the mist. However, foggy images can also reveal an atmospheric interplay of light and shapes. Although it's recorded on color film, this type of evocative, monochromatic view is essentially black and white with silhouetted forms.

Another trait of fog is its ability to blot out unsightly elements in the distance. In a park near my home, I often enjoy photographing oak trees. When things are clear, background buildings, parking lots, and ballparks are difficult to hide, even when I vary my camera angle; on fog-filled mornings, however, those unsightly elements evaporate from sight.

84

An overcast day is the perfect time to fill frames with smaller subjects, such as this close-up of interest-ing seaside rock-and-pebble formations.

[55mm lens, Fuji Velvia]

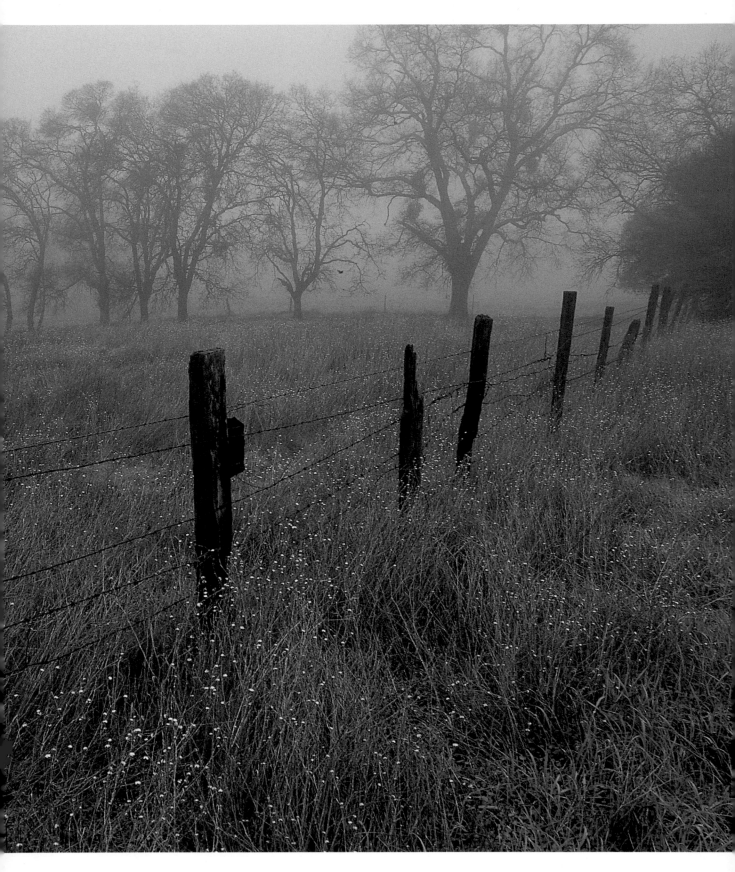

Shoot a rural landscape on a foggy day and you'll likely come up with an image like this — one that evokes a sense of tranquility. I also used the fence as a strong diagonal line across the frame to lead the eye into the composition.

[24mm lens, Fuji Velvia]

Snow　　　The beauty of the out-of-doors is never out of season, particularly in winter, when it's possible to make many majestic images: a white wonderland of glistening vistas, frosty trees, and simple shapes. However, when the sun reflects off the snow, the brilliant light wreaks havoc on a camera's metering system, because the meter reads a snow scene as very bright and underexposes it to compensate. In spite of this problem, though, there are ways to prevent your camera from going snow-blind.

　　　Snow's whiteness (and fog's brightness, too) can throw exposures off; it can lead to gray snow, since the camera's built-in exposure meter is calibrated to read neutral tones. One solution is to add light by overexposing by 1 to 2 stops. My usual remedy is to switch to manual or spot-mode metering, meter a middle-tone (a jacket, for example) in the same light as the prime subject, and then shoot with those settings.

　　　It's impossible to come up with hard-and-fast guidelines for snowscape exposures, since different scenes reflect different amounts of light. In a pinch, if you can't determine the correct exposure compensation or if you can't find a middle tone off which to take a reading, film manufacturers advise the following: For both ISO 50 slide film and certain ISO 100 negative films, try 1/125 sec. at $f/16$; for ISO 100 slide film and some ISO 100 negative films, 1/125 sec. at $f/22$. These settings, though, come with the following stipulations: that you're shooting in bright sunlight in snow (or at the seashore), that your scene is frontlit, and that you're shooting in the time from two hours after sunup to two hours before sundown. In these conditions, these settings should work fine for print film. For slide film, you may wish to use these settings as middle ground for bracketing with insurance exposures both above and below the indicated settings.

Being Prepared　　　Winter photo sessions don't have to be short ones, if you are wearing the proper clothing, are using the correct camera-care techniques, and are armed with the latest weather forecast. Still, photographing in January can chill you all the way

It's tough enough to get a proper exposure in the snow, but just try adding fog to the mix. One way to handle a situation like this is to take an alternate reading on a middle-tone object. For this scene, I took an overall reading and added about 1 1/2 stops of exposure to compensate for the brightness. I then bracketed my exposures, just in case.

[75–150mm zoom lens, Kodachrome 64]

This winter wilderness image (opposite) demonstrates an advantage to using a telephoto lens: You can make it seem like you're out battling the elements while recording clearing storms like this one.

In reality, I was sitting on my truck's tailgate, all bundled up, a cup of hot cocoa beside me, and my camera mounted on a tripod.

[180mm lens, Kodachrome 64]

down to your shutter finger. For cold-temperature protection, I wear thin gloves that let me operate my camera's controls. Between shots, I slip heavier gloves or mittens over these liners. For more warmth while photographing, I may even wear wool fingerless gloves over the lightweight pair.

In a downpour or snowstorm, look for doorways, overhangs, or awnings. When you're out in a drizzle or light snow (or blowing sand or ocean spray, for that matter), you'll need help protecting your gear from the elements, assuming you're not using an all-weather camera. One trick is to form a shelter with your body (for taking pictures, changing film, or switching lenses) by hunching over and keeping your back to the breeze. However, while rain generally falls from one direction, snowflakes can swirl at 360 degrees, making an open camera fair game. If you plan to shoot a lot during difficult or extreme weather conditions, perform this drill at home: Practice changing lenses quickly, and with an outdated or ruined roll of film, rehearse a series of reloadings. Once you're able to

do this swiftly, you'll be ready for those times when you're in the field and under the gun.

Some protective camera accessories to consider are filters (UV, skylight, or warming), lens hoods or shades (to deflect errant water drops), absorbent cloth, and optical cloth or lens paper. A camera covering—either a commercially made plastic shroud or a "raincoat" that you fashion yourself from a plastic bag—works surprisingly well in mist and spray, but keep it off the lens front.

Also, avoid condensation. Don't breathe on your camera (it can fog your lens and viewfinder), and don't expose your gear to sudden temperature changes (in extreme cases, it can create condensation inside the camera). When heading indoors from the cold, for example, I keep my camera, lenses, and film zipped up tight in my photo bag. I then stuff it inside a big plastic bag and place it as far away as possible from the hottest spot in the room. I let all my gear adjust gradually to the inside air before doing any cleaning or organizing.

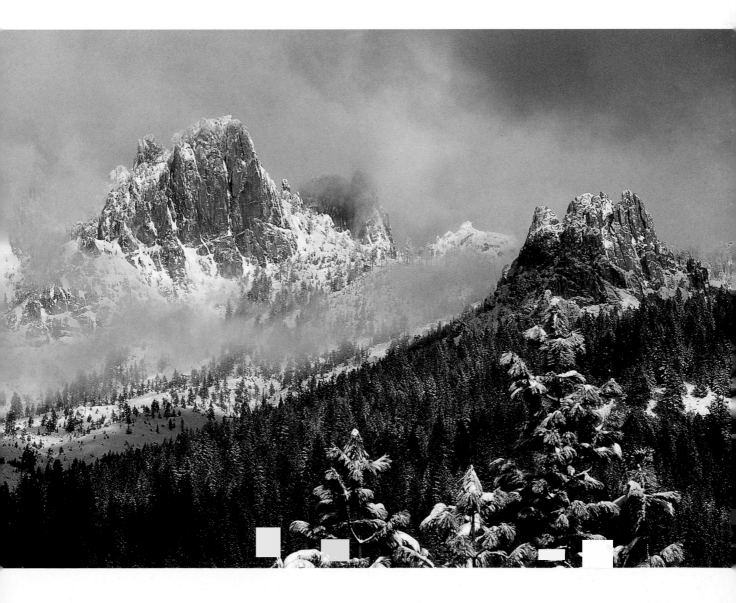

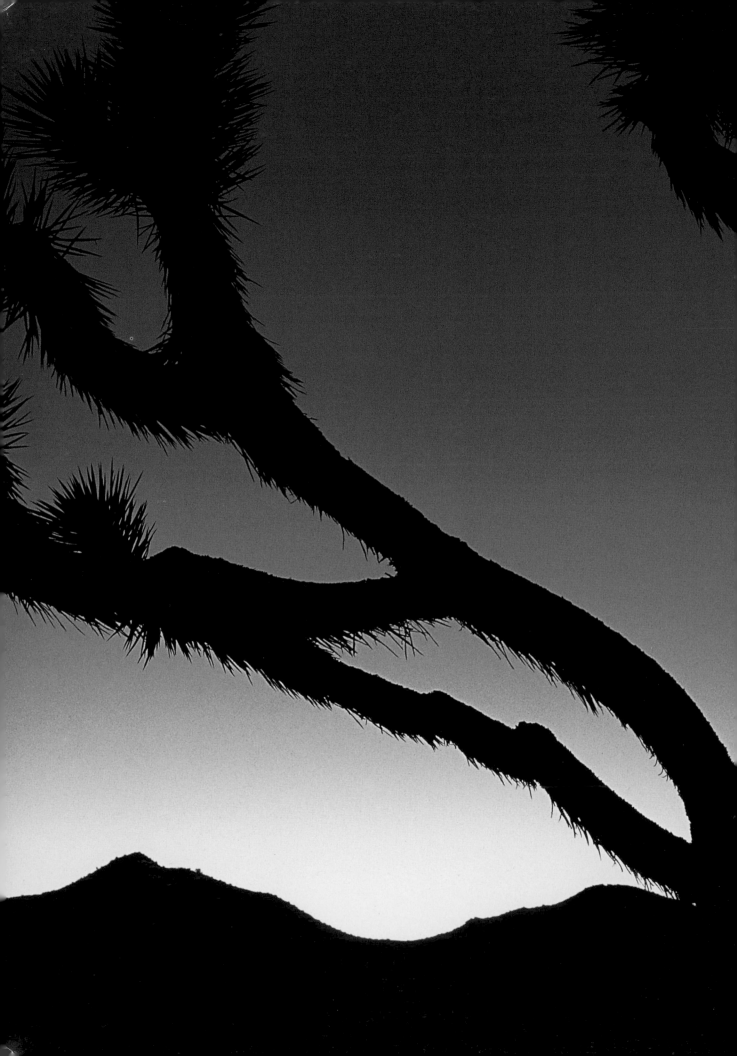

3 | **Composition**

Lenses

90

Tote around a camera bag full of lenses and people will assume you're a "serious" photographer. Break out a tripod and you must be a professional, too. However, it's the size of your artistic vision that counts, not the size of your lens arsenal.

Don't fall into the "lens-envy" trap, when you think you need an endless supply of lenses in all different lengths. I made most of the photos in this book with just four 35mm-format lenses: a wide-angle 24mm, a normal (50mm or 55mm) lens, a short telephoto (85mm), and a medium telephoto (180mm). For scenic photography, I've found that this range, which can also be covered with all-encompassing zoom lenses, enables me to produce a variety of compelling images. In any case, lens selection is an important factor that affects the design and composition of your photographs. This section explains lens terminology, explores your lens options, and discusses how to exploit the attributes of various lenses.

Focal Length Measured in millimeters, the *focal-length number* refers to the lens' magnifying power and to how much of the scene is included in the frame. With 35mm cameras, normal lenses (which approximate the human eye's angle of view) are around 50mm.

Shorter focal lengths (wide-angle lenses) have smaller numbers, make the subject smaller, and provide a broader field of vision. Longer focal lengths (telephoto lenses) have larger numbers, make the subject bigger, and narrow the field of vision. Zoom lenses offer a range of focal lengths in one handy package; for example: a wide-to-telephoto 35–70mm or 28–200mm lens; a wide-to-normal 24–50mm lens; an all-telephoto 80–200mm or 70–300mm lens; and an all-wide 20–35mm lens.

These 35mm-format numbers, incidentally, don't match up with the focal-length numbers of other camera systems. For example, a standard APS camera lens runs around 40mm, while a medium-format normal lens is about 80mm. Regardless of the camera format, though, the visual principles of normal, wide, and telephoto lenses remain the same. Likewise, photos made with both a single focal-length lens and a zoom lens that's set at that same focal length will look the same.

If you have just one lens, whether it be normal, wide-angle, or telephoto, put it to use and learn all of its capabilities. Keep in mind that there are many other design decisions you can make, plus lighting options you can use, that will put variety into your work. (Still, as you progress in your scenic photography, you'll likely want to expand your lens collection.)

This bay filled with boats made for a colorful composition one evening. I couldn't decide on the best approach: Vertical or horizontal? Normal or telephoto focal length? However, this uncertainty actually led to the best approach — to record the scene in a variety of ways for a variety of images.

[85mm lens (right), 55mm lens (opposite), Fuji Velvia (both photos)]

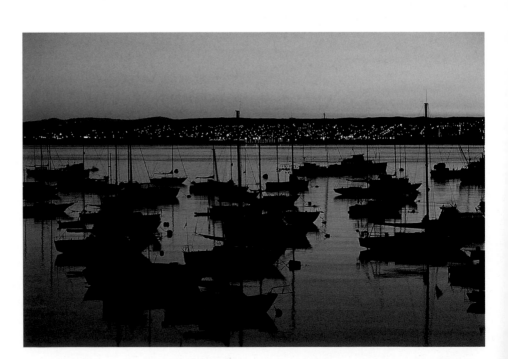

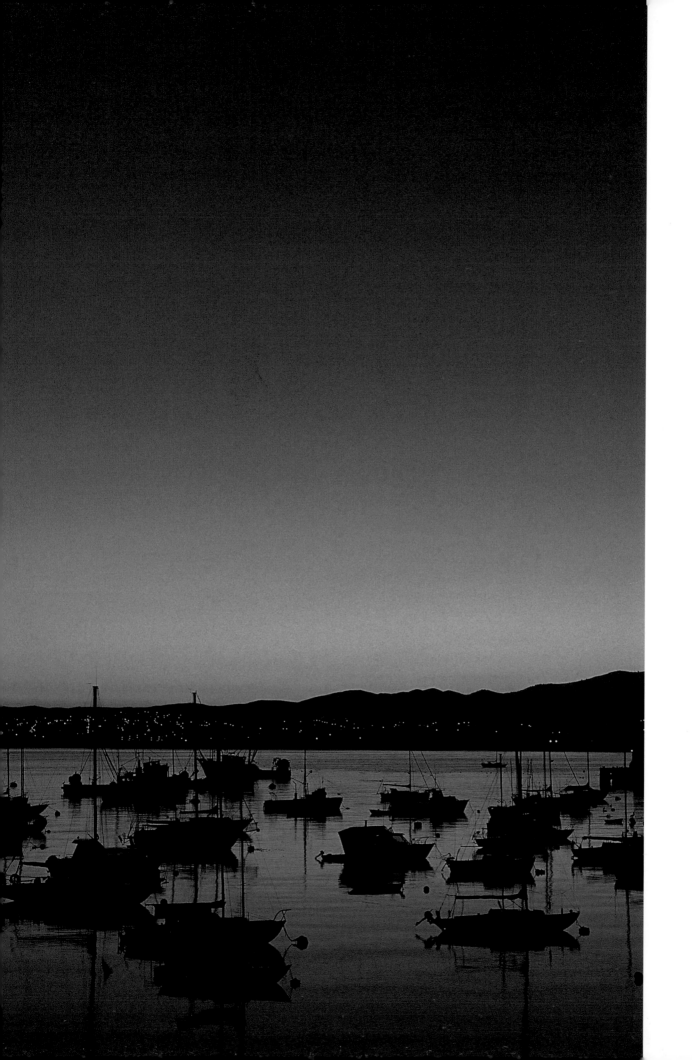

Aperture Designation Aperture designation pertains to a lens' widest *f*-stop and speed. Fast lenses have big apertures (indicated by small numbers) and allow the use of faster shutter speeds in low-level *available* light (that means no flash or strobes). Thus, an *f*/1.4 lens is considered faster than an *f*/2.8 lens. (Zoom lenses generally have variable maximum *f*-stops.) The trade-off here is that faster lenses are heavier, bulkier, and costlier than slower lenses. Lens speed, though, is far more relevant in sports, wildlife, and candid photography than it is in scenic work, which usually involves static subjects.

Normal Views Different focal lengths offer different looks at the world. Normal views, attained with the focal-length range of 45mm to 55mm (in 35mm format) and 35mm to 45mm (in APS format), have been bashed as boring and too straightforward. It's true that a normal focal-length lens doesn't have the unique perspective of other lenses; it doesn't spread things out like a wide-angle lens or pull things in like a telephoto. Photographers who shoot with wide-to-telephoto zoom lenses generally either zoom out to one end of the spectrum or zoom in to the other, rarely stopping in between to take a "normal" look at things.

A frontal, overall view with a normal lens can provide a very "normal" look, as I accomplished one day at California's capitol (right). But returning at another time, I found another photograph (below) with the same lens. Whether you use a fixed lens or a zoom that incorporates a standard focal length, the normal focal length may not seem as sexy as the more popular telephoto and wide-angle focal lengths; however, it all comes down to where and how you aim it, not what length lens you use.

[Both photos: 50mm lens, Fuji Velvia]

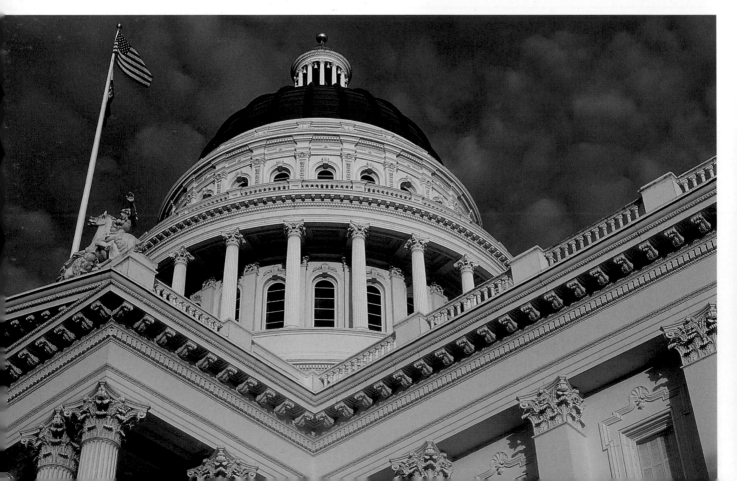

However, a normal lens always occupies a slot in my camera bag. Sure, I use wide and telephoto lenses more often, but eye-catching scenes that demand normal focal lengths are out there, and when I come across one, no other lens will do. In addition, my 55mm lens doubles as a normal lens and as a macro (close-up) photography lens.

Wide Views The wide-angle is my favorite focal length. In 35mm format, the most popular wide-angle focal lengths run from about 20mm to 35mm. Below 20mm involves extreme perspectives (ultra-wide

and fish-eye views), which you may wish to use in special situations.

There's one side effect that's especially prevalent with wide-angle lenses: converging lines. Point your camera upward or downward and buildings will appear to tilt, while parallel lines will seem to meet at a distant vanishing point. This is known as *distortion*, but it's a natural phenomenon that we often overlook; if you gaze straight up at tall trees or buildings (without a camera), you'll see that they really do appear to converge. If you stand beside railroad tracks, you'll see them "meet" in the distance.

Many developing photographers find the wide-angle lens difficult to use at first. However, once you get used to its unique properties, it can become a favorite scenic photography lens. Moving in close and pointing the camera up is a way to take advantage of the "distortion" sometimes caused by this lens. In the case of this 134-foot thermometer in the California desert, I placed the center of interest (the subject) in the center of the composition, to keep it straight, and let the flag poles tilt inward.

[24mm lens, Fuji Velvia]

94

There are two ways to take control of converging lines: either prevent the distortion or embrace it. To prevent it and straighten up the lines in your photograph, hold your camera straight and level; if possible, back away from the subject and switch to a longer lens. Architectural and commercial photographers often use a specialized perspective-control lens or a view camera to correct perspective distortion.

Sometimes a slight tilting can make a scene look clumsy. To embrace distortion, travel and outdoor photographers can venture beyond the straightforward world into the interpretive realm, in which scenes can be approached from more unique angles. If done right, distortion can not only be acceptable but even desirable. Instead of minimizing distortion, I occasionally exaggerate it using bending lines to convey a sense of movement or to emphasize distance, depth, or height. For example, I'll move in close to a skyscraper, tilt the camera up dramatically, and let things soar.

Telephoto Views A telephoto or tele-zoom lens pulls in faraway subjects and makes your composition cleaner by cropping out all of the extra stuff in a scene, such as a blank foreground or a boring sky. You can, of course, also achieve these same results by physically approaching your subject. However, sometimes you can't, or don't want to, get closer. And at other times, you may want to take advantage of the telephoto's unique view. Long lenses can compress space by making things appear closer together than they really are; use this effect to "stack" a row of cottages or sailboats, or to make mountains loom over horses or trees. A telephoto lens can also isolate small parts of big scenes, such as rock formations in the desert, window reflections in a tall building, or fall foliage on a mountainside.

The longer the focal length, the more the telephoto's magnification and perspective qualities are intensified. My favorite telephoto focal lengths

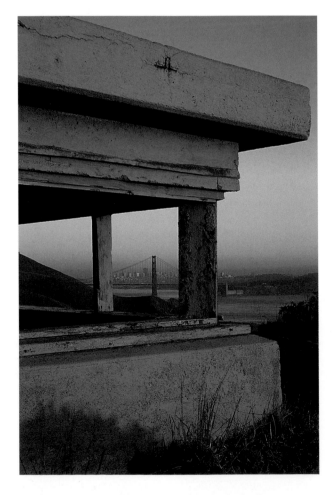

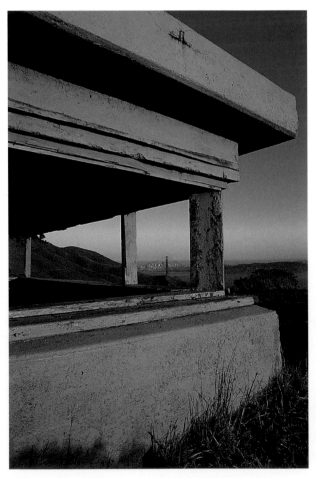

Although shot on different days, this pair of photos illustrates how you can take advantage of the lens-and-subject relationship to *alter the look of a scene. While I kept this deserted coastal defense bunker roughly the same size in both images (by changing* *camera position), the front-to-back view took on a new look when I switched from a normal to a wide-angle lens.* [55mm lens (left), 24mm lens (right), Fuji Velvia (both photos)]

(in 35mm format) for scenics range from short (around 85mm) through medium (around 180mm). I find the short telephotos valuable for cityscape and landscape portraits; you can capture broad areas of distant scenes, or zero in on intimate details of closer subjects. Some landscape and travel photographers, though, do wonderful work with lenses of 300mm or longer. Super-telephotos can produce interesting effects, but they're large, expensive, and hard to handle, almost always requiring a tripod that is equally big, costly, and cumbersome.

An accessory to consider is the teleconverter (or tele-extender), which is an optical device that fits between your lens and your camera to increase your focal length. Teleconverters usually come in two types, 1.4X and 2X; a 1.4X teleconverter would convert a 300mm lens into a 420mm one, while a 2X teleconverter would convert a 300mm lens into a 600mm one. They are lightweight, compact, versatile, and

economical (in the sense that they cost less to buy than several lenses). However, there are some drawbacks; even the best teleconverters show some loss in image quality (contrast and sharpness) and some reduction in light reaching the film (up to 2 stops or so). Plus, they can be restricting when used with a variable-aperture zoom lens. Because of those limitations, I never use them, but they can be a viable option. In many applications, the light loss doesn't matter; other times, the quality loss doesn't show up in small-size photographs. A number of professionals and serious amateurs use them, although they choose quality teleconverters to optically match their quality lenses.

Lack of image clarity, incidentally, is a frequent complaint of telephoto and zoom lens users. Long lenses magnify any blurring from camera shake. To avoid this, use a faster shutter speed, hold your camera steadier, or best yet, break out that tripod. Telephoto lenses also emphasize the effects from atmospheric haze. To minimize this, try a UV or polarizing filter, switch to a shorter lens, move closer to your subject, or return when atmospheric conditions are better. Lastly, some telephoto or tele-zoom lenses simply aren't as sharp as others. Check product reviews, ask other photographers, and in general, expect to pay more for better quality.

If you're in the market for a new lens, note that lenses made by camera manufacturers are rarely bad choices. However, optics made by independent manufacturers are generally less expensive, and many of them are almost as good, or as good, as the camera manufacturers' versions. In addition, to improve my photographic results, I outfit every lens I use with its own lens shade or hood to help prevent lens flare caused by the sun's rays hitting the lens front. I prefer the hard (not rubber) versions to help protect the lens' front glass. Be sure the shade fits the lens, since the wrong size may cut off the edges of the photograph. Some lenses, by the way, come with built-in, retractable hoods.

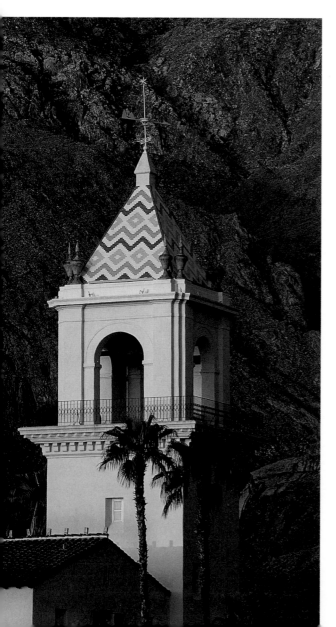

After a few mornings of photographing desert landscapes, I decided to see what I could do with this landmark tower in a resort area of Palm Springs, California. The bottom of the building was still in shade, but the low-level sun created a pleasing light. A telephoto lens enabled me to get Mount San Jacinto looming large in the background, while eliminating any distracting surroundings.

[180mm lens, Fuji Velvia]

The wildflower-strewn hillside in this scene caught my eye one day. But when I decided to include part of the historic park in the foreground, I ran into a problem: a very white, very unattractive overcast sky. A telephoto lens, however, allowed me to zero in on the features that I wanted and to leave out everything else.

[85mm lens, Fuji Velvia]

Zoom vs. Fixed Lenses

One zoom lens does the work of several fixed lenses. By zooming in or out, you can accomplish precise cropping or framing, and you can easily capture the scene within a scene—without having to change lenses or change your position. By exploring your subject with a zoom lens, you can capture a number of different shots in a short time span. But note that you don't always have to be zoomed all the way in or all the way out; there are countless intermediate positions, one of which may be just right for your particular view. At times, you may wish to "zoom bracket," shooting several different compositions of the same scene.

But, are zooms as sharp as single focal-length lenses? In the not-so-distant past, fixed lenses far outperformed zooms in optical quality. But advanced zoom technology means that the best of the new zooms are now almost as sharp—or, for most practical purposes, well within the acceptable sharpness levels—as single focal lengths. Many professionals, in fact, now use zooms due to their convenience and precise framing capabilities. (Still, sharpness can vary from brand to brand, model to model.)

There are, of course, trade-offs when you use a zoom lens rather than a fixed one. Zooms, particularly tele zooms, tend to be slower than fixed lenses in the same range, thus requiring the use of longer shutter speeds. But the fastest glass usually is of little concern in scenic applications, when most subjects stay put, and using a tripod is frequently an option. In general, zooms also have traditionally been bigger and heavier than fixed lenses, making them harder to hand-hold when using slower shutter speeds. And, highly reflective and backlit scenes can cause flare problems, due to the zoom's extra lens elements.

Although comparable fixed lenses in the same price range may slightly surpass a zoom in terms of optical quality, this isn't always a problem. Zoom images are more than adequate for many personal and professional uses, and while I only rarely use a zoom, its adaptability and compositional virtues have won over some of the most passionate photographers.

In any case, a zoom is certainly no substitute for walking and exploring. For controlling composition, your best lens is often your feet. And if you have only one lens and it has a fixed focal length, physically moving is your only alternative for fine-tuning your composition. Of course, if you have a zoom, and you're in the right spot and your composition needs some tweaking, then go ahead and fine-tune your shot as only a zoom can.

Exercise

GETTING TO KNOW YOUR LENS

Doing self-assignments is an educational and enjoyable way to become familiar with a new lens, or with one you already own but have rarely used. These exercises helped me learn firsthand what certain lenses would— and wouldn't—do.

Start by picking a scene. Plan to shoot at least one entire roll with your widest focal length. As you work, frame both vertical and horizontal compositions, experiment with various shooting angles, and focus on different parts of the scene. Examine your photos later, and then go out and do it all over again, striving to find even more creative ways to frame the scene. Next, repeat the process with your longest focal length and, finally, with a normal focal length.

From time to time, I fall into optical ruts in which I tend to use a certain focal length for one type of scene, and another focal length for another type of scene. When this happens, I force myself to be creative in my self-assignments—to use my lenses in ways I've never considered and to explore fresh procedures for working with familiar lenses. For example, I'll head out with just a telephoto lens, in search of "wide-angle" scenes. Or, I'll hunt for "tele-subjects" with my wide-angle lens. In these practice sessions, I discover that limiting my optics helps open up my vision.

98

Sharpness

Why aren't my pictures as sharp as yours? This is a frequent question asked of experienced photographers. While lenses and films play a part, sharpness problems usually have more to do with technique. When designing a photograph, one of my first considerations is this: How much of the scene do I want in focus? This is important because focus can greatly affect the look of a composition. Much of the time, I want overall sharpness, in both foreground and background. Once in a while, though, I prefer a limited area of sharpness, with a well-focused foreground subject and an unobtrusive, soft, blurred background.

For many people, sharpness is a mystery. They mindlessly zero in on their subject and never consider that some objects in front of, and behind, that point will also be in focus. No matter how wonderful the light or your subject, if the focus is off your picture will be off, too. However, you can take charge of this sharpness zone; in fact, controlling what's known as depth of field should become one of the key creative strategies in your photography.

After the clouds rolled in one day on the coast, I set out in search of small scenes and big colors (far left). I found both at this old farmstead, now part of a state park. Since it wasn't windy, I chose a composition that enabled the foreground to stretch into the distance. It took a wide-angle lens and a small f-stop (f/22) to create a deep zone of sharpness, or depth of field. The lack of wind helped, too, since I was shooting at a very slow speed (1/4 sec.) on a tripod.

[24mm lens, Fuji Velvia]

On a spring morning in southern California, I photographed the wildflowers of the Antelope Valley (near left). Stretching out at trail's edge and zeroing in on nearby poppies, I set my macro (close-up) lens at its widest opening (f/2.8) to create a narrow depth of field and focused close-up and very personal (some flowers almost touched the lens).

[55mm macro lens, Kodachrome 25]

For a scene like the one below, with all the elements in the frame at infinity, that's where you focus and that's what will be sharp. I used a telephoto lens to isolate these peaks at daybreak.

[180mm lens, Fuji Velvia]

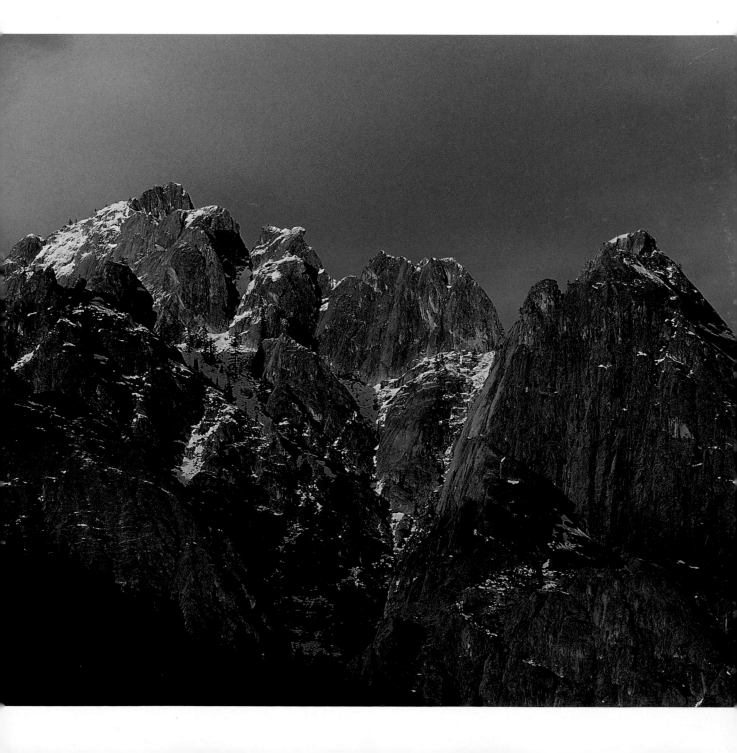

Depth of Field

Depth of field is the area of acceptably sharp focus both in front of and behind your subject or point of focus. About one-third of the depth of field falls in front of the point on which your lens is focused, while two-thirds fall in back. In other words, there's twice as much sharpness behind your subject as there is in front of it. You can adjust the width of that zone by adjusting the *f*-stop (aperture). The larger the aperture, the shallower the depth of field (area of sharpness). The smaller the aperture, the greater the depth of field; in other words, more of the scene's background and foreground will be sharp, as well as your subject.

For example, with a given lens and focusing point, a setting of *f*/16 or *f*/22 will yield far more depth of field than *f*/2.8 or *f*/4. In general, longer lenses (telephotos) produce less depth of field than shorter lenses (wide-angles). Switch from an 85mm lens to a 24mm, for instance, and your sharpness zone will increase, assuming that your subject, shooting position, and *f*-stop remain constant.

Shooting distance—the amount of space between camera and subject—also affects depth of field. Regardless of the lens, greater shooting distances increase depth of field, while focusing on points closer to the camera narrows the sharpness range.

What can trip you up with depth of field and a view-through-the-lens SLR camera is that what you see isn't always what you get. Except during the actual act of making a picture, the lens' aperture stays wide open in order to provide a bright viewfinding screen. That means you're analyzing the scene at an *f*-stop that shows the *least* amount of depth of field for that particular lens, even though your lens opening may be set at a much smaller aperture. That's why the resulting photo often appears vastly different from what you saw, and why you need to know in advance whether key elements will fall within the zone of sharpness. The idea is to determine what parts of the scene, from near to far, you want to outline in distinct detail, and then come up with the appropriate *f*-stop and focusing point.

Determining Depth of Field The camera's *depth-of-field preview* feature shows how much of the scene will look sharp in the photo. In most cases, activating the preview mode stops down the lens to the shooting aperture, so expect the viewfinder to get darker, since the *f*-stops are progressively smaller. (The darkening won't affect your final exposure.) If possible, instead of switching instantly from, say, *f*/2 to *f*/16, slowly stop down the lens until you get the result you want. This

lets you see what's happening with the sharpness while also helping your eye adjust to the changing light levels.

Also, if your camera is mounted on a tripod, try cupping your hands around your shooting eye to shield the viewfinder and keep out extraneous light. With practice, you'll learn to quickly "read" the darkened screen, and using the preview feature will become almost second nature. In fact, I use it as part of my previsualization process for almost every shot I make.

The *depth-of-field scale,* which incorporates the principle of hyperfocal distance (the focusing point that provides the greatest range of sharpness at a given *f*-stop), appears on the focusing mount of many lenses. To use the depth scale, first determine the camera-to-subject distances for the nearest and farthest points that you want to be sharp in your composition. Then, by consulting the scale, choose the aperture and focusing settings that keep everything within the desired depth of field. For instance, to get everything sharp from about 7 1/2 feet to infinity with my 55mm lens, I must lock in the focus at 15 feet and set the aperture at *f*/22.

To decrease the possibility of camera or subject movement causing image fuzziness, it's generally best not to stop down the lens any more than is necessary. If *f*/11 accomplishes the desired depth of field, there's no sense using *f*/16, which requires a slower shutter speed. Of course, if you want to convey a sense of movement within the frame—for example, when photographing flowing water or wind-blown grasses—set the smallest possible aperture, which permits both a wide depth of field and a blurred-motion effect.

Some high-tech cameras incorporate other features, such as depth-of-field autoexposure programs, in which the camera sets the focusing point and *f*-stop. Unfortunately, many modern cameras and lenses lack absolutely any depth-of-field features. In those cases, you may wish to consult the table that came with your lens or buy a hyperfocal chart that shows the range of sharpness for any given focal length, lens aperture, and subject distance.

If you don't have any depth-of-field preview modes, scales, programs, or charts, and you still want deep sharpness, try photographing with a wide-angle lens; set the *f*-stop at the smallest possible aperture, don't get too close to your nearest subject, and if possible, focus a little ways into the scene. If possible, make a few insurance shots by experimenting with your position and the focusing point.

Non-adjustable cameras have moderate depth of field, too. Although a fixed-focus point-and-shoot, for example, is calibrated for average snapshot distances, it may accommodate reasonable sharpness from around four feet to infinity. The owner's manual provides the particulars.

These photographs demonstrate depth of field—the front-to-back sharpness zone determined mostly by the lens opening and the focusing point. In the two photos opposite, I used a wide aperture (about f/4) when I focused first on the front chair and then the rear chair. In the photo at left, however, I focused on the hyperfocal distance— the point between the closest and farthest spots that I wanted rendered in crisp detail; I determined the focusing point and the aperture (f/16) by referring to the depth-of-field scale on my lens barrel.

[All photos: 85mm lens, Fuji Velvia]

102

Dealing with Depth of Field The depth-of-field discussion in scenic photography usually concerns maximizing the sharpness zone, since landscapes often demand a well-defined foreground and background. But *selective focus,* in which some things are intentionally thrown out of focus, is another creative option. A shallow depth of field directs the viewer's eye to a single subject that is in sharp focus, since the foreground details are softened and background colors are blended. The large aperture, of course, must be balanced by a faster shutter speed, which can be useful when photographing delicate vegetation.

I've used selective focus to isolate a variety of subjects, while eliminating distracting background or foreground clutter. In the poppy photograph on page 98, for instance, I focused on a single flower, while leaving an indistinct splash of colors in front and in back. Incidentally, in extreme close-ups with specialized lenses or accessories, the range of sharp focus is so narrow that it's measured not in inches, but in centimeters, even with the lens stopped down. Thus, a tiny change in camera position makes a huge difference in composition.

Sometimes depth of field isn't a concern — for instance, when shooting a wall mural, a flat pattern of fallen leaves on the ground, or distant mountains in which everything is focused at infinity. In these cases, the sharpness zone pretty much starts and ends at the same point. But while the *f*-stop may not matter in terms of depth of field, it may matter for another reason: The sharpest apertures at the point of focus are said to lie at the middle range; therefore, you might consider using an aperture of, say, *f*/8 whenever possible.

Despite your goal of deep depth of field, sometimes you simply can't keep everything sharp, even after stopping down the lens and shifting your point of focus. Other times, although apertures of *f*/16 or *f*/22 may do the trick as far as depth of field is concerned, the resulting shutter speed is too slow to handle subject movement. At this point, you may have to compromise. Either accept some blurring, or forfeit some depth of field. If you must sacrifice sharpness, though, try letting far-off objects go soft, since close blurry objects can be bothersome; and in reality, distant subjects often look fuzzy anyway. When there's no satisfactory solution, change your subject or composition, or pack up and move on.

Avoiding Camera Shake None of this depth-of-field talk matters if you don't hold the camera steady during exposure. Exploring the zone of sharp focus often means using long exposures. With lower light levels and slower films, this means shooting at 1/15 sec. or longer.

A lot of blurry photos are made by hand-holding a camera when shooting at slow shutter speeds. Telephoto lenses and close-up shots in particular are susceptible, since they magnify any blur from camera shake.

To avoid this, some lenses come with a built-in image stabilization system that allows shake-free shooting at somewhat slower speeds. Otherwise, use an often-cited "rule" for hand-holding: Set the shutter speed equal to, or faster than, the reciprocal of the lens' focal length. Translated into 35mm photography terms, that means at least 1/30 sec. for wide-angle lenses in the 20mm to 28mm range, 1/60 sec. for 45mm to 55mm lenses, 1/125 sec. for 70mm to 105mm lenses, 1/250 sec. for 135mm to 200mm lenses, and 1/500 sec. for 300mm to 500mm lenses. With a zoom lens, the focal length may change but the lens size doesn't, so figure the focal length at its maximum extension, even though you may actually be shooting at a shorter focal length. For a 35–105mm zoom, use 1/125 sec.; for 70–210mm, use 1/250 sec.; and for 24–50mm, use 1/60 sec.

That formula is no guarantee, though. Large zoom and telephoto lenses may require faster speeds to prevent camera movement, and even at supposedly "safe" exposures, some photographers have trouble maintaining a steady hand. When there's no tripod available try steadying yourself by leaning against a wall or tree, or lessen wobbliness by pulling your elbows in toward your body and pressing the camera against your face. And, widen your legs into a comfortable and stable stance. Also consider kneeling down with one leg and using the upright knee as an elbow support. Or, sit down on the ground and brace your elbows on your knees. You could also lie prone and prop your elbows on the ground. In addition, try cradling your camera on a beanbag or a rolled-up jacket atop a railing, fence post, car door, or boulder.

Of course, even with a tripod, it's still possible to jiggle the camera inadvertently during the act of tripping the shutter. To lessen this, I use the tripod's companion accessory — the cable release — which attaches to the camera shutter button and lets you keep your hands off the camera while making the exposure. I consider the cable release an essential accessory and always carry a spare.

Some SLR cameras have a lock-up mode that reduces the possibility of vibration (and a resultant loss of sharpness) when the mirror flips up during slower exposures. If your camera lacks this feature, you can also use the self-timer, since most timers automatically lock up the mirror as soon as they're activated. Use of the timer assumes that your subject doesn't require a decisive moment at which to trip the shutter.

When I first ran across these two garden sculptures, they were almost lost amid glaring highlights and deep shadows caused by bright overhead sunlight. On this overcast day, however, the soft light, dark background, and fairly narrow depth of field all helped me to enhance my subjects. The shallow depth of field blurred the background just enough so that it didn't compete with the sculptures. To accomplish this, I used a telephoto lens and a mid-range f-stop of f/5.6 to f/8. My camera's preview feature gave me an idea of what I would get.

[180mm lens, Fuji Velvia]

Exercise

THE SHARPNESS ZONE

This is where another self-assignment comes in handy. Devote a roll or two of film to exploring depth of field, understanding exactly how to manage it, and learning firsthand how to make it work for you. To complete this exercise, pick any scene, and photograph it at different f-stops. Vary the focusing points. Switch focal lengths a few times. Take notes on what you're doing as you go. Soon, you'll feel more and more comfortable as you pursue that often mysterious, yet very controllable, photographic realm: the sharpness zone.

Designing the Image

Rather than pointing your camera at things randomly, you should use the camera's viewfinder to carefully compose your scenics. Good design involves identifying the focus of your attention and then determining how best to arrange the main subject and the side elements within the frame. Even though you may not know at the time which is the best rendition, the key is to experiment since there are many valid ways to interpret a scene. Spend time studying the work of other photographers and you'll see the wealth of compositional choices.

Simplifying a Scene　　Many photographers become so caught up in the scenery that they fail to zero in on their main subjects. The tendency is to back up to make sure everything gets into the picture. The resulting photo shows so many things vying for attention that viewers wonder what they're supposed to look at. While our vision is selective, meaning that we can look at a scene and pick out the important elements, the camera's vision isn't. It records everything that shows in the viewfinder.

Except for patterns, abstract subjects, and certain other scenes, most scenics have a center of interest. If you're not sure what it is, ask yourself what exactly is catching your eye in a scene. Defining your subject helps you resist the compelling urge to "get it all in" and helps you get rid of anything that doesn't belong. It's not necessary to include every building, rock, or tree in your picture. If you have more eye-catching points of interest than your photo can handle, it may be best to compose two or more images of the same scene instead of trying to shove everything into a single shot.

Once you have a clear idea of the picture you wish to make, you can make the decisions—about viewpoint, composition, focal length, depth of field—that go into designing images that match your vision. A photo rarely falls short because the subject isn't *good* enough. More likely, the photo falls short because the subject isn't *close* enough. When evaluating your work, try this technique on some of your weaker pictures: Using file cards (for slides) or L-shaped pieces of cardboard (for prints), try reframing your shot by cropping down from the top, up from the bottom, or in from the sides. You'll most likely find a stronger photograph somewhere inside that overall snapshot.

Of course, it's always best to do your cropping in the field while making the photograph. You can simplify a sloppy scene either by moving physically closer to it or by zooming in tighter with a telephoto lens. With a fixed-length lens, moving closer is the only method for making a subject bigger, although sometimes this may be impossible due to a steep land drop-off or some other barrier. Also note that moving closer and zooming closer aren't equal choices. Different focal lengths alter the spatial relationships between foreground and background objects—something that could either enhance or weaken your composition—while actually approaching your subject enables you to fine-tune your composition by shifting the viewpoint to eliminate extras and embrace essentials.

Filling the frame with your subject leaves little doubt as to your pictorial intentions. But don't use the get-closer principle in all of your compositions. The theme of your photo should dictate the size of your center of interest. Sometimes the idea is to show the relationship between your subject and the surrounding environment, to provide perspective or scale, or to tell a bigger story. This may mean showing a distinctive center of interest—a person, animal, plant, building, mountain peak, or any other object—small in the frame.

On this day in the Gold Rush Country of California, I wanted to capture two landmarks—a huge concrete statue of a gold miner and a historic courthouse—in a single shot. In an effort to leave out the adjacent street, buildings, and sidewalk,

I decided to photograph from a low and close camera position (opposite). The result is a much cleaner, striking image.

[24mm lens (right), 50mm lens (opposite), Fuji Velvia (both photos)]

Off-Center Subjects

When looking through the viewfinder, many amateur photographers place the subject in the center of the frame, creating a bull's-eye composition. But just because the primary subject is the center of interest doesn't mean it has to occupy center stage in the image. Generally, the more you move your main subject from the center, the stronger the composition. Such an imbalance can create a certain energy; in fact, there's a rule, the *rule of thirds,* based on this concept of placing the main subject off center in the frame. To use it, imagine dividing your frame into thirds both horizontally and vertically, like a tic-tac-toe board; then place your subject on or near one of the four points where the lines would intersect.

However, when I analyze a scene and compose a picture, I rarely think about the rule of thirds. Subject placement shouldn't be a matter of jamming your subject into a preconceived formula. It should be a matter of experimentation—of moving back and forth, up and down, and finally deciding what looks good or feels right. More often than not, the spot where the subject lands is somewhere off center. There are times, though, when a dead-center composition is dead-on.

Although many images have a center of interest, some subjects don't need one: a tapestry of autumn leaves, a row of trees or columns, a field of flowers, ripples on sand dunes, an arrangement of multi-toned rocks, a line of ocean waves, animal tracks in the snow, layers of colorful objects. Besides repetitions or patterns, other compositions hinge on lines that lead the viewer's eye through the picture or draw the eye to specific parts of the photo. Rivers, roads, fences, and railroad tracks can all do this. Curved, wavy, or zigzagged lines also can energize a composition. Although there are exceptions, the strongest, most dynamic lines usually are not square with the frame's borders, but diagonal.

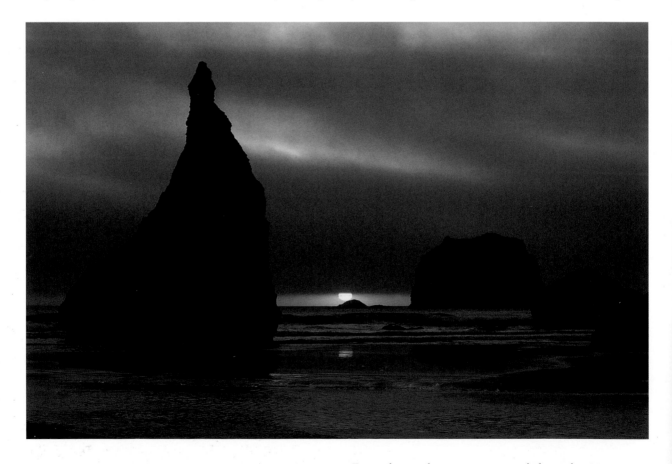

Fog and seastacks are Oregon coast specialties. For this composition, I placed the main rock formation to the left of center but kept several smaller ones at the right to balance the picture. I raised the camera slightly, to lower the horizon and to keep the sun out of the dead-center realm.

[50mm lens, Kodachrome 64]

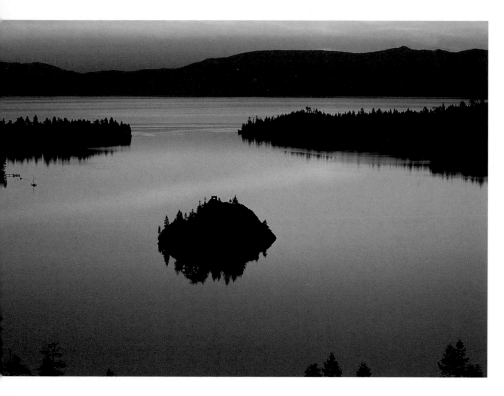

Overlooking Lake Tahoe in the Sierra Nevada one morning, I composed an overall view with a zoom lens (and no filter). However, I couldn't decide where to place the island within the picture frame, and colors like these don't last long. My solution was to position it in different spots in several images, each involving just a slight swivel of my tripod-mounted camera. The right-of-center placement in the bottom photo, avoids the "bull's-eye composition" of the top image.

[Both photos: 75–150mm zoom lens, Kodachrome 25]

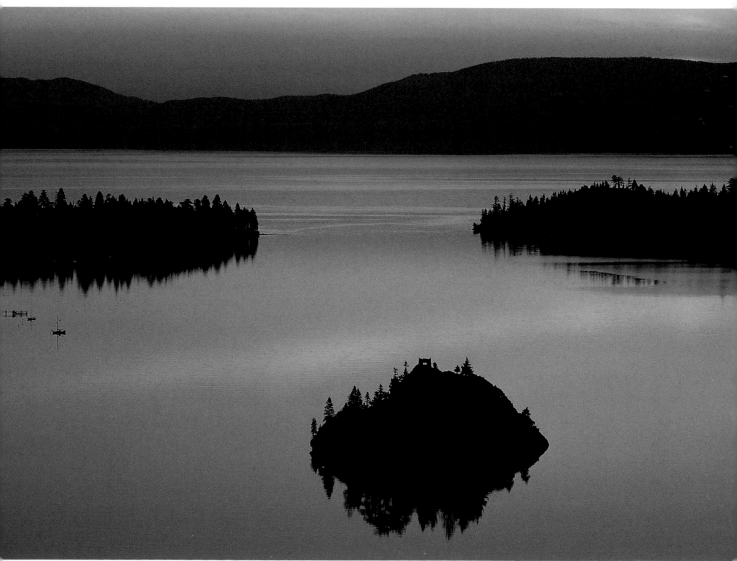

Alternate Viewpoints

It may seem natural to shoot from eye level, but consider other angles, too. Lie down and aim upward at trees, buildings, or monuments. Drop to your knees to heighten the importance of small subjects by making them appear large in relation to their setting, or to simplify your scene with a blue-sky backdrop, as I did on page 105. To deal with the town's surrounding distractions, I settled on a low viewpoint and close camera position to eliminate those extraneous elements.

Still another perspective is to get above it all with a higher vantage point; shoot down at your scene from atop a coastal bluff, tall building, or balcony. Sometimes the additional elevation removes objects or landmarks that block the view, and it prevents background and foreground subjects from overlapping in a chaotic way.

Avoiding the Obvious In his book *Galen Rowell's Vision* (Sierra Club Books, 1995), noted outdoor photographer Rowell describes the difference between "immature" or unfamiliar subjects (which demand a direct visual approach likely to be found in textbooks) and "mature" or familiar subjects (which require a more subtle visual interpretation). For example, Rowell writes, "A deer is a mature subject for almost everyone. A picture of the entire animal just standing there doesn't do much for us, but an image of only the deer's ears and eyes poking out of the grass could be tantalizing. People recognize the subject as a deer, and their mind fills in the missing part of the animal." Change the animal to a rare snow leopard, he points out, and viewers expect a more straightforward treatment that reveals the entire animal.

This concept—documentary vs. inventive— applies to any subject. For instance, is it always necessary to photograph a classic Victorian building so that it looks like it belongs in a real estate advertisement? Instead, try zooming in on different portions of the gingerbread trim. Zooming in close to your subject or photographing it from different vantage points can help you avoid making typical snapshot images.

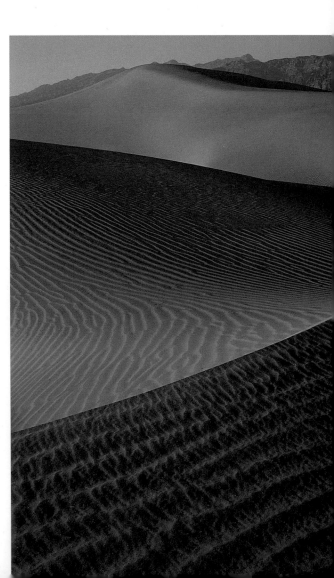

In this desert image (right), I included a portion of the distant mountains to suggest its Death Valley location. However, it was the patterns in the sand, accentuated by the low-angle sunlight, that really captured my eye. A more unique interpretation of the subject would have been to crop down just below the horizon, leaving the sky and mountains out of the picture to create an abstract dunescape.

[24mm lens, Kodachrome 25]

To avoid making a typical photograph of a shoreline (opposite), I climbed up to a higher vantage point that looked down on the beach, and I cropped the sky out of the image entirely. In addition to this, the water's edge creates an interesting diagonal line that leads the eye through the composition.

[180mm lens, Fuji Velvia]

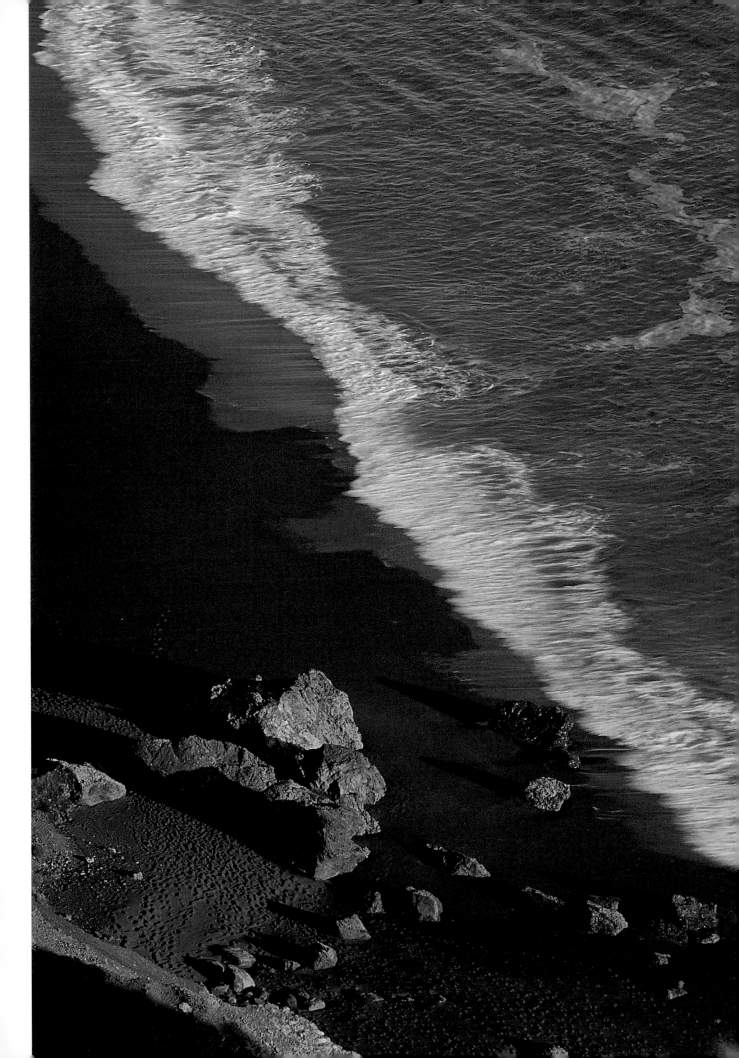

110

Framing Your Subject

Your surroundings can often act as an enclosure, framing the subject of your photo in an interesting way. Shooting a scene through a frame can fill up empty space (a blank sky, for instance) while also conveying a sense of depth.

Mention a frame, and trees or overhanging branches usually come to mind. But I've shot a village scene from beneath a wooden overhang, a beautiful mission through colorful flowers, and a city skyscraper through an outdoor art exhibit. I've also sought out side frames (of walls or rock formations) for vertical borders. In addition, using objects or even shadows as frames also helps conceal surrounding distractions or distant clutter; this enables you to create a stronger image by cleaning up your composition and setting off your subject.

Sometimes you can use more than one frame. On several occasions, I've pictured a subject through two paneless windows on separate walls of an old cabin (see cover photo and page 133). Using frames also involves a consideration of depth of field: a blurry foreground frame can direct the attention to the focused background, or a sharply defined frame can highlight an equally sharp subject. However, be aware that a frame is a compositional tool intended to *reinforce* your center of interest by directing the viewer's eye to the subject; it shouldn't add more clutter to an already busy scene. And be sure that an overly interesting frame doesn't overshadow your subject. (See pages 16, 49, 94, 114, and 135 for examples of the use of frames.)

To avoid a straightforward, this-is-a-building composition, I used a short telephoto lens to zero in close to this historic hotel.

[85mm lens, Fuji Velvia]

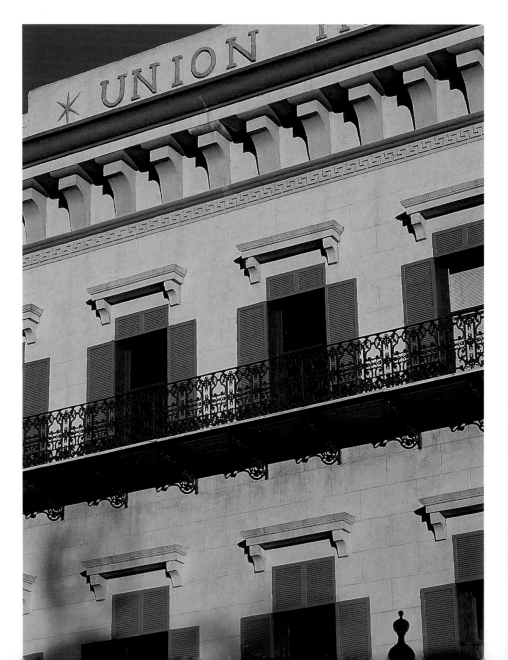

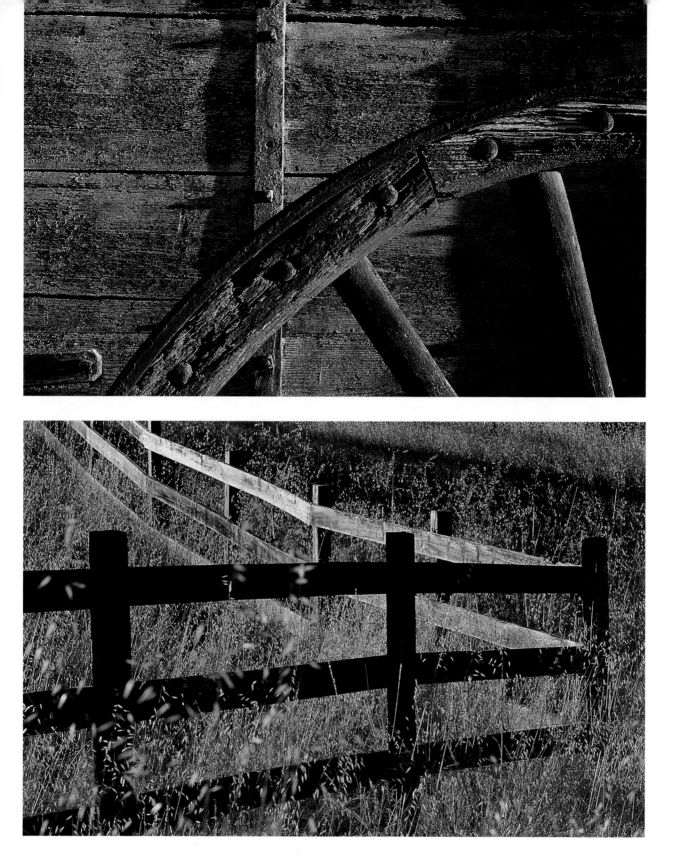

I wanted to avoid making a typical image of an old wagon (top), so I recorded a telling slice of the subject by moving physically closer to it. Rather than photographing a composition that showed equal amounts of ground, subject, and sky, I used side-light to emphasize the texture of the peeling paint, and I focused on the spokes of a giant wheel, with just a bit of the wagon as a back-drop. This shot, I feel, suggests more by showing less.

[55mm lens, Kodachrome 25]

By photographing this fence at a low angle, rather than from eye level, I was able to crop out the sky, capture a more unusual view of the subject, and create a more interesting composition.

[55mm lens, Fuji Velvia]

112

Taking a Last Look Before pressing the shutter-release button, take a final look through your viewfinder, checking the scene from edge-to-edge. It's easy to get so wrapped up in composing your picture that you miss some of the extra things that may have slipped into your image. Assuming that light or subject circumstances don't demand quick photo-taking, I perform a last-second inspection before making every picture.

Examine not only the center of the frame, but also scan the corners and edges. Search for any visual annoyances—litter, out-of-focus foreground items, tree branches, harsh glares of sunlight, or plane contrails.

Look, too, for merges. The classic example is a tree or pole sprouting out of someone's head, but a merge can be any separate subjects or same-color objects that overlap each other in a confusing way. Also watch for any element that touches the edge of the frame; adjust your image to give that item breathing room, or leave it out of the composition altogether. Perhaps you haven't pointed the camera down far enough and a sliver of white overcast sky is lining the top of the image. Or, maybe something in the background is distracting; a slight side-to-side shift may solve this compositional snafu.

The SLR camera is billed as a what-you-see-is-what-you-get camera, and that's mostly true—except that not every model lets you view the entire field that will appear in your photograph. While some cameras offer a 100-percent viewfinder, many SLRs show less than 100 percent of the scene. As a result, at times, an annoying element that was just barely outside your viewfinder's field of vision will appear just inside the border of your final photo. To avoid this, double-check for potential distractions right outside the picture area. At the same time, note that a subject that is almost, but not quite, touching the edge of the frame may have adequate breathing room in the final photograph. Also, regardless of your camera type, make sure a finger or camera strap doesn't intrude in front of your lens.

And finally, a personal tip for eyeglass wearers: Periodically, when composing a photo—assuming there's time and you're using a tripod—take a look through the viewfinder *without* your glasses. I find that with my camera viewfinder, which is not eyeglass-friendly, this affords me a full-viewfinder look at the scene. More importantly, reducing the scene to fuzzy shapes and lines helps balance the elements within the frame. On a related note, don't forget that sunglasses, whether prescription or not, can change a scene's color cast. Once again, do a lighting/color check from time to time, without your sunglasses.

Exercise

FINE-TUNING YOUR COMPOSITIONS

Amid the excitement and energy of shooting, it's not easy to keep all the compositional concerns in mind all the time. These exercises will help speed your progress in this area. During one photo session, concentrate on simplifying your composition by moving in close to your subject. During the next, pick a subject and position it in different parts of the frame. During still another, try photographing the subject from a few different angles.

Finally, play with your composition; dig really deep to find new variations. After all, successful picture strategies rarely involve prescribed formulas that dictate each and every composition. Think of rules as take-it-or-leave-it guidelines that you consider thoughtfully, not as hard-and-fast orders that you follow mindlessly.

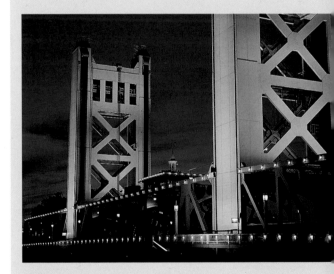

For the image above, I moved in to get a close view of the subject, capturing a dramatically different angle and composition than I did in the photos opposite. In the top image opposite, I liked the light but not the tilting bridge towers, the result of me tipping the camera slightly upward to eliminate a busy foreground. So, for my next attempt (bottom), I used the same wide-angle lens but chose a different camera position—one that allowed me to keep the camera parallel to the towers. I also decided it wasn't necessary to include all of the front tower in the photo.

[Above: 50mm lens, Koda-chrome 64; Opposite: 24mm lens, Fuji Velvia] (both photos)]

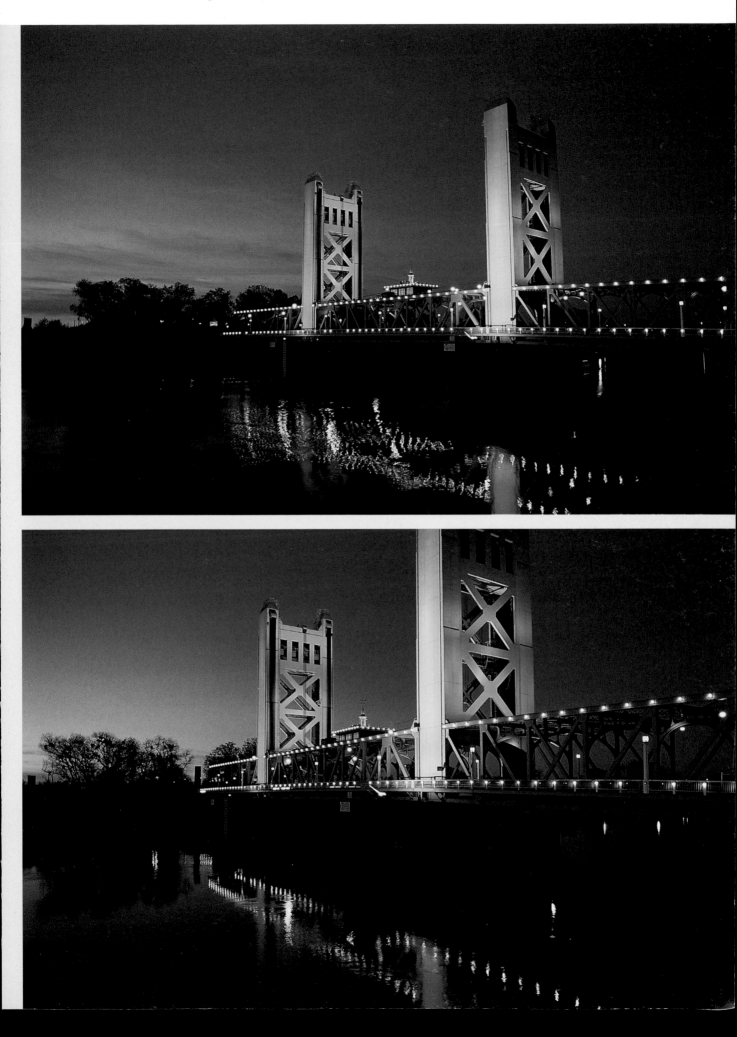

114

Vertical vs. Horizontal

Some subjects work successfully in both horizontal and vertical formats, while other compositions perform better in one or the other. Yet far more photos are taken in a horizontal mode; for many people, it's the automatic choice probably because many scenes seem more natural if pictured in a horizontal format, and because most cameras are more comfortable to handle when held horizontally. However, switching formats—even shooting scenes both ways whenever possible—is a strikingly simple way to beef up your compositions.

As with other areas of scenic photography, it pays to experiment with formats and composition. When analyzing a scene, ask yourself which format is the most suitable for it. Even if your first inclination is to shoot a horizontal (or vertical), turn the camera on its other axis and take a look through the viewfinder. The choice of vertical or horizontal depends primarily on informational aspects (what elements you wish to include in your photo) and creative concerns (which format looks best to you). In fact, some subjects (patterns or lines) may call for a diagonal format, with the camera positioned between vertical and horizontal.

Below the High Sierra (opposite page), the knobby Alabama Hills have been a frequent setting for movies, TV westerns, and commercials. This arch lies just a short ways off Movie Road, which profiles the area's Hollywood history. For this wide-angle scenic, I shot the scene in both formats, because I liked it in both compositions.

[Both photos: 24mm lens, Fuji Velvia]

You can experiment with vertical and horizontal formats even for close-up subjects (this page). Here, I framed in tightly on the front end of a weathered yellow truck.

[Both photos: 24mm lens, Fuji Velvia]

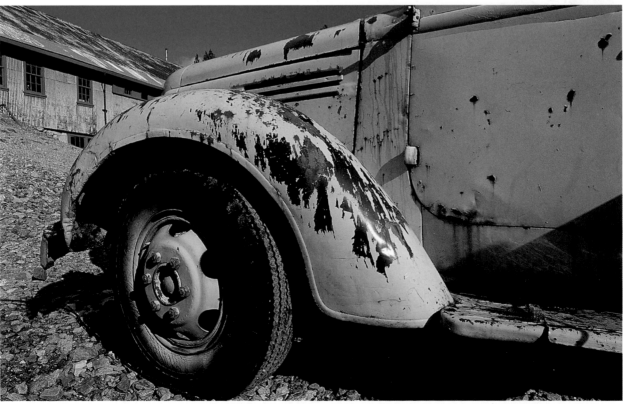

116

Traditionally, certain subjects have seemed to demand horizontal compositions: for example, scenes dominated by horizontal shapes and lines—such as sweeping landscapes and seascapes—and shots in which you wish to emphasize the horizon. Orienting your camera vertically, though, can command the viewer's attention, since it's a different way of framing the world. Using a vertical format sometimes makes it easier to fill the frame with your subject, and also lets you fit in more of the sky or more of the land. With tall subjects, a vertical shot can enhance the sense of height. On still other occasions, you can use it to emphasize the near-to-far relationship of your scene's foreground and background. A vertical view can also add extra energy to a static scene. In fact, with a suitable subject or creative composing, effective panoramas can even be shot vertically.

Of course, changing shooting locations or switching lenses may enable you to vary the format. However in some cases, no matter how you work the scene, only one format looks good. Other times, a moving subject or fleeting light may limit you to the first format you choose.

Shooting Both Ways Don't be afraid to break the rules. Frame "horizontal" scenes vertically and "vertical" scenes horizontally. Some subjects may demand vertical compositions, for example: a mountain peak,

skyscraper, tall tree, or a person standing. And it makes sense to use the vertical format, assuming your intention is to show *all* of the peak, building, tree, or person. However, you might also try a horizontal shot, since just a part of a subject can sometimes most effectively suggest the whole. If in doubt, shoot the picture both ways—a procedure that may mean switching lenses or changing focal lengths with a zoom—and compare your results later.

There are several good reasons for shooting a mix of formats. For one, since the opportunities for making both horizontal and vertical frames are about equal, by ignoring one, you severely limit your compositional choices. Just as compelling a reason is

this: An unrelenting series of horizontal scenes can be monotonously boring; your future viewers will appreciate the visual variety gained from some verticals.

In addition, as a professional, the importance of regularly rotating your camera cannot be overstated, because publishers need both types of compositions. Calendars, for example, are usually designed in just one format, while magazine covers are almost always vertical. For other print or online uses, it varies, and the prudent photographer submits both. On numerous occasions, a photo editor or art director has seen one of my published images and requested it in the opposite format. I've often been glad I'd photographed the scenes both ways.

The towers of San Francisco's Embarcadero Center light up each year during the holidays. I naturally approached

this towering shopping and office complex first with a normal lens and a vertical format (far left). Then I got braver and tried

it with a wide-angle lens (near left). Then I broke all the "rules" and shot the tall buildings not only with a wide-angle lens but

also in a horizontal format.

[55mm lens (far left), 24mm lens (near left, and above), Fuji Velvia (all photos)]

Horizons

As if there weren't enough compositional questions, another consideration is where to place the horizon line. For example, have you ever seen pictures with huge expanses of featureless sky? Or photos with vast, empty foregrounds? Don't let a stark sky or foreground ruin half your frame. Many photographers automatically place the horizon dead center (halfway up) in the frame, a practice that can lead to a static composition. It divides the picture into halves and divides the viewer's attention. The placement of the horizon is up to you. You should decide which part of the scene carries more weight—the sky above or the land or sea below—and position the horizon line accordingly.

The Thirds Principle The rule of thirds (see page 106) applies to subject placement, but it also applies to horizons. Positioning the horizon, or shoreline, somewhere other than in the middle of the frame will help you create a more dynamic photographic composition. To use the rule of thirds, whether you're using a horizontal or vertical format, imagine dividing the frame equally into thirds from top to bottom. Then use those positions as guidelines for where to place the horizon.

Proper horizon placement depends on which part of the frame—the upper two thirds of the lower two thirds—has the most eye-catching stuff in it. For instance, when you want to spotlight a dazzling sky or objects rising above the horizon (such as peaks, sailboats, people, or buildings), place the horizon line low in the frame. When a scene's visual drama lies below the horizon (such as fields of wildflowers, tide pools, or winding roads), aim down to position the horizon high in the frame; this pulls the eye into the scene and helps create a sense of depth.

You can adapt the thirds principle as necessary. If, for instance, things are exceptionally dull overhead, even a third of the frame devoted to that space may be way too much. You may want to minimize it by cropping it tightly at the top so that there's only a sliver of sky—just enough to define the horizon and give viewers a sense of place. Or, you might decide to delete *all* of the sky from the picture. With a particularly spectacular sky, on the other hand, you could include only a slice of land.

Tilting We've all seen—all right, we've all shot—pictures in which the horizon slants in one direction or the other, making it appear as if it's going to slide right out of the photo. Everything seemed perfect at the time, so what went wrong? At the instant the image was made, we were probably so busy admiring our

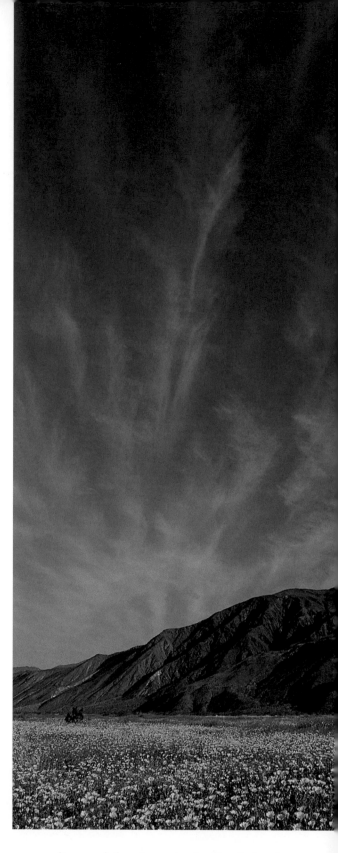

surroundings and the picture in the viewfinder that we just didn't notice.

To avoid making images that "tilt" there are a couple of things you can try. First, be aware of the potential problem and do the following visual check: make sure each side of the frame seems to have both an equal amount of foreground and of sky. You might also consider using a bubble level, a feature that indicates whether or not the camera is on even ground.

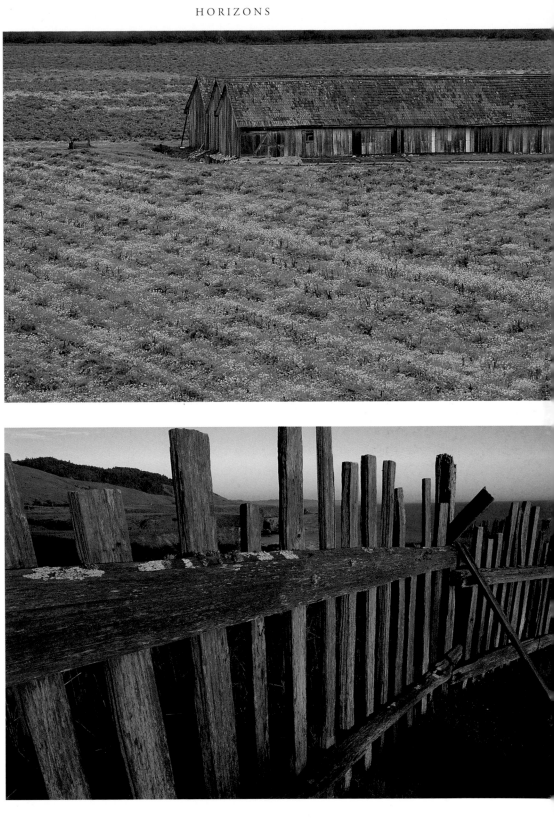

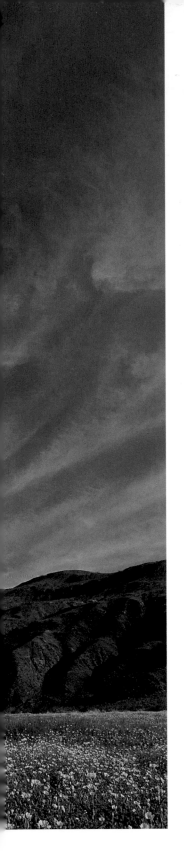

In all the photographs here, I let the scenes dictate the placement of the horizon. At left, I included just enough of the ground to show off the field of wildflowers, but otherwise I wanted to focus my attention on the wild sky. At top right, I decided to focus on the rich green expanse of the foreground, so I eliminated the sky from the composition altogether and kept just a sliver of distant brown trees in the background at the very top of the frame. At bottom right, I found this fence during an afternoon coastal exploration, and returned later in the day to catch the colors just before sunset. A high horizon and tall fencing helped de-emphasize the sky.

[24mm lens, (left and bottom right), 85mm lens (top right), Fuji Velvia (all photos)]

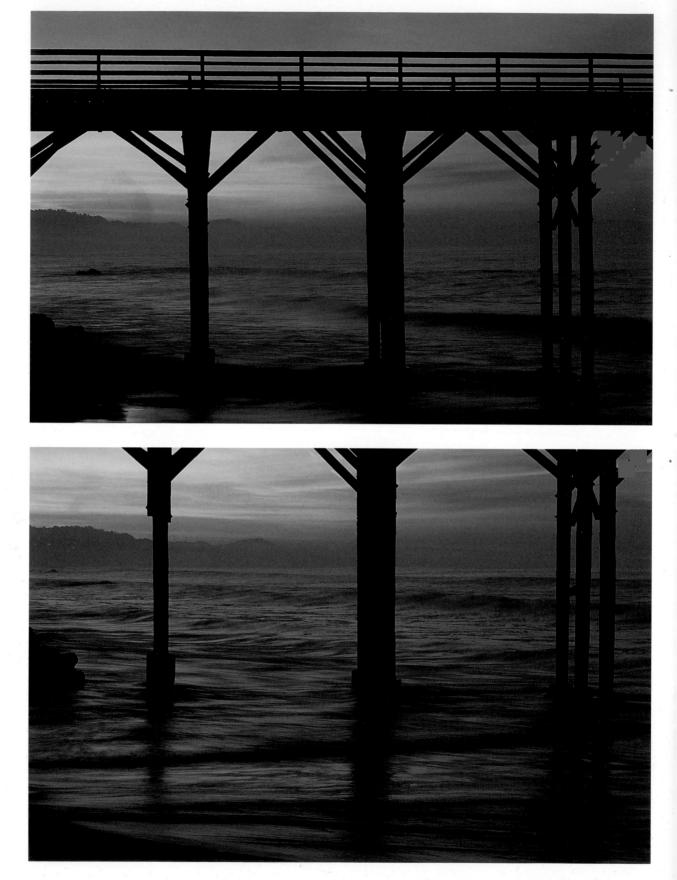

When I make the effort to rise early for a daybreak session, I try to capture as many interpretations of my subject as possible. But colors such as these only last a few minutes, leaving little time to run around looking for compositions in all the right places. After making the top photo, I simply repositioned the horizon to make the bottom one.

[Both photos: 85mm lens, Fuji Velvia]

Some tripods and tripod heads have built-in bubble levels, or you can buy an accessory bubble level, which slips onto the camera's flash shoe. Note that the best bubble systems work both ways, whether your camera is on the vertical or the horizontal axis.

Some cameras accept interchangeable viewfinder screens, and allow the use of an architectural-style grid screen, which has etched lines, both horizontal and vertical, that can be used for horizon and other compositional references. These screens are advertised for shooting buildings and close-ups, but are well-suited for general photography with most, if not all, lenses. Each of my cameras has one.

Even without fancy accessories, however, there's a low-tech approach that I use a lot. When using a tripod, I step back, look at the camera, and ask myself if it appears reasonably level with the scene. If it doesn't, I adjust it and check things again through the viewfinder. And, if you're hand-holding your camera, be sure to press the shutter button gently. After carefully going through all the other compositional steps, a hurriedly pushed shutter can tip one side of the camera down at the exact moment of exposure, resulting in a slightly tilted horizon. This is a common malady.

Of course there are exceptions. During a field workshop I once attended, a group of photographers focused on a desert sand dune on which the low-angled sun produced swirls of light and shadow. Several participants slanted their cameras, leaving the horizon out of the frame and creating some eye-catching abstract images of sand ripples.

Striking a Middle Ground What if both the sky (or background) *and* the foreground are equally interesting? This is a "problem" I enjoy because I don't have to shoot just one version; each approach conveys a different feeling, a different statement, even though each may involve the same lens and camera position. This situation of fine foregrounds and striking skies also opens up another possibility—to split things more or less equally. In mirrored reflections at mountain lakes, for example, you may wish to take advantage of the mood and give equal weight to both the top and bottom of your frame. With everything perfectly balanced, a horizon that cuts through the viewfinder's midsection helps create an eye-catching blend of symmetry and serenity. It's yet another example of how breaking a rule can fix a picture.

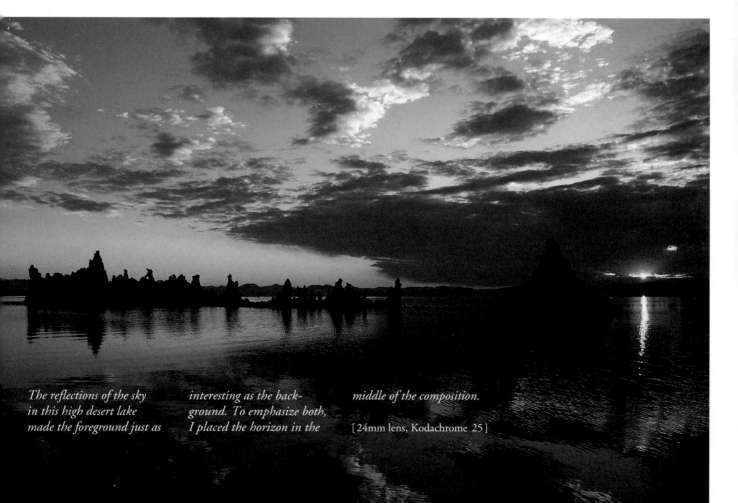

The reflections of the sky in this high desert lake made the foreground just as interesting as the background. To emphasize both, I placed the horizon in the middle of the composition.

[24mm lens, Kodachrome 25]

The Magic of Water

boulders. At the ocean, pay attention to the incoming tide. You must take care of your camera, too, unless you're using a weather-resistant or water-proof model. See suggestions outlined on page 87.

It's little wonder that so many scenic photographers are drawn to water. It's almost everywhere, and the photographic possibilities are almost endless. The look and feel of any body of water, whatever its size, changes with the time of day, the wind, the tide, and the light. Then there's the matter of color, reflected both from the surrounding scenery and from the sky.

Water, however, doesn't always translate into magical photographs. Getting the results you want takes know-how and practice—and sometimes luck. Many of the principles of light, exposure, and composition outlined previously in this book apply to water scenes as well, but we'll cover other specifics here that will help you increase your odds of making successful waterscape images.

Any camera will help you tame flowing water, so lack of sophisticated equipment is no excuse for not taking a plunge into water photography. An adjustable camera can help, however, especially in the realm of shutter speeds. If your camera isn't adjustable, just ignore the shutter-speed information, and pay attention to the other suggestions. Keep in mind that any mentioned camera settings are intended as starting points only, since subject, lighting and compositional conditions can vary widely.

Also make sure, when shooting waterscapes, not to overlook the safety factors. Take care when negotiating riverbanks, walking along crumbling cliffs above the sea, or stepping onto slippery waterfront

Reflected Images Still water adds a unique dimension to both cityscapes and landscapes by letting you record two elements in one picture: the subject and its mirrored reflection in the water. And, the water doesn't have to be looking-glass smooth; when there's a slight breeze, ordinary reflections turn into colorful collages of impressionistic designs.

Sometimes, on seeing one of my water-reflection images, a viewer will say, "I've been there, and I've never seen that." In many cases, finding a reflection results from searching for one. This is another case in which an alarm clock comes in handy, since perfect reflections most often occur just after dawn when the colors are rich and warm, and the air is most likely to be calm (although the wind may settle down again near sunset, too). Another reason to get up early is that in the wee hours of the day, a magical mist often rises from peaceful ponds.

Of course, there's no guarantee of calm conditions at dawn. If you must have a mirrorlike water surface for your photo, you may have to wait for a slight breeze to die down or go searching for small bodies of water—such as river backwaters, ponds, and puddles—or still stretches of larger lakes. Another option when there's slight movement on the water's surface is to use a fast shutter speed (1/60 or 1/125 sec. or shorter) to stop the action.

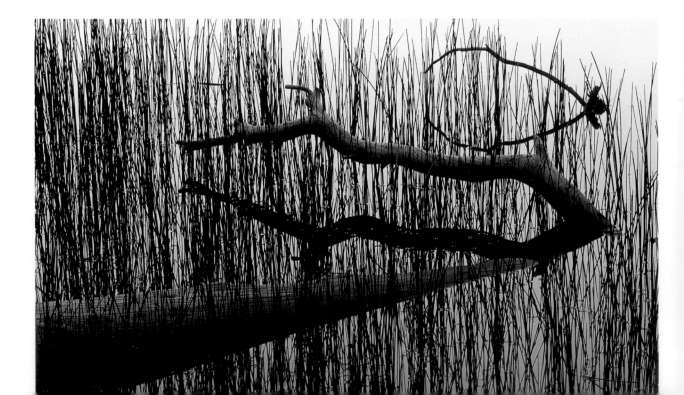

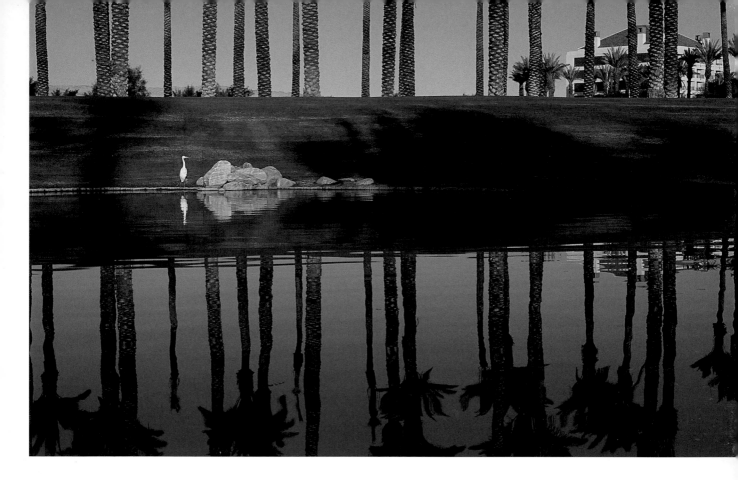

During a mountain camping trip, I set out to photograph a lake at dawn. As I strolled along the lake in search of big views to shoot, I found this intimate, tranquil scene of water reflecting the blue sky (opposite). Later on I found the grand landscapes, but this was

the most satisfying photo of the day, perhaps because it came about so unexpectedly.

[75–150mm zoom lens, Kodachrome 64]

Several elements — mid-afternoon shadows, lack of wind, an extremely cooperative egret — came together to create this image of a resort. I tried several compositions, finally using my short telephoto lens and placing the center of interest (the bird and rocks) off-

center. I decided against a vertical format; it would have included more of the palms but also more of the uninteresting midday sky. Besides, this view reveals the scene's upper, hidden parts in the reflection itself.

[85mm lens, Fuji Velvia]

You also can make mild ripples work for you. With wind or a boat's wake affecting the surface of the water, rich tones and bold patterns can turn into striking abstract subjects. A fast shutter speed freezes the designs pretty much as you see them. (In order to accomplish this in low light, however, you may have to sacrifice depth of field or use a faster film.) Slower speeds result in more pronounced ripples and can create an artistic array of swirling colors. At much slower speeds (for instance, 1/8 sec. or less), the colors start blending together and the patterns begin mixing up into a kind of brush-stroke effect. Don't stop after just one picture, though. Using other camera settings and viewpoints, you may catch various versions that you like. Water surfaces are constantly changing, and you can't always predict what you'll get.

In addition, note that most waterscapes include land elements of the riverbank, lakeside, or shoreline; these anchor points can provide contrast to

the water's reflection (or movement) and provide a sense of scale. A wide-angle lens can help you create a big view with a beautiful combination of the reflected image and the surrounding scenery. Or, for a visual change of pace, try focusing on just the water itself; move in close and point your camera downward, or zoom in closer with a long lens. A telephoto also lets you zero in on a particularly radiant reflection. Sometimes a low camera placement (as close as possible to water level) produces a striking reflected image, quite different from the typical eye-level view.

Exposures for Reflections Reflections generally appear darker than the subject itself. Therefore, unless you're careful, you'll end up with a black foreground or a washed-out background. The trick to shooting an overall well-exposed view is to underexpose the water surface slightly while holding acceptable color in the rest of the scene.

As with just about any other outdoor scene, waterscapes are inherently less contrasty in early morning and late afternoon (when they are frontlit) than they are at midday. Presuming that sunlight is hitting both the water and surroundings, I find that the difference between the reflection and the subject runs around 1 *f*-stop—just within the range of even the most finicky color slide film. Often, an overall autoexposure reading averages things out nicely, although I usually expose for the brighter subject (not the darker reflection) to ensure that the colors appear well saturated. If the reflection is a couple of stops darker than the subject, you may want to even out the difference with a graduated filter. Or, you could try a more creative approach and zoom in tight to eliminate the subject and leave only the reflection.

Filter Tips You may be tempted to use a polarizing filter to enhance the water's colors and to remove unwanted glare, but use it carefully. It's capable of removing not only the reflections you don't want, but also the ones you do want. It can remove all the sparkle and life from your water images. Like other pieces of photographic equipment, a polarizer can't think for you. If you wish to subdue some excessively bright highlights on water, don't just slap the polarizer on your lens and start photographing; look through your viewfinder and keep rotating the polarizer until you get the desired outcome. You may even decide you don't need a filter after all.

Capturing Motion Flowing or falling water is ever-changing and ever-magical. Unlike most scenics, in which aperture is the first priority in order to attain the desired depth of field, the recording of motion operates mostly under the shutter-priority approach, meaning you blur the motion with a slow shutter speed or freeze it with a fast one while the camera automatically selects the *f*-stop. When capturing motion, plan to experiment with your shutter speeds in order to increase your choices of photos.

Slow shutter speeds can convey calmness and a soft sense of movement, by turning running water into a milky, fluid flow. To blur moving water, start with a shutter speed of 1/15 sec. set manually, or use an auto-shutter function. Working down from there—into the 1/8 to 1/2 sec. range—increases the blurring while still holding some water detail. The silkiest and most sensuous texture starts to set in at a full second or so. Also, the closer you are to the water, the easier it is to blur it.

To hit the slowest exposures, you'll need not only slow-speed film but also low light and probably a small aperture. If it's early or late in a heavily overcast day, you'll probably be shooting at a second or two. Depending on your *f*-stop, twilight may extend your exposure to at least several seconds and perhaps much longer, with the scene becoming downright ethereal. However, photographing flowing water is not a precise science. With slide film, I bracket exposures if I'm not sure. And I also try several shutter speeds, since the constantly changing water makes it difficult to tell exactly what I'll get.

Invariably, my photography students say that they've tried, but failed, to obtain that flowing

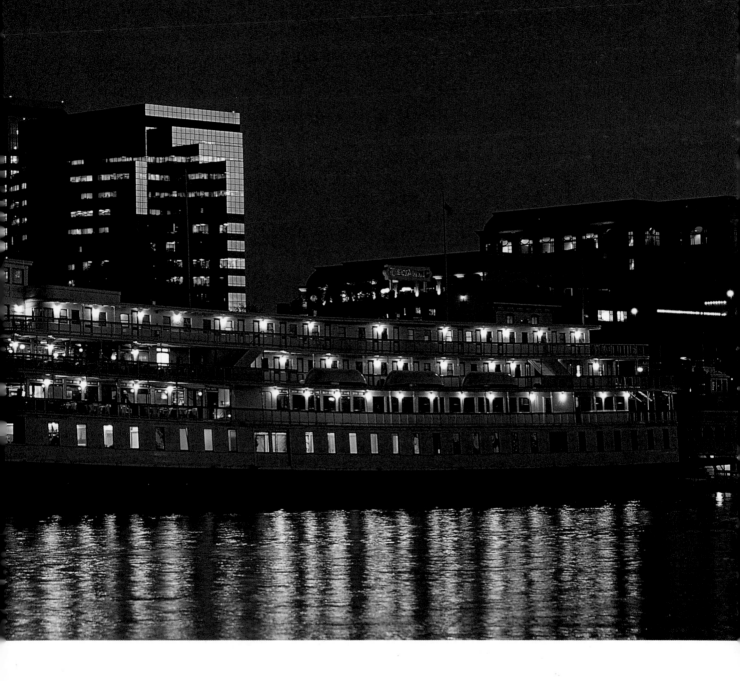

"cotton-candy" water effect. Usually they are shooting the water with reasonably fast shutter speeds; they photographed with the camera set on autopilot and in light that was too bright for slow shutter speeds. You can obtain the slow shutter speeds necessary for capturing flowing water in several ways. First, you can photograph in heavy overcast, sunrise, sunset, or twilight. In these conditions, you can expect not only low light—just the thing for slow shutter speeds—but also fairly even illumination, which prevents the dark darks and bright brights of harsh midday light.

When I first set out to capture this scene, the colors were muted and a wind whipped up the river. I thought conditions could be better. A week later, I returned for another try, and this was the result: the riverboat hotel reflected in the mild ripples of the Sacramento River, with California's capital city as a backdrop.

[85mm lens, Fuji Velvia]

Other things you can do to reduce shutter speeds in bright-light situations include the following: use a slow-speed film, set your lens at its smallest opening, and attach a polarizer (which cuts 1 or 2 stops of light while also toning down the highlights) or a gray neutral-density (ND) filter (which reduces the amount of light entering the camera without changing the colors). ND filters come in various densities to reduce the light by 1, 2, or 3 stops; some photographers even combine them to further cut the light.

Long exposures, of course, require a steady camera, but photographing moving water can test your tripod-using skills. It's always a challenge trying to set up on a beach while the tripod legs slowly sink into the sand. I've been forced to operate on rocky slopes with my tripod legs stretched into strange positions in order to keep things in proper balance. If using a tripod becomes too tough, you might try an alternative: Brace your camera on a wadded-up piece of clothing on top of a boulder.

Freezing the Action
Most serious photographers shoot moving water in low light for two very good reasons: the preferred blurring effect and the beautiful lighting conditions, as mentioned prior. Nonetheless, certain water scenes made in bright sunlight can produce pleasing results, too. When the brilliant light reflects off surf and sand, it's easy to photograph with a fast shutter speed and capture a crashing wave stopped in seemingly suspended animation.

So how fast is fast? It depends. Perhaps 1/125 or 1/250 sec., or perhaps 1/500 sec. or faster if you want to stop the droplets of a whitewater river. There's no precise formula since various factors—such as how fast the water is moving and how close you are to it—influence the effects. To find the speed that works for you, you may want to bracket your shutter speeds, beginning, for example, at 1/30 or 1/60 sec. and going faster from there. Even without altering your shutter speed, you'll find that each photograph will be unique, particularly at the ocean where no two waves are exactly alike. I've spent a lot of time and rolls of film shooting wave after wave, thinking the next one will be bigger and better than the last.

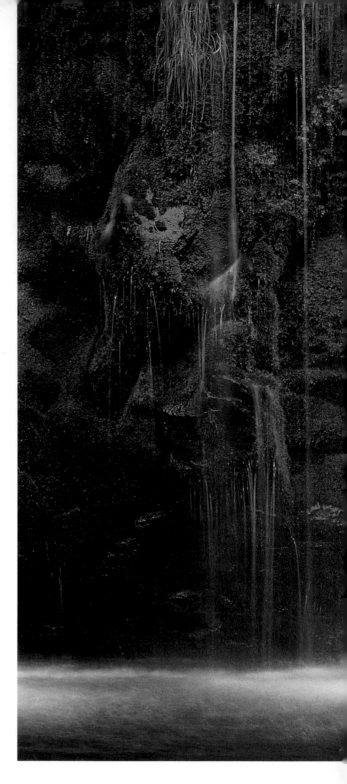

The decision-making process for taking this photograph focused on shutter speed, as well as composition. Since this scene was in deep shade, I had no problem employing a slow shutter speed (about 1/2 sec.) to blur the water's movement. I used a telephoto lens to zero in on the best part of the waterfall.

[85mm lens, Kodachrome 25]

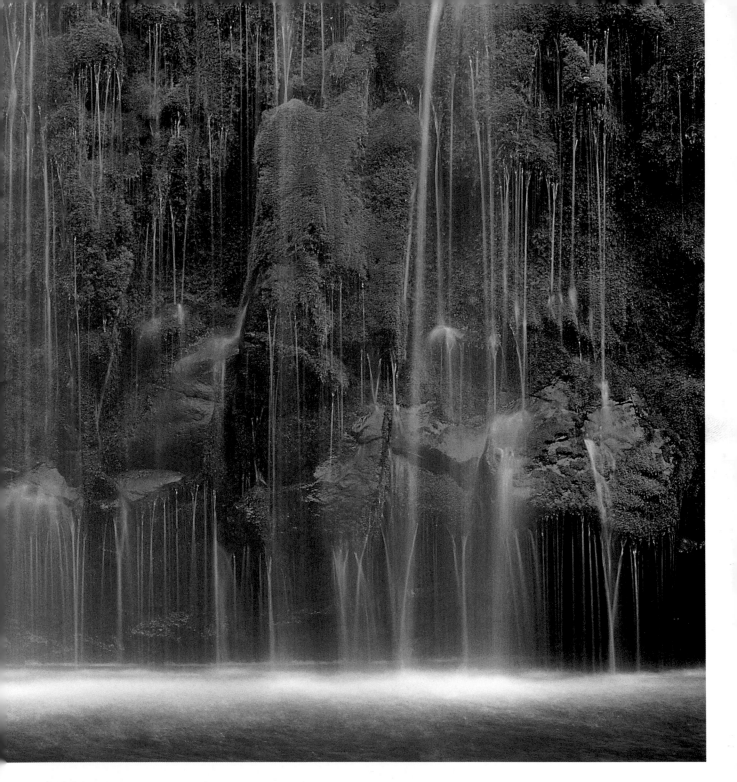

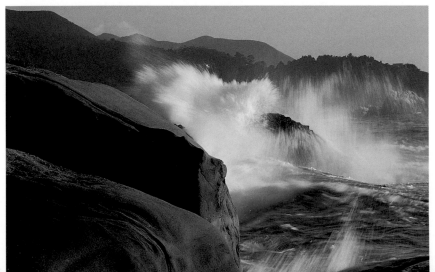

Late one afternoon, rocks
and waves collided in all
sorts of visually exciting
ways. Since each crash of
the surf is different from the
previous one, I shot a surf
series. I used shutter speeds
ranging from about 1/30 to
1/125 sec.— each capable
of stopping at least some of
the water movement.

[24mm lens, Kodachrome 64]

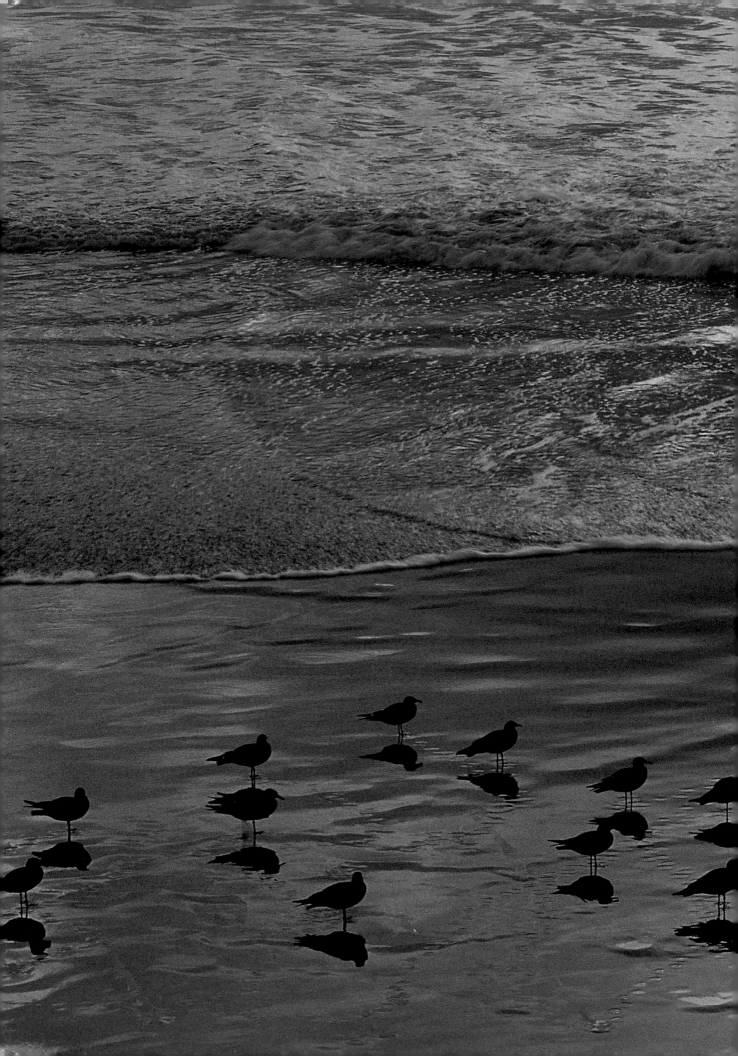

4 **Capturing Details**

130

Fleshing Out Your Scenics

help you crop out distractions, such as telephone wires and parked cars.

At a harvest festival one fall afternoon, a scarecrow caught my eye; but just as I started to leave after photographing it, I noticed a little boy focused on a nearby pumpkin. It boasted rosy cheeks, a red nose, twinkling eyes, and a wide smile. Once the boy left, I captured one of my all-time favorite shots of a charming autumn icon (below)—and I had almost missed it!

This illustrates the importance of looking—and shooting—comprehensively, from the grand perspective to the intimate view. This in-depth approach can improve your photography on two fronts. First, you'll capture a greater variety of images; and second, you'll tell a more complete story by providing your viewers with a real feeling of being there.

Fleshing out your scenics means proceeding beyond the big view, looking for smaller scenes that provide greater detail. Isolating the details can also add a touch of intimacy to your photographs, as well as help you simplify your compositions. In fact, sometimes the little view tells more about your subject than the bigger scene.

Although you don't necessarily need specialized gear to flesh out your subjects, you do need specialized thinking. A good method is one long used by cinematographers. Begin by establishing the setting—for instance, an overall mountainscape. Next, focus on a medium-range shot, perhaps a lush meadow. Finally, wrap it up with an intimate look, such as a stream. Of course, time constraints may limit you, or the lighting might not be conducive to shooting both broad and narrow scenes in the same conditions. However, start considering the idea of fleshing out your scenics, even if, in a given circumstance, shooting comprehensively takes place more in your mind than in your viewfinder.

Working Close-Up

Shooting close-ups has at least two practical benefits. First, it can

This pumpkin almost got lost amid the scarecrows and bales of hay at a fall harvest festival. I excluded those extras by moving in tight.

[50mm lens, Fuji Velvia]

Second, it's an excellent pursuit on overcast days, which often lack the necessary drama for majestic scenics. Cloud-induced soft light eliminates distracting bright highlights and deep shadows. Also, with close subjects it's easier to adjust the lighting (using reflectors and fill flash) and the angle of the light, to eliminate any annoying compositional or lighting elements. I've often been able to block extraneous light with my body, camera bag, or a cooperative friend.

Dealing with Details There are lots of ways to capture small scenes. One is simply to focus as close as you can with whatever lens you're using. Everyday lenses are often overlooked for their reasonably good tight-focusing ability. I photographed many of the detail shots in this book with non-macro lenses. Incidentally, a fixed-focus camera lets you move in tight, too; check your owner's manual to see how close you can get to your subject and still keep it sharp.

On some occasions, though, you just can't get close enough. To fill the frame with little things, there are a few tools you can try. A *macro lens* is convenient and versatile; it covers a broad shooting range, either as a close-focusing specialty lens or as a conventional lens that can focus all the way out to infinity. In 35mm photography, traditional macros check in at 50mm or 55mm, which combines a normal focal length with a macro feature. Many telephoto and tele-zoom lenses also offer macro capabilities. The extra working room a tele-macro provides, between the lens front and subject, makes it ideal for photographing easily disturbed things, such as delicate flowers and skittish insects.

While macro lenses usually offer the best in image quality, there are also a number of attachments and accessories available to help you get closer. *Extension tubes* fit between the lens and the camera body and extend the lens' close-focusing range. You can use these hollow cylinders, which come in different lengths, either alone or in any combination. *Close-up lenses* (or diopters) work similarly to filters (fitting on the front of a regular lens) and are available in varying strengths. They enable your camera to see more clearly at closer distances.

Working at ultra-close spans calls for paying special attention to motion, camera movement, and lighting. Greater magnification requires even greater concentration. At the extreme limits of closeness, even with the lens stopped all the way down, the range of sharpness shrinks to a super-shallow slice, making focusing incredibly critical.

East of San Diego lies Anza-Borrego, a spacious desert state park with this semi-underground visitors' center. Early one morning, I grabbed a big scenic but wasn't really satisfied until I photographed the bighorn sheep door handles (top left). Elsewhere in the desert, I continued my quest for details with a close-up of the flowers on a Mojave mound cactus (top right). The diffused light from an overcast sky made the colors of the flowers really pop out. I used a 55mm macro lens, but you can start fleshing out your scenics right now with the gear you already have. Note that the best vantage point for photographing some small subjects often lies at ground level. So, to stay relatively clean, dry, and cozy, use a plastic tarp (to ward off dew and dirt) and a foam pad (to protect your knees from cold, hard surfaces).

[50mm lens (top left), 55mm lens (top right), 24mm lens (bottom), Fuji Velvia (all photos)]

Wide-Angle Views

One of the American West's most photogenic ghost towns is Bodie, whose past was as wild as its present-day pictorial potential. In its 1880s heyday, the one-time gold town boasted 10,000 residents, 65 saloons, and enough barroom brawls, stagecoach holdups, and poker room shoot-outs to make undertaking a lively business. While things have calmed down on the crime front, things have heated up on the photo front, with Bodie's abandoned buildings, warped walls, and sagging sidewalks preserved as a California state historic park. The visual variety has compelled me to cover many of the compositional and lighting bases: verticals and horizontals, close-ups and broad vistas, morning and late day. As for lenses, I almost always choose just one: a wide-angle. This lets me reveal the smaller scene within the bigger picture.

The wide-angle lens' storytelling virtue and unique visual perspective—combining very close details with far-off views in the same picture—are what make it a valuable tool for serious travel and outdoor photographers. Almost any subject can work with a wide-angle lens to create a "sense-of-place" composition: a field of wildflowers backed by snow-capped peaks, for example, or a white fence leading up to a country home. The idea is to shoot close up to a foreground object, and then show it in the context of its environment. Done effectively, this technique produces a three-dimensional effect, with the scene sweeping away from front to back. It almost seems as if you could stroll right into the photograph.

Incidentally, any wide-angle fixed or zoom lens can handle this technique—even a basic point-and-shoot camera lens, which is a single focal length that usually lies within the wide-angle range. The effects, of course, become more exaggerated as the focal length widens.

Finding Foregrounds

Despite the wide-angle's advantages, developing photographers often have trouble putting the lens to effective use. That's because the wide-ranging perspective can also be a drawback. The exploded look produced by the short focal length exaggerates the size of objects in the foreground, while making the background seem smaller and farther away than it actually is. As a result, many people underestimate the foreground's dominance, which often leads to a vast empty space in front that overwhelms the intended subject beyond. This can make mountains or skyscrapers appear as disappointingly tiny knobs on the horizon.

The key is to take advantage of the lens' ability to focus down surprisingly tight and create a near-to-far feeling of depth. I never completely understood this concept until I attended a Kodak-sponsored seminar. The instructor repeatedly referred to a short focal-length lens as a "foreground lens" to reinforce the importance of close-by subjects in wide-angle compositions. That reference worked for me, along with forcing myself to really start seeing, and paying attention to, what appears in my viewfinder.

Wide-Angle Compositions

The traditional wide-angle composition—showing a subject in the context of its surroundings—often involves using railroad tracks or roadways that lead the eye into the distance. But you can do this with all sorts of things. For instance, you can frame a town square with a graceful archway, or you can play up a classic white church with a splash of fall color.

In most cases, you'll want everything in the scene to be sharp, since a great depth of field helps produce a great feeling of space. Usually this won't be a problem with a wide-angle lens, but it does require employing some sharpness techniques, such as using a small lens opening and focusing on the hyperfocal distance (a spot in between the closest and farthest points in the frame). And, a tripod is frequently a necessity.

Closing in tight on a foreground object requires extra care not only with depth of field, but also with composition. Often, I'm working at a distance of two or three feet from the nearest point, filling much of the frame with the foreground while including a meaningful slice of the surroundings. Even a subtle shift in camera position can alter the relationship between foreground and background.

As far as format goes, both horizontals and verticals work with wide-angle scenics. In fact, a vertical format can produce a feeling of even deeper depth than a horizontal one. Expect to give your camera a sharp tilt downward in order to record all the relevant foreground elements. Or, in the case of an overhang or other high object, tilt upward. In addition, don't photograph every wide-angle shot from eye level; low-level foreground objects, such as flowers and tilework, may also require low-level camera angles.

Should delicate foreground subjects blow in the wind, consider photographing in the early morning before the wind kicks up. Or, use a companion or other buffer to block the breeze, or wait for a lull in the action; if you're patient, things may die down for a short while.

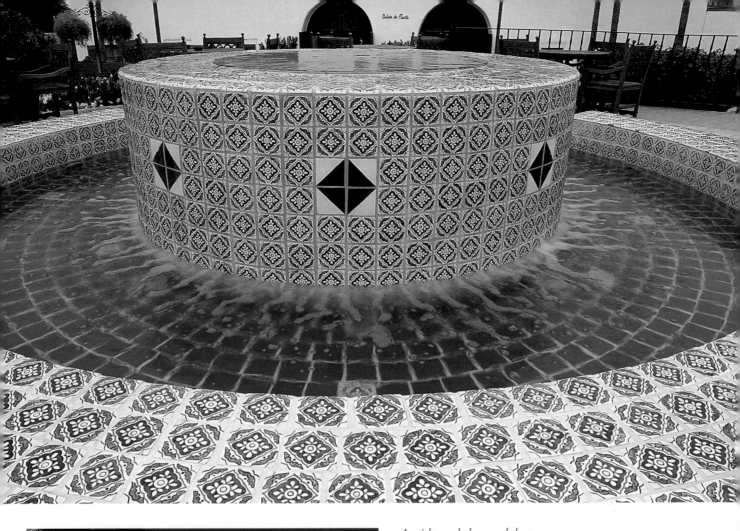

A wide-angle lens and deep depth of field made an ideal pairing for this fountain image. Capturing a scene like this involves using a small lens opening (f/22) and often a sturdy camera support (I used a tripod). With a non-adjustable camera, check your manual for the range of focus.

[24mm lens, Fuji Velvia]

Armed with an adjustable camera and a wide-angle lens, I used a small f-stop (f/22) to keep everything sharp in this ghost-town scene. Just about any camera can capture wide-angle scenics, even a point-and-shoot model, since most simple cameras come equipped with a wide-angle lens.

[24mm lens, Fuji Velvia]

134

You can also freeze the motion with a faster shutter speed (this may not be an option due to the required small *f*- stop, plus low light and slow-speed film).

And finally, when composing wide-angle scenics, plan on this occasional irritation: people intruding into your picture. It's not that they want to invade your space; most likely, they simply don't realize that your wide-angle lens captures an area far beyond (and far wider than) what appears to be your subject. Be patient, or consider rearranging your composition so that an element in the viewfinder obscures unwanted people. (For times when you want people in your scenes, see pages 136–137.)

Learning to See Wide Storytelling success obligates you to train yourself to see "wide." Soon you'll become adept at finding foregrounds that create depth in your photographs and reveal more information about your scene by showing a subject within the context of a larger view. It all begins with a mental shift in your mind set. An acquaintance once asked for help with a photography class she was taking at a local college. Her assignment was to photograph any building, but with this mandate: The photo had to show the entire structure, not just an eye-catching section. She couldn't find a building she liked, and since the photo could include other objects, I suggested the wide-angle-scenic approach: By concentrating on an enticing foreground, a building in the background would take on less importance since it would be in the distance and far less prominent. By the next day, she had her shot and was hooked on the technique.

If you need some wide-angle lens rehearsal before a big trip, try the following exercise. Use your widest focal length exclusively over a few days or weekends. Practice framing near-to-far scenes by backing up to get more in and then moving in tight to keep out the extras. Examine the ins and outs of depth of field. Check your work later, and reshoot the scenes that failed.

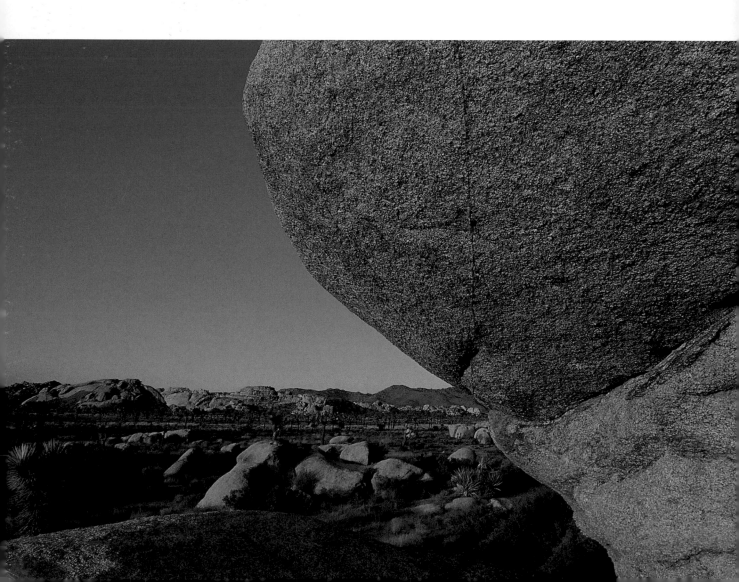

These two photos represent a pre-visualized composition in which I wanted a near-to-far combination of subjects that revealed the rock's texture up front and the desert scenery in back. At first, I didn't have any of the particulars arranged. After a short reconnaissance mission, I found the right rock and composed it as a horizontal. The next day, I went back and shot it as a vertical.

[Both photos: 24mm lens, Fuji Velvia]

People in the Landscape

While most landscape shots can stand on their own, you can liven up some scenics with a human presence. This doesn't mean, however, picking a beautiful backdrop and then employing the firing-squad approach: line 'em up and shoot 'em. In photographs that successfully incorporate figures within the scenery, people play supporting, not starring, roles. They serve as design and storytelling elements in bigger scenes. Pictured small and often not even recognizable, a few passersby can show scale, create mood, and add energy; they can provide a sense of being there, by helping viewers relate to your photograph.

Incidentally, you can do the same with animals in wildlife photography by showing them in their environment. With a telephoto lens, it's often tempting to frame a head-and-shoulders portrait of an animal. These face shots tell a lot about the particular animal but little or nothing about where the animal lives. Showing the animal within the context of its surroundings may be far more enlightening.

The Decisive Moment

Making compelling photos that incorporate people requires insight and preparation—or the anticipation of what has been called the decisive moment. This concept—of being able to see your picture coming—is most often applied to news, sports, and candid photography. However, it works with people-in-the-scenery subjects, too. The idea is to identify an appropriate setting or backdrop, get yourself and your equipment into position, and then wait for the right person to make your photograph happen.

Photographing people at random can turn into an anticipation exercise: recognizing the decisive-moment potential, seeing the moment coming, and being ready to snag it. At times, the images are ready when you are, and it's just a matter of setting up and shooting. Other times, it's a bit more challenging; for example, you want a couple of people to move into your pre-determined scene, but they notice you and change directions altogether. Or, they pause to let you complete your shot. In this case, I smile, thank them for their courtesy, and motion them on; then I snap the shutter. Posing a companion in your image sometimes works out, but you must direct your "model" with care, otherwise the photo may appear unnatural.

Shutter Speeds for People

Shutter speed can be a concern when incorporating people in your scenics. It depends on several factors: the camera-to-subject distance, how fast the subject is moving, and the direction of movement (if it's across your field of vision, rather than coming toward or going away from you, you may need a faster speed).

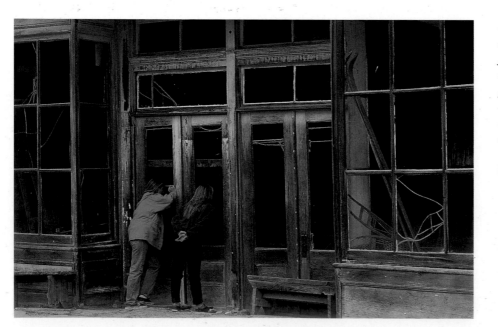

During a family outing at Bodie ghost town, I followed my stepdaughter and her friend as they peered into abandoned buildings. A short telephoto lens enabled me to remain at an unobtrusive distance.

[85mm lens, Fuji Velvia]

I photographed a number
of early-morning scenes
in this area when I noticed
a couple of beach strollers
heading in the direction

of my framed picture.
I waited a few minutes
for them to reach the right
spot before snapping the
shutter. Even though they

appear small in the photo,
they have a strong effect on
the composition.

[85mm lens, Fuji Velvia]

Olvera Street, a world-renowned Mexican market-place in Los Angeles, lights up at dusk during the Christmas holidays. Using a slow film and stopping down the lens to keep everything in sharp focus, I knew the required shutter speed would be far too slow to stop the action. But that's exactly what I wanted (blurred renditions of tourists) to keep the focus of attention on the street's colorful atmosphere, not on specific individuals. I shot a number of frames to ensure that I captured the right blend of people and motion.

[24mm lens, Fuji Velvia]

In most cases, the people are so small in the scene that motion usually isn't a major shutter-speed concern. This type of work rarely requires the movement-stopping speeds (1/250 sec. or faster) of close-up sports/action photography. However, just to be sure, I shoot at the fastest speed possible, given depth-of-field, lighting, and film limitations. In lower light, this may require some compromise, since slow shutter speeds won't even stop people strolling. These situations may call for faster film, a new composition that doesn't need a deep range of sharpness (and therefore a slow shutter speed), a subject that isn't moving, or incorporating a feeling of blurred motion (as in the picture above). If I'm in doubt, and it's possible, I'll bracket a mix of shutter-speed and depth-of-field variations and hope for the best.

Design Issues Including people in your photos involves some special compositional considerations. For instance, in most cases, passersby should move into, not out of, the frame. This also applies to figures just standing and gazing; have them looking into your pictured scene. This helps guide the viewer's eye into the composition. However, I have seen well-executed exceptions to this "rule." One example might be a boat racing across a lake and providing a sense of speed with its wake.

Be aware that while people may enhance some photographs, too many people simply get in the way. A busy composition can have a negative impact. To avoid the masses at popular tourist sites, avoid holidays, visit on a weekday or in the off-season, and photograph earlier or later in the day (when the light may be better anyway). Having patience works, too; eventually, they have to move, or there has to be a lull in the action. I've even headed out when it's misty,

although sometimes I've ended up with the opposite problem—there's no one around at all!

Using Contrast A person shown small in the frame may seem unlikely to grab the viewer's attention. In an effectively executed photo, though, the subject will jump out in relation to the surroundings. A lone figure or two in a grand landscape can capture the imagination, and certainly the eye, just by virtue of the contrast in sizes. In fact, it's contrast that is the key to successful people-in-the-landscape photography.

However, you must also make certain that the person doesn't get lost in all that wonderful scenery. You can prevent your subject from blending into the environment in many ways, all using the idea of contrast; for example, try a well-lit subject in shadowed surroundings, a silhouetted form before a bright backdrop, a colorfully dressed person surrounded by dull colors, a subject outfitted in white against a dark background (and vice versa), and a person wearing a red jacket in a foggy setting.

Conveying a sense of scale shouldn't necessarily be the overriding reason for including a person in your scenic photograph. Arbitrarily tossing a person into an already inspiring landscape can turn it into a stilted snapshot. Viewers generally know how big mountains, trees, and buildings are; a person just standing and looking up is the equivalent of a ruler or coin in a scientific photo to give an idea of an artifact's proportions. In other cases, size simply doesn't matter. Some subjects (say, a natural pattern or an urban abstract) may hinge on a feeling of mystery. In addition, if you're faced with an empty and uninspiring landscape, you probably can't improve it by including a person; although it may not be empty anymore, it will probably still be uninspiring.

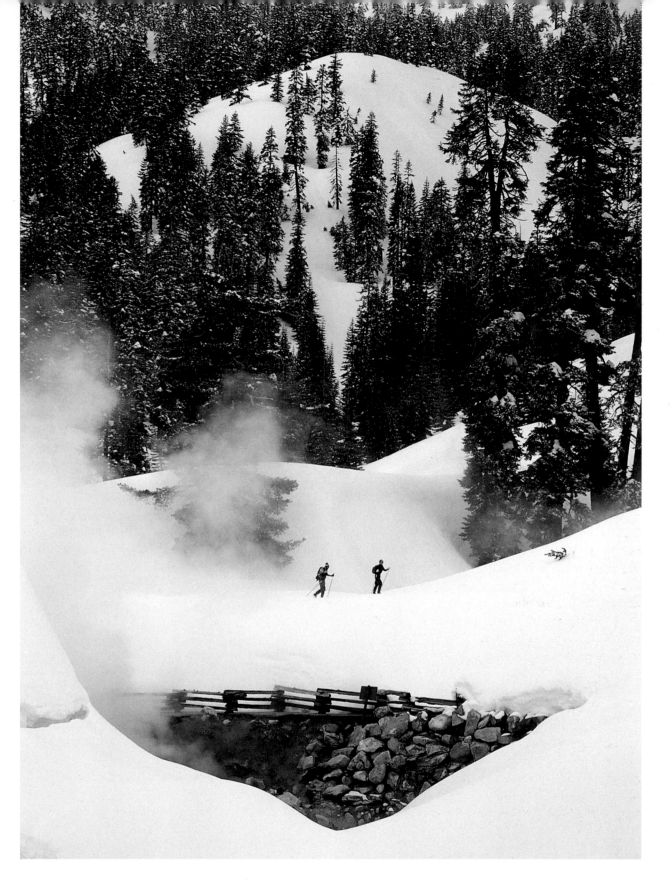

Skiers in northern California's Lassen Volcanic National Park provided the accent I wanted for this snowscape. Sometimes the decisive moment can be elusive, requiring persistence. When several skiers finally came along, one fell down right at the key moment; then it was another hour before two more skiers moved into view and I finally got my shot. To ensure that both skiers were in sync at the same time, I shot half a dozen frames as they moved through my composition. Several versions turned out the way I wanted, including this one, but a few others failed when, quite unpredictably, one or both assumed an awkward-looking position. A medium shutter speed (about 1/125 sec.) easily stopped the slow-moving, far-off action.

[75–150mm zoom lens, Kodachrome 64]

Self-Assignments

140

A self-assignment can be the solution to escaping the inspirational and motivational doldrums that periodically strike photographers. Whether it's a quick project or a multi-day undertaking, a self-assignment helps put purpose into your photography. It can sharpen your creative eye and polish your camera skills. It can let you tell an in-depth visual story. And, it can be an effective way to add to your photo files. Need another incentive? Self-assignments are fun, too.

The aim is to choose a subject that you like. It can be an intimate theme (maybe fall foliage, window reflections, or waterfalls) or a specific setting (a lake, local park, or botanical garden). Or, it might be a broad subject (a quaint village, national park, or coastal area). Or you could photograph a concept (such as "groups" or "symmetry") or a color. Whatever you choose, explore it and shoot it every way you can.

The Mini-Drill Around town or on a trip, the mini-assignment lets you examine a single subject in-depth within a relatively short duration—perhaps a morning, a single day, or several weekends. Picture your subject from different angles and with different focal lengths. Stick with it until you either run out of time or run out of compositions. The advantage of a mini-project is that it accommodates a short photographic attention span; you can choose another subject the following day or weekend. On one two-day coastal excursion, I focused on some broken-down fishing boats. Another self-assignment took place at Joshua Tree National Park, where I shot shadows of the park's contorted trees superimposed on the area's moonlike rock formations.

The Ongoing Theme This type of project usually takes place close to home and lets you watch and record a scene as it goes through changes (at various times of day, in different weather conditions, perhaps in other seasons). An advantage to an ongoing assignment is that you get to regularly review your photos of the particular subject and return for reshoots. My ongoing projects have included fall scarecrows, a bridge lit up at night, and stately oak trees.

You can also put self-assignments to more serious uses. Perhaps you'd like to make people aware of a local environmental issue; your pictures could serve as a valuable way to highlight an unspoiled area or wildlife worth saving. Or, you could take on a historic preservation goal, using your images to help gain protection status for a significant site. But whether you focus on serious themes or casual subjects, self-assignments are one more way for beginners to break out of the snapshot rut and for seasoned photographers to give their vision a tune-up.

For years, I set aside a day or two in October to photograph a crow's worst nightmare: the gathering of more than 200 scarecrows at a former fall festival near San Francisco. During this on-going self-assignment, I photographed the scarecrows early or late in the day, sometimes from a low angle to include the blue sky as a backdrop. Most often, however, I visited in cloudy conditions, zeroing in tight to play up the colors and spotlight the American folk art of scarecrow-making.

[55mm lens, Kodachrome 64 (top left); 55mm lens, Fuji Velvia (top right); 85mm lens, Fuji Velvia (bottom left and right)]

During an extended trip to Joshua Tree National Park, I devoted several sessions to photographing rocks and shadows. It was an interesting and enjoy- *able mini-drill, one that helped keep my shooting eye in top visual form.*

[Both photos: 24mm lens, Fuji Velvia]

While shooting seascapes and fishing villages one week, some old boats caught my attention, and over the course of a few mornings, I used them as a self-assignment. Both cloudy *and clear conditions helped me produce different renditions of the same subject with the same lens.*

[Both photos: 24mm lens, Fuji Velvia]